The Drawings of

John Ruskin

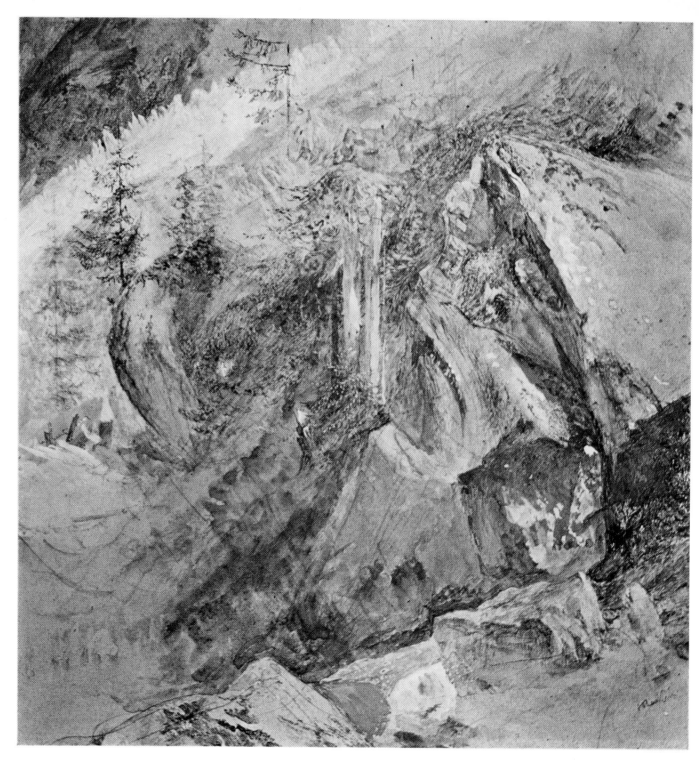

Mer de Glace, Chamonix. c. 1860. Detail of Plate 62

The Drawings of

John Ruskin

Paul H. Walton

First published by Oxford University Press
London, 1972

© Oxford University Press 1972

Reprinted by agreement with the
original publisher
by Hacker Art Books, Inc.
New York, 1985

Library of Congress Catalogue Card Number 84-80598

International Standard Book Number 0-87817-298-X

Printed in the United States of America

Acknowledgements

When the editors of the Library Edition of *The Works of John Ruskin* compiled their invaluable catalogue of Ruskin drawings in 1912 they listed over 2,145 works, of which over half were in private hands. Since that time there has been much re-distribution, and thanks to the devotion of two Ruskin enthusiasts, J. H. Whitehouse and F. J. Sharp, a much larger portion of Ruskin's artistic output is now available to students for study and comparison. In 1932 the late Mr. Whitehouse purchased Brantwood, Ruskin's former home near Coniston, opened it to the public as a national memorial to Ruskin, and began to collect Ruskin drawings for exhibition there, and in the Ruskin Galleries at Bembridge School, Isle of Wight. There are now over 800 noteworthy items in this fascinating collection. At the same time the late Mr. Sharp formed a smaller, but extremely interesting group of drawings, and it is to the present custodians of these relatively little-known collections that I owe my first debt of thanks in the preparation of the present study. Mr. R. G. Lloyd, C.B.E., Q.C., the Chairman of the Education Trust, has generously provided me with every facility for study at Brantwood and Bembridge School, while the curator of the Ruskin Galleries, Mr. J. S. Dearden, has kindly given me the benefit of his detailed knowledge of Ruskin's life and career. Dr. Helen Gill Viljoen guided me in examining the Sharp Collection at Queen's College, New York, and offered valuable suggestions based on her own extensive research and contributions to Ruskin studies.

At Oxford, Mr. Gerald Taylor kindly provided me with his manuscript catalogue of Ruskin drawings in the Ashmolean Museum and the Ruskin Drawing School, and Mr. Luke Herrmann advised me about Turner, English water-colourists, and drawing masters. At Harvard, where this project began as a study of the Ruskin drawings left to the Fogg Art Museum by Ruskin's friend, and Harvard's first Professor of Fine Art, Charles Eliot Norton, I was given essential advice and encouragement by Miss Agnes Mongan, Dr. F. B. Deknatel, and Dr. Mark Roskill, who guided me in preparing this material for presentation as a doctoral dissertation.

Many others generously gave assistance, and to them I would like to express my gratitude, especially Mr. Quentin Bell, Mr. G. W. Cottrell, Jr., Mr. Edward Croft-Murray, Dr. Joan Evans, Mr. Ian Fleming-Williams, Professor E. H. Gombrich, Mr. J. G. Links, Mr. John Manning, Dr. E. Marseglia, and Mr. D. F. Snelgrove. The editors of the *Burlington Magazine* and the *Harvard Library Bulletin* have kindly allowed me to re-use material first published in their journals. The Canada Council generously granted a Fellowship which made much of the travel and research possible, and I am grateful to McMaster University for providing special grants for photographs and research. I owe a further debt of gratitude to all public and private owners of Ruskin drawings and other material for their kind permission to reproduce the works illustrated in this study. Finally, I dedicate this book to my wife, whose constant encouragement and assistance has made the whole enterprise possible.

Contents

List of Plates

Introduction

John Ruskin is one of those great figures in literature, like Goethe, Victor Hugo, and D. H. Lawrence, whose work as an amateur artist has always attracted a certain amount of attention because of its biographical interest and the light that it throws on important aspects of his writing, but, unlike the other authors mentioned, his art has received relatively little serious study. This is surprising when one considers the obvious importance of looking at his drawings in relation to a body of criticism that shows in an unique way, as a recent writer has remarked, a life's work based upon visual sensations.[1] Furthermore, his art deserves to be more widely known than that of almost any other amateur for its intensity and subtlety of development, and it is the purpose of this book to discuss some of these matters from the point of view of the art historian.

Ruskin's considerable talent developed initially under the influence of teachers who maintained very high standards for amateur art in England, because they were involved in a campaign to revive and improve the Renaissance theory that art had an important role to play in the education of the fully-rounded individual. That idea had been first stated in an influential way in 1528 by the Italian nobleman, Baldassare Castiglione, who wrote in his *Book of the Courtier* that gentlemen should be able to draw: first of all, because of precedents from classical antiquity; secondly, because of the practical utility of drawing, especially for recording geographical features and architectural landmarks during travels and military campaigns; and finally, because of the spiritual advantages derived when drawing elicits a better appreciation of beauty in art and nature. One of his paragraphs anticipates completely the spirit and purpose of Ruskin's art, which can be seen as a product of the final phase of this tradition.

And truly [the gentleman] who does not esteem this art, seems to me very unreasonable; for this universal fabric that we see,—with the vast heaven so richly adorned with shining stars, and in the midst the earth girdled by the seas, varied with mountains, valleys and rivers, and bedecked with so many divers trees, beautiful flowers and grasses,—may be said to be a great and noble picture, composed by the hand of nature and of God; and whoever is able to imitate it, seems to me deserving of great praise: nor can it be imitated without knowledge of many things, as he knows well who tries. . . .[2]

The influence of Castiglione was largely responsible for the establishment of French, German, and English academies during the seventeenth century for the education of gentlemen on lines suggested by his book, and in these institutions drawing was almost invariably a part of the curriculum. In England, Castiglione's influence can also be seen in Henry Peacham's book, *The Compleat Gentleman* (1622), designed as a textbook to assist in the instruction of the sons of noblemen, which included a treatise on drawing, the first in a long series written for English amateurs.

The general approach of Peacham's book and subsequent treatises assumed that for utilitarian purposes a gentleman should not only acquire knowledge of perspective and some skill in imitating natural forms, but also exercise his imagination in the

invention of ideal figure and landscape compositions. However, it was naturally assumed that his imitative and imaginative aptitudes need never be subjected to the kind of intensive training undertaken by students in the art academies, for this would involve the sort of labour that was more to be expected of an artisan than of a gentleman. Besides, current academic theories of art made it possible for him to feel that he might have the soul of an artist without worrying unduly about the need to acquire disciplined technical skills. These theories taught that art originates in ideal conceptions emanating from mind and soul, conceptions which may be adumbrated in a moment of inspiration by means of a sketch. Who was to say that the talented gentleman could not imagine ideal harmonies of form, colour, and expression, and sketch the shape of his vision almost as well as any artist? Of course it was left to the professional artist to bring imagination and imitation under the rule of reason, tradition, and technique in illustrations of the great humanistic themes of classical art, and this was understood to be a noble task very different from the limited endeavours of the amateur. Still, this conception of art allowed the gentleman to believe that he could achieve something aesthetically significant as he exercised his talents on the threshold of artistic creation.

It was in France that this classic relationship between amateur and professional, based on shared beliefs about the ideal nature and function of art, began to break down. With the decline of the grand regime of Louis XIV at the end of the seventeenth century, artists were no longer required to treat elevated themes, and soon the sensuous, decorative manner of the Rococo period replaced academic classicism as the favoured style. Amateur practice also became more decorative, based on the sketchy, expressive manner and rustic subject-matter of Boucher and Fragonard, and sketching became an elegant accomplishment especially admired in ladies. In fact, there was now an almost complete identity of aims and methods between amateurs and professionals, for academic artists had abandoned heroic idealism to join the amateur in his devotion to the increasingly frivolous pleasures of sketching and decoration.

At the same time, French culture as a whole was exerting great influence everywhere in Europe. French instructors in dancing, fencing, and drawing were in demand by the middle classes to teach them the accomplishments appropriate to their new social status. Thus it was that when the ranks of amateurs were greatly enlarged toward the middle of the eighteenth century, their practice took the decorative form that had developed in France earlier in the century. This is particularly noticeable in England, where seventeenth-century amateurs like William Lodge and Francis Place had based their methods on the realism of Dutch draughtsmen like Jan Wyck and Anthonie Waterloo, or the Bohemian Wenceslaus Hollar. The Dutch influence remained important in the following century, but when numbers of French drawing masters began to teach in England, particularly after the wars with France ended in 1763, they set a new fashion. The significance of this development was noted by the earliest historian of English water-colour painting, W. H. Pyne, writing in numerous periodicals in the first half of the nineteenth century. In 1832 he commented on how the study of drawing became very fashionable in the eighteenth century, with the appearance of foreign drawing masters such as Jean Pillement, Joseph Goupy, and J. B. Chatelaine. He described the way both Pillement and Chatelaine sketched landscapes in black chalk that were 'the veritable beau-ideal of the landscape regions of the shepherds and shepherdesses of the French opera',[3] and he commented significantly that Thomas Gainsborough had based his style of landscape sketching on their practice. He noted that landscape sketching subsequently became a craze under the influence of Gainsborough. 'The polite idlers' at Bath, he

wrote, vainly fancied, 'because this rare genius could, by a sort of graphic magic, dash out romantic scraps of landscape, rural hovels, wild heaths, and picturesque groups of rustics, that they had but to procure his brown or blue paper, and his brushes and pigments, and do the like'.[4] Pyne regarded this phenomenon as the beginning of a period of bad taste (even as a symptom of aristocratic decadence) among amateurs, whose influence persisted to his own day. He connected Alexander Cozens, another Bath drawing master, with this trend, 'splashing yellow, red, blue, and black [on a china plate] and taking impressions from the promiscuous mass, on prepared paper'.[5] (This was a misunderstanding of Cozens's famous method of using ink blots as the basis for landscape compositions.) William Payne, a later and equally popular drawing master, had been another offender, in Pyne's view, for he taught his pupils to use a split brush for free, sketchy effects; and in his contemporary John Glover, another target for his abuse, he saw similar tendencies.

Such comments amounted to vigorous condemnation of the whole school of picturesque sketching, originating with French drawing masters, but in which the central figure among amateur enthusiasts after 1782 had been the Rev. William Gilpin, author and illustrator of numerous volumes describing picturesque tours in England and Scotland. Other influential amateurs of the school were Sir George Beaumont, Sir Francis Bourgeois, and Dr. Thomas Monro. They all employed a free style in their sketches to create decorative and expressive effects that can be related to the 'Gainsborough mania' condemned by Pyne, and their drawings constitute the practical expression of the picturesque theory that has received so much attention in recent years, especially from literary critics.

As we shall see, the next phase of the history of amateurism in the nineteenth century was dominated by a reform movement which may be described as 'anti-picturesque'. It grew out of neo-classicism, and it aimed at re-establishing the traditional seriousness of amateur art, but at the same time it retained many of the ideas that had emerged from the discussions of the picturesque point of view. Ruskin's art can be seen as the most important result of this movement, and he was at the same time one of the most vigorous reformers, stressing the use of drawing to obtain useful knowledge, and giving exaggerated emphasis to the need for the old sense among amateurs of the gulf separating their art from the imaginative and ideal creations of true artists. Of course, he owed this latter feeling to his enormous admiration for the work of J. M. W. Turner, and it was the stimulus of this enthusiasm that enabled him gradually to carry his artistic achievement beyond the limits of the amateur tradition. The result is that Ruskin's art shows development and change in a way that is probably unique among amateur artists, who are generally content to acquire a serviceable and pleasing style. This was the case with Edward Lear, whose much admired work was so similar in its origins and in some superficial aspects to that of the early phases of Ruskin's development.

The most important consequence of Ruskin's reverence for Turner was the way it led him to a kind of double renunciation, where on the one hand he scorned the ordinary delights of amateurs like Lear, who achieved a rather simple kind of decorative unity in their sketches, while on the other hand he dared not attempt the awe-inspiring harmonies that he admired in Turner. The result was that Ruskin's art became increasingly fragmented and personal in character, and this presents a serious problem for anyone attempting to give an account of his development. To do so, one must select, and this inevitably does violence to the extraordinary collage of notes, diagrams, sketches, compositions, studies and scribbles that constitute his *oeuvre*, none of which can be related, as would be the case with a professional artist, to key paintings that sum up his intentions and methods. Of course, it is just this

lack of conclusiveness in Ruskin's art, its tentative, explorative, and experimental character, that gives it such interest to the modern eye, and something of this has been sacrificed in the present study, where the emphasis has been placed on landscape, without doing full justice to architecture, portraits, or his special kind of still-life subjects. However, it is hoped that this will be least initiate a·wider interest in Ruskin's drawings, as objects of delight for their own sake, and as pointers to important sources of his ideas.

1. The Young Draughtsman (1826–1833)

1. The parents of John Ruskin began to form ambitious plans for their son when they realized that he could rise above their suburban world through the exercise of his precocious talents. His mother hoped that he would follow a career in the Church, and at the earliest possible age initiated Bible studies that trained him into permanent habits of thought and expression. His father was delighted when his son began to write poetry at the age of seven, and saw in this phenomenon a reflection of his own cultural and intellectual interests, long ago set aside for the sake of his career as a wine merchant in London. The young poet was offered models in the works of Scott and Byron through regular readings in the family circle, and with almost equal indulgence he was encouraged to develop his interest in art. Again his father set an example, as he sketched monuments and views during family excursions that combined the business of visiting his clients with the pleasure of travelling throughout Great Britain. This artistic ability, a very modest one, had been developed by Ruskin senior as a schoolboy in Edinburgh under the instruction of Alexander Nasmyth, a painter of some distinction who had conducted art classes for children at his home, and John Ruskin later recalled that one of his father's most ambitious works, a framed view of Conway Castle, had often provided the starting point for stories invented to amuse him as a very young child.

Ruskin seemed to remember making his own drawing of a castle or a tower in his spelling book when he was about four years old, but the earliest surviving examples of his work are some sketches, from 1826 or 1827, made to illustrate a carefully composed and printed imitation of the educational stories for children by Maria Edgeworth. These little notebooks are preserved at Yale University, with their childish outlines of houses, ships, and castles. There is also a landscape (Plate 1) that shows the beginning of a concern for perspective, composition, and conventional shading techniques, suggesting that by then he may have looked into a book of elementary art instruction. By 1828 he had begun to practise his father's favourite technique, pen and ink, in a number of minutely detailed copies of maps (Plate 2), and during the next year or so he composed and printed a puppet play illustrated with drawings of the play's characters (Plate 3). These are small figures in pen washed with water-colour, imitating the style of George Cruikshank in his etched illustrations for the Grimms' fairy-tales (*German Popular Stories*), some of which Ruskin had copied in ink with meticulous care. All these early works show an attention to detail, achieved by powers of concentration and sustained effort unusual in a child, and these qualities were to characterize a great deal of Ruskin's future production as an amateur artist.

When Ruskin was about eleven years of age, an orphan cousin who had been taken in by the family began to have lessons from a drawing master at her day school, and when she brought her exercises home the boy imitated her work with such enthusiasm that in 1831 his father engaged the same teacher to give young John a weekly lesson at home, since he had always been considered too delicate to be

exposed to the rigours of an ordinary school. The artist was Charles Runciman, an obscure teacher who came to be one of the rare regular guests in the Ruskin family circle for many years afterward. He specialized in the teaching of perspective, a subject that his young pupil found intellectually challenging, but he would not allow Ruskin to use pen and ink, and in the usual manner of drawing masters set him to copying his teacher's pencil drawings. This task Ruskin found very dull; it was also difficult, for he was expected to imitate the free, controlled sweep of the pencil in his models, and at first his characteristic solution of this problem was to stipple the lines with a sharp pencil point in a prolonged and concentrated effort to meet new adult standards of achievement.

After the lessons had progressed through such skill-training exercises, Ruskin was set the problem of actually inventing a landscape subject, and this important event was described by the young artist in a letter to his father dated 1832. He rather gleefully tells how he chose a scene based on memories of a family trip to Wales, and then copied from his cousin Mary, to foist a mild deception on his teacher.

I took my paper, and I fixed my points, and I drew my perspective, and then, as Mr. Runciman told me, I began to invent a scene. You remember the cottage that we saw as we went to Rhaidyr Du. . . ? I thought my model resembled that; so I drew a tree—such a tree, such an enormous fellow—and I sketched the waterfall, with its dark rocks, and its luxuriant wood, and its high mountains; and then I examined one of Mary's pictures to see how the rocks were done, and another to see how the woods were done, and another to see how the mountains were done, and another to see how the cottages were done, and I patched them all together and I made such a lovely scene—oh, I should get such a scold from Mr. Runciman (that is, if he ever scolded)![1]

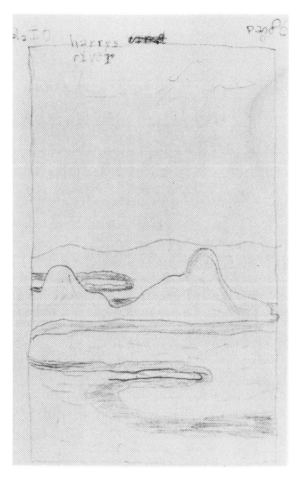

1. *Landscape. c.* 1827. Pencil. 6″ × 4″. From the manuscript, 'Harry and Lucy . . .', Beinecke Rare Book and Manuscript Library, Yale University.

2. *Map of North America.* 1828–9. Pen and water-colour. $7\frac{1}{4}'' \times 9\frac{1}{4}''$. Education Trust, Brantwood, Coniston.

Runciman was impressed rather than annoyed by this performance, and, thus encouraged, his pupil soon 'patched together' another composition featuring Dover Castle, this time based on his earliest outdoor sketches, made during a trip to Dover in 1831 or 1832 (Plate 4). The castle was drawn from memory, as Ruskin later remembered, and the technique is reminiscent of the popular pencil style of David Cox, while the dramatic sky was borrowed from a work by the water-colourist, Henry Gastineau. However, this kind of inventive effort was apparently undertaken quite rarely, and later the young artist was happy to revert to pen and ink in more factual studies of picturesque buildings and views (Plate 5). Here we have the true beginning of Ruskin's career as an amateur artist, which was for a long time to be characterized by this kind of division between more or less factual records of his travels and interests, and an occasional, rather painfully-produced poetic or dramatic version of the same scenes.

The limitations of these juvenile drawings as well as their indications of special aptitudes and interests are important for their evidence about the origins of Ruskin's art. They show genuine talent, but to be seen in proper perspective they may be compared with the earliest drawings of Ruskin's hero, J. M. W. Turner, whose youthful works show a spontaneous response to visual experience that makes Ruskin's *Dover Castle* appear laboured and dry. Nor was Ruskin as precocious as the young J. E. Millais, his later friend and rival in love, who drew vivid portraits, hunting-scenes, and history-subjects from the age of eight, a comparison that also makes us realize how seldom Ruskin's youthful drawings treated the subjects usually preferred by boy artists: soldiers, animals, machines, caricatures of family and friends. The explanation may lie in the difference between the happy, normal family life of a boy like Millais, and the lonely, strictly disciplined childhood of Ruskin. His elderly mother was his only teacher until the age of ten, and her supervision of his activities

8

3. *Page from the Puppet Show.* c. 1829.
Pen and water-colour. 6″×9″.
Collection Dr. Helen Gill Viljoen.

was constant, severe, and puritanical. Ruskin may have exaggerated the rigour of his upbringing, but certainly he was allowed few toys and little freedom. Instead, both his parents encouraged him, with praise and cash payments for every page of work, to be incessantly busy with educational projects that took the form of stories, essays, and poems, carefully printed to imitate book pages and illustrated with minutely detailed pen drawings in imitation of engravings. In this way his earliest art activity was directed along lines strictly defined by adult standards and ideas of what was educationally desirable, so that he was not encouraged, nor did he have the time, to draw in a playful way the kinds of figure subjects in which a child imaginatively expresses and defines a conception of himself within a framework of human relationships. This may account for a fact that Ruskin himself observed in recalling his early art activity. 'I never saw any boy's work in my life showing so little original faculty, or grasp by memory. I could literally draw nothing, not a cat, not a mouse, not a boat, not a bush, "out of my head". . . .'[2]

His continuing lack of creative originality in later life was a source of surprise and disappointment to Ruskin, and it confirms the impression that to some extent his imagination had been crippled by the early lack of encouragement to identify freely and creatively with others through his art, with consequences that determined the course of his career as a critic, and had much to do with the tragedy of his personal life.

Another limitation set on Ruskin's early art activities by the nature of his upbringing can be seen in the circumstances surrounding the event referred to earlier, when he was asked by his drawing master to invent a landscape composition. Runciman was not perturbed by what his pupil would have regarded later as a significant failure to truly 'invent' a subject. Instead, he was rightly impressed by the ambition, cleverness, and perseverence of the young artist, and decided that he would, as Ruskin reported to his father at the time, 'totally change the method that he had hitherto pursued' with his pupil. He advanced him from drawing practice to simple exercises with water-colour, as an introduction to this medium, 'but the latter only as a basis for oil'.[3]

Apparently Runciman had decided that Ruskin was specially talented, and could be introduced to more advanced techniques, with emphasis on oil painting as the ultimate goal. This suggests that he saw more in the future of his student than the usual amateur competence in sketching and water-colour. Perhaps he believed that he had encountered a boy who would one day bring lustre to his teacher's name through his success as a professional artist in the exhibitions of the Royal Academy, where Runciman himself had tried unsuccessfully for years to attract favourable attention as a painter of landscapes, genre scenes, and historical subjects. If this was the case, Runciman had something to learn about the intentions of Ruskin's parents in providing him with a drawing master. They saw their son's future in terms of literary, social, and spiritual development rather than professional success, and they had no thought of encouraging him to embark on a course of study that might lead him into the competitive world of academic art. Ruskin's mother had dedicated him to God at birth, and her piety, combined with his father's social ambition, resulted in agreement between them to prepare him for a career in the Church. Ruskin wrote humorously at a later date that his father had recognized powers in his son 'which had not their full scope in the sherry trade. His ideal of my future . . . was that I should enter at college into the best society, take all the prizes every year, and a double first to finish with; marry Lady Clara Vere de Vere; write poetry as good

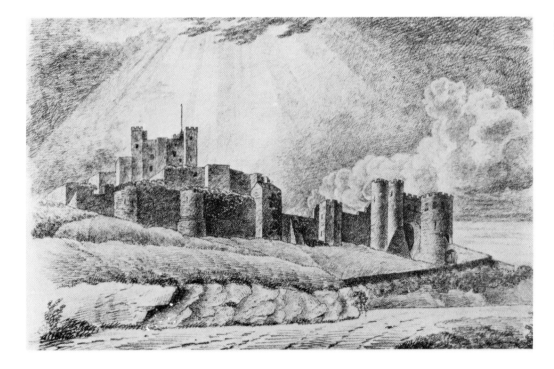

4. *Dover Castle. c.* 1832. Pencil. 7″ × 10¼″. Bembridge School, Isle of Wight.

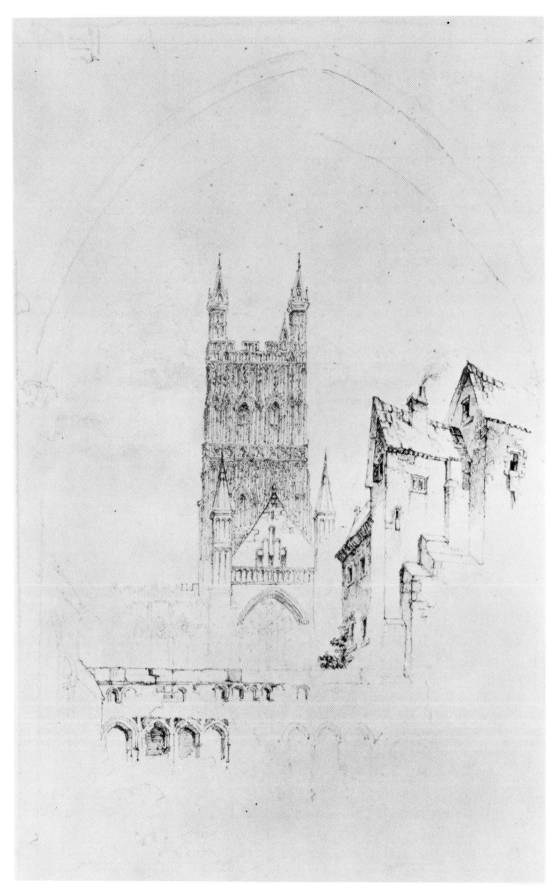

5. *Tower of Gloucester Cathedral. c.* 1834. Pen.
11½″ × 7″. Ashmolean Museum, Oxford.

as Byron's, only pious; preach sermons as good as Bossuet's, only Protestant; be made, at forty, Bishop of Winchester, and at fifty, Primate of England.'[4] His mother, he said, thought of his becoming 'another White of Selborne, or Vicar of Wakefield, victorious in Whistonian and every other controversy'.[5]

These ambitions, touched on so lightly by Ruskin, had nevertheless a decisive and far-reaching effect on his parents' plans for his his education. They included a fairly clear idea of the place that art training should have in the education of a clerical gentleman. He would only need to practise art as an amateur in the traditional way, with as much skill in sketching with pencil and water-colour as a good drawing master could give him in a few lessons. Advanced training in the techniques and materials of art would introduce an unnecessary and inappropriate degree of specialization. This idea was somehow communicated to Ruskin, for when he finally undertook some experiments in oil painting in 1835 he complained in a rhyming letter about the messiness, odour, and effort involved, showing his conviction that water-colour was the medium best suited for the aesthetic exercises of a gentleman.[6]

It is evident from Ruskin's subsequent development as an amateur artist that for a long time he remained faithful to this conception of the purpose and character of his art, and that it was difficult for him to shake off the mannerisms and prejudices which it entailed. That he was successful to a large extent in overcoming this influence gives special point to the study of his stylistic development, but the enduring result of these conditions of his early education was the deliberate subordination of his considerable artistic talent to his literary work.

2. The skills that the gentleman amateur acquired from his drawing master were brought into full play during his travels, when he was expected to participate in the fashion that had developed in the eighteenth century for making verbal and pictorial records of the picturesque scenes along his route. This tradition continued into the nineteenth century, but there were many changes from the time when the Rev. William Gilpin had first composed his volumes of 'Observations' on the picturesque beauties of Great Britain. The nineteenth-century English traveller moved farther afield and in much greater numbers during the upsurge of middle-class tourist travel that followed the Napoleonic wars, and he was more likely to depend on the services of professional artists to provide him with ready-made pictorial souvenirs of his journeys. Large numbers of professional travel illustrators now roamed over Europe, the Near East, and North America, making sketches to be engraved or lithographed for publication, often with a text providing the historical and literary background for scenes and monuments along popular tourist routes. The best-known practitioners in Ruskin's youth were men like Samuel Prout, David Roberts, J. D. Harding, and William Callow, a group that regarded J. M. W. Turner as the enviably successful founder of their profession in its modern form. Following Turner's lead, they still gave their illustrations the attraction of the kinds of composition favoured by 'picturesque' theory, but this traditional concern for purely visual effect was complicated in the early years of the nineteenth century by the introduction of additional forms of response to the landscape. The Romantic Age felt a reverence for nature quite different from the attitude taken by enthusiasts for the picturesque, an adherence to the academic view that nature was imperfect, requiring correction according to general and ideal principles of beauty. This outlook had been modified by the influence of artists like Turner and Constable, with their deep affection for every detail and accident of land, sea, and atmosphere, and this resulted in new and difficult standards of naturalism for both professional and amateur travel illustrators. Another new element was the Romantic sense of history, which ensured that towns, fortresses, and monuments associated with great events in the past would form

essential centres of interest in illustrations of the European landscape. Finally, there was the Romantic concern to record and magnify the individual emotional response of the artist to exotic foreign scenes and the infinite mystery of nature.

This nineteenth-century combination of the 'picturesque' with Romantic naturalism, historical associations, and personal emotion found its fullest expression in the poetry of Byron and the paintings of J. M. W. Turner. The third and fourth cantos of *Childe Harold* became 'the manual for a whole generation of tourists'[7] at the same time that Turner's painted and engraved landscapes, with their suggestions of a tragic relationship between man and nature, were becoming widely known. Then, inspired by Byron, Samuel Rogers published his poetic travel book *Italy* in 1822, and it was republished in 1830 with engraved illustrations in vignette form, most of them after Turner (Plate 6). This combination of mildly Byronic verse with miniature decorations translating Italian scenery into delicate visions of a kind of fairy-land was very popular with middle-class readers, who liked their Romanticism in a refined and elegant form.

Roger's *Italy* came into young Ruskin's hands about 1832, and the interest that it stimulated in European travel was excited still further, although in a very different way, during the following year, as he and his father pored over Samuel Prout's newly published *Facsimiles of Sketches in Flanders and Germany*. This was a large book of lithographs presented without text, as if it were an artist's portfolio of pencil studies of picturesque streets and buildings made on the spot during his travels (Plate 7). When Mrs. Ruskin saw their enthusiasm she suggested that they might all visit such scenes in reality, and there followed some 'weeks of entirely rapturous and amazed preparation' for the family's first Continental tour.[8] These preparations included review and study of the illustrations in Rogers and Prout, for some careful copies from both are preserved. The former book provided a model for dream-like imaginings on the theme of realms of beauty far removed from the narrow environment of a London suburb, while the latter suggested how to convey the excitement of direct visual contact with the old stones and picturesque silhouettes of exotic foreign towns. They indicated to Ruskin how he might exercise his skills as a draughtsman and poet in a way that would make his journey a 'picturesque' tour in the full nineteenth-century meaning of the term.

This, at least, was the intention; but in fact, the Ruskins were too inexperienced in European travel to make their journey during the summer of 1833 in the relaxed and easy way that would have allowed young John to sketch and meditate as he had

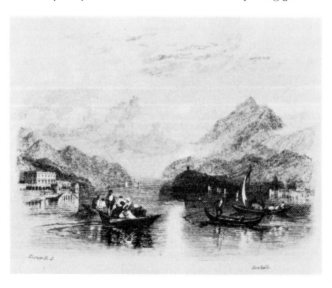

6. J. M. W. Turner. *Como*. 1832. Engraving. From Rogers' *Italy*. The New York Public Library.

7. (right) Samuel Prout. *Hôtel de Ville, Louvain*. 1833. Lithograph. From *Sketches in Flanders and Germany*. The New York Public Library, Prints Division.

hoped to do, so that the actual records in word and picture, while ambitious, are rather fragmentary.

The plates in Prout's book dealt entirely with architectural subjects, and they showed Ruskin a way of using his pencil to record the texture of old buildings with broken lines and dots, in an outline style deriving ultimately from Canaletto, by way of the early work of Turner and Thomas Girtin, but coarsened and simplified by the use of lithographic crayon. In one of his first Continental sketches Ruskin tried to work this way from nature: a pencil drawing of the Hôtel de Ville at Cassel;[9] but the result is shaky and uncertain, and another drawing, of a watch-tower at Andernach,[10] sees him reverting to pen and ink, probably applied later over a simple outline made on the spot. He was not yet able to practise the impressionism of

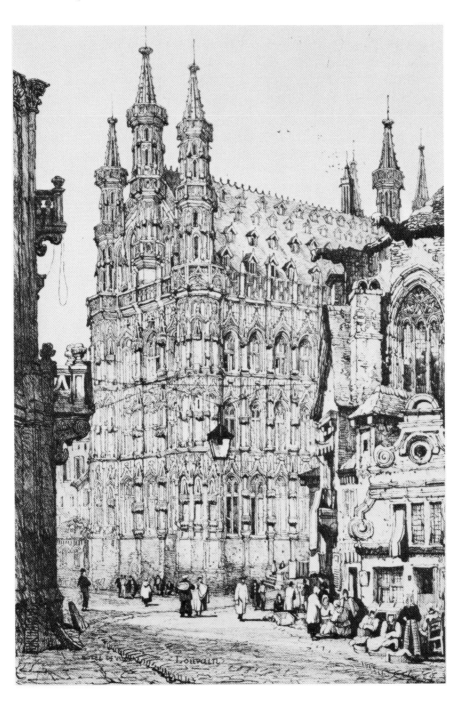

Prout's style, with its sophisticated translation of visual experience into a system of conventional touches.

Some of the pen drawings made at this time look like school copies rather than records of things seen, and these were probably elaborated in hotel rooms or at home; but sometimes the pen is skilfully handled in a loose, conventional texture of accents that shows how far he had advanced in manual dexterity under Runciman's instruction. This is seen in a sketch of the Lake of Thun (Plate 8), shaped like a vignette, and composed with schematic distinctions of tone and form from plane to plane in an eighteenth-century manner that probably derived from Runciman.

On another sheet Ruskin made two of his first mountain sketches (Plate 9), the one a view of a fortress among fantastic rocky peaks, reminiscent of a detail from a Cruikshank illustration for a fairy-tale, the other a more realistic sketch of the needles of Mont Blanc against the sky, showing some observation of effects of light and shade. A comparison between these sketches and his way of recording the same scenes in his diary shows that his timid drawing style, limited at this time by eighteenth-century conventions, fell far short of expressing a romantic vision of the Alps that his easier command of language enabled him to give in a breathless torrent of words:

. . . seven thousand feet above me soared the needles of Mont Blanc, splintered and crashed and shivered, the marks of the tempest for three score centuries, yet they are here, shooting up red, bare, scarcely even lichened, entirely inaccessible, snowless, the very snow cannot cling to the down-plunging sheerness of these terrific flanks that rise pre-eminently dizzying and beetling above the sea of wreathed snow that rolled its long surging waves over the summits of the lower and less precipitous mountains.[11]

As soon as he returned home Ruskin began work on an account of the tour, partly in verse imitating Rogers, and partly in prose, with a number of illustrations based on Turner's vignettes for the *Italy*. It was intended to have 150 verses with

8. *Lake of Thun, Near Oberhofen.* 1833. Pen. $5\frac{7}{8}'' \times 8\frac{5}{8}''$. Bembridge School, Isle of Wight.

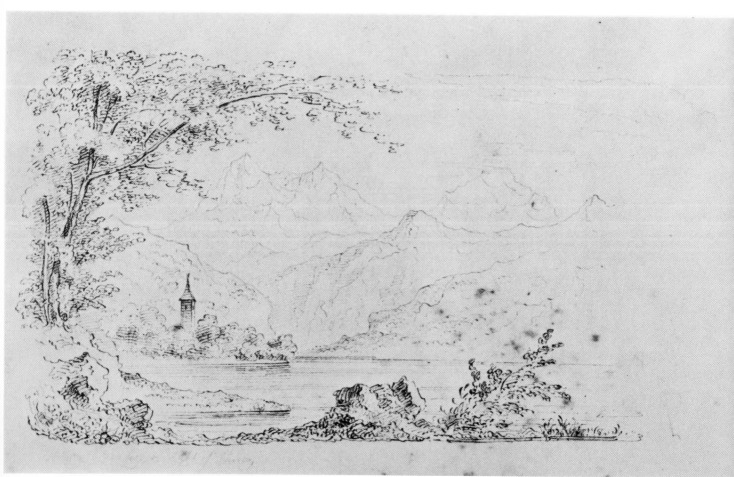

9. *Fortress above Balstall and Mont Blanc from Geneva.* 1833. Pen. $8\frac{7}{8}'' \times 5\frac{1}{8}''$. Bembridge School, Isle of Wight.

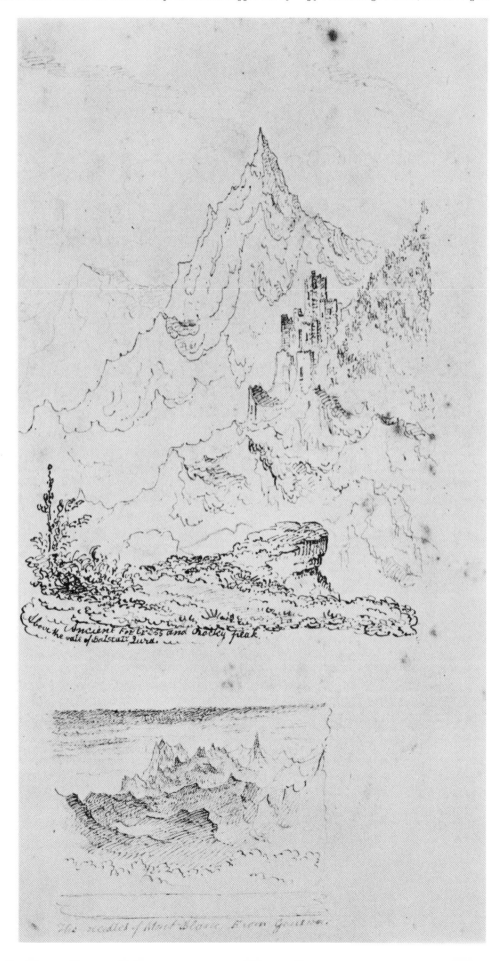

accompanying illustrations, but only fragments, sketches, and a few finished studies were completed. Some of the vignettes are very minutely drawn with the pen to resemble engravings (Plate 10), and these are the first of the imaginative compositions in a Turnerian style that Ruskin was to make occasionally to illustrate his travels. In this result of his first contact with Turner's art we see a fascination with that artist's feeling for infinite light and space, in which the landscape forms seem to float, defined by gently spreading and interfused areas of shadow. The question of how to reconcile this visionary style, so real in its emotional appeal, with his own increasingly scientific observations of the material reality of natural forms must already have been arising in Ruskin's mind.

3. Questions about the meaning of Turner's art were not yet very relevant to Ruskin's own artistic interests and pursuits at this time, for he was becoming more and more absorbed in the comfortable artistic milieu of the Society of Painters in Water-Colours, from whence Turner appeared as a remote and mysteriously splendid star. Visits to the exhibitions of the Society must have begun at least as early as 1830, with his father, who soon began to assemble a small collection of water-colours, beginning in 1832 and 1833 with a Scottish scene and a 'sea piece' by the Society's President, Copley Fielding. This led to an acquaintance with Fielding which resulted in Ruskin's enrolment, in June 1834, as his pupil for a series of six lessons that were, as Ruskin put it, 'supposed to have efficiency for the production of an adequately skilled water-colour amateur'.[12] Fielding was to be but one of a group of teachers and models from the ranks of the Society who influenced Ruskin's development as an artist (the others were Samuel Prout, David Roberts, and J. D. Harding); and this, together with his father's purchases from the annual exhibitions over ten years, gave him close acquaintance with an institution he described many years later with humorous affection in a frequently quoted passage from *Praeterita*.

I cannot but recollect with feelings of considerable refreshment, in these days of the deep, the lofty, and the mysterious, what a simple company of connoisseurs we were, who crowded into happy meeting, on the first Mondays in Mays of long ago, in the bright, large room of the Old Water-Colour Society; and discussed, with holiday gaiety, the unimposing merits of the favourites . . . Copley Fielding used to paint fishing-boats for us, in a fresh breeze . . . but we were always kept pleasantly in sight of land, and never as much as a gun fired in distress. Mr. Robson would occasionally paint a Bard, on a heathery crag in Wales; or it might be, a Lady of the Lake . . . A little fighting in the time of Charles the first was permitted to Mr. Cattermole . . . But the farthest flights even of these poetical members of the Society were seldom beyond the confines of the British Islands [until Mr. Prout introduced] foreign elements of romance and amazement into this—perhaps slightly fenny—atmosphere of English common sense.[13]

There is, however, an unmistakably patronizing note in this late assessment of the importance of the water-colourists. It does not reveal the seriousness with which Ruskin regarded their art in the 1830s, an outlook recorded more faithfully in the first volume of *Modern Painters*. This book, with its detailed discussion of the contribution of English water-colour masters to the European landscape tradition, shows the extent to which his ideas and his art were rooted in the special kind of artistic world created by the water-colourists and drawing masters in the Society.

The Society of Painters in Water-Colours had been founded in a mood of resentment against the Royal Academy, where water-colours had always been given an inferior place in its exhibitions. This was because the Academicians regarded water-colours as 'drawings', and according to academic standards those who made only drawings, without leading their studies toward idealized composition on canvas,

10. *Ehrenbreitstein.* 1833–4. Pen. 3″ × 4½″. From the manuscript, 'Account of a Tour on the Continent,' Beinecke Rare Book and Manuscript Library, Yale University.

were virtually amateurs, hardly to be ranked as artists in the full sense of the term. However, water-colourists in the early nineteenth century were less prepared to accept this estimation of their importance than they had been during the previous century, when leading practitioners like Paul Sandby and his school had seen themselves primarily as topographers, continuing a tradition established in England by visiting landscape draughtsmen from the Netherlands. More exciting aims and ambitions had been revealed with the emergence on the Continent of a neo-classical school of water-colour landscape painting, whose best known representatives were J. G. Hackert (1744–73) and A. Louis Ducros (1748–1810). Their large-scale works depicted classical scenes in a style based on Claude Lorraine and Gaspard Poussin; and Sir Richard Colt Hoare, an enthusiastic collector and connoisseur of water-colours, expressed the view in 1822 that it was Ducros who had been responsible for the advance of English water-colour from 'drawing' to 'painting'. By this he meant that the example of Ducros had encouraged water-colourists to emulate oil painters and apply their medium to classical subjects, to exercise their imaginations in the invention of large-scale compositions, and to brush colour directly on the paper without the meticulous underdrawing and ink washes of the topographical style. This enlargement of scale, methods, and ideas enabled the practitioners of water-colour to claim that their art was no longer confined to making imitative coloured drawings, but was capable of producing monumental, ideal, images of nature.

The first artist to use water-colour in this spirit as a major means of expression was J. R. Cozens, who had been influenced by neo-classical artists in Italy. He was followed by Girtin and Turner, who exhibited ambitious large-scale water-colours at the Royal Academy in an attempt to emulate the great classicist of English landscape painting in oils, Richard Wilson. As early as 1798 and 1799 observers had been struck by the way Turner transformed topographical views by means of heroic and dramatic effects of light and atmosphere, giving water-colour an un-precedented force and depth of tone which rivalled oil painting, and comments on this phenomenon sparked the famous controversy lasting throughout the first half of the century as to the relative merits of the two media. Turner continued to astonish

critics and fellow artists with monumental water-colours like *The Great Falls of the Reichenbach*, a work attempting the most intense expression of the sublime in an interpretation of mountain scenery remembered from a recent visit to the Continent. This, together with similar works, was shown in Turner's own gallery in 1804, and in the same year a small group of water-colour artists, fully conscious now of the possibilities of their medium, met to consider how they could exhibit their works to better advantage than in the Academy. The result was the formation in the following year of a society whose members declared their conception of the dignity and status of their art by describing it as an organization for *painters* in water-colour.

Some artists in oil thought it presumptuous that water-colourists should call themselves 'painters'. The distinguished amateur and connoisseur, Sir George Beaumont, spoke for a party of Academicians who noted the ambitions of the new Society when, as Joseph Farington reported, he 'reprobated the rage for water-colour drawing', and looked forward to the day when the fashion had run its course.[14] In a short time the traditionalists even felt threatened by the new development, for we find one connoisseur telling Farington in 1811 that he was alarmed to observe the way 'drawings now seemed to supersede painting'.[15] A similar awareness of opposition between the Academy and the new organization was expressed in 1808 by a commentator with radical ideas who rejoiced in the formation of 'this little republic of art' to challenge the older establishment.[16]

The ambitions of the water-colourists led them not only to invade territories which the academies had hitherto reserved for oil painters, but to make bold claims on scientific grounds in the controversy over the relative merits of the oil and water-colour media. Many of them were willing to subscribe to statements made in a series of public lectures delivered in 1806 by W. M. Craig, a drawing master who maintained that since the purpose of art was to imitate nature by different intensities of light and colour, water-colour was superior, since it was 'the process of painting which furnishes the most extended scale of means on the sides of light and dark'.[17] He went on to argue that transparent water-colour was more pure in hue than oil paint, and since it was applied on a white ground it could give greater range of tone, coming nearer to 'the philosophical principles on which the appearances of nature are founded, than any other process of painting as yet known'.[18] (When Craig's claim, together with some critical remarks about Sir Joshua Reynolds, were reported to Farington and his circle, they were 'disgusted at his presumption and folly'.[19]).

Water-colourists of the nineteenth century continued to insist on the scientific accuracy of what they regarded as a peculiarly British medium, urging its use in conjunction with the colour theory of Sir Isaac Newton, and the perspective theory of Brook Taylor, a Cambridge mathematician, whose difficult work had been interpreted for artists by the topographer Thomas Malton in his *Compleat Treatise on Perspective* (1775). Several comparable treatises were written in the nineteenth century by drawing masters associated with the Water-Colour Society, like John Varley and T. H. Fielding. These works usually included some discussion of the phenomena of light, colour, and vision, and their authors often stated that their aim was to help students to see scientifically. This was an attempt to elevate topographical draughtsmanship to a form of experimental science, and it gave artists of this class considerable claim to respect for their knowledge of mathematics and natural philosophy, in a way that supported their bid for Academic respectability. The best example of the recognition of this claim can be seen in the appointment of J. M. W. Turner, who had been Malton's pupil, as the first Professor of Perspective in the Royal Academy.

One of the results of this kind of ambition was that a new breed of drawing master

appeared who took a much more serious view of the educational value of his instruction. W. M. Craig was one of many teachers who now saw a course of drawing as a means to 'the education of the eye' by which the student could acquire 'a true knowledge of forms', and his numerous quotations from Leonardo da Vinci underline his intention to restore the Renaissance conception of drawing as a tool of scientific inquiry. This led Craig to attack the popular and careless drawing style of picturesque sketchers like the Reverend William Gilpin, who encouraged amateurs to draw with 'irregular dashes of the pencil which . . . if they are not one thing may be easily conceived to be another'.[20] Craig insisted on the need for careful observation and accurate imitation by means of a careful outline style, and his criticisms of the idealism and aestheticism of picturesque sketching initiated a campaign to reform amateur art along the lines that he suggested. Later drawing masters, like W. H. Pyne, John Varley, and David Cox, also taught their students 'to substitute correctness of drawing for incoherency and scrawling, and precision of touch for blotting and sponging'.[21]

Through his contacts with the drawing masters in the Water-Colour Society John Ruskin acquired the same ideas about the purpose of drawing in association with studies in perspective and the analysis of light and colour. He carried their anti-picturesque doctrine even further as his art developed, and in his *Elements of Drawing*, where he takes on the role of drawing master himself, we see the climax of the long campaign to reform amateur practice in the direction of the precise and scientific observation of nature.

However, it was very far from the intention of the water-colourists to exclude the ideal from their art in the interest of science. Their campaign to establish water-colour on a higher academic plane had begun with the realization that academic idealism was attainable in their medium, and many artists believed that true greatness of achievement would depend on their ability to combine a scientific vision of nature with the grandest traditional themes. That is why the Society offered special premiums to members who produced large works treating sublime or 'beautiful' subjects for its annual exhibitions. In this way the Society made its claim to competence in all branches of landscape, and even figure composition, but it was nevertheless believed that their most original achievement would result from searching out a peculiarly British form of the ideal in what was called 'the true pastoral style of English landscape'. This field of endeavour had been defined by J. T. Smith (1766–1833), the water-colourist friend and early adviser of John Constable. In his *Remarks on Rural Scenery*, published in 1797, Smith had discussed 'the theory of rural scenes', and he had made the assertion that 'the landscape painter's beauty does not necessarily exist in grandeur exclusively or alone; but pervades every department of Nature, and is found in the most humble as well as in the most stately structures of scenery.'[22] It is the theory of the 'picturesque' that Smith refers to here, but in the form that it took after the original idea of the picturesque as any 'picture-like' view had been modified until it referred to close-up sketches of humble rural subjects grouped in an informal way. This was a style and subject that looked back to the example of Gainsborough, who had been the first, Smith said, 'to give distinct characteristics and original varieties to his cottagery'.[23] Smith's book was a plea that English painters should follow this example, and also that of the English nature poets, in treating native rural themes as a means of achieving a national school and style distinct from the foreign heroics of academic classicism.

This advice was taken by many members of the Water-Colour Society who made such subjects their speciality, but at the same time they usually avoided the generalized sketchiness of Gainsborough's style, identified by some as the original

source of the bad tendency that W. M. Craig condemned in amateur and professional practice. There was also a strong inclination among water-colourists to stress the connection between their art and nature poetry, for Smith had been correct in noting the importance of landscape poets in the development of a taste for the picturesque. Following the example of Turner and other members of the Academy they exhibited works accompanied by poetic quotations, and critics acquired the habit of describing water-colours with phrases like 'fresh as a sonnet by Crabbe', or 'he paints morning and evening odes',[24] or 'painted with the poetic feeling of the author of *The Seasons*'.[25]

Under these circumstances it is not surprising that the youthful Ruskin should at first put his best artistic efforts into the illustration of his own poetry, and throughout his life he continued to think of his art in association with the prose poems on landscape in his later books. Equally understandable in this context is his early enthusiasm for 'the true pastoral style of English landscape' centring on the English cottage, which was to provide the theme for his earliest critical essay, 'The Poetry of Architecture' (see below, pp. 33ff.). If his taste later tended toward grander aspects of scenery, he was always to insist on the importance of the kind of intimacy between man, nature, and architecture that he had first studied in native rural scenes. There he had found an ideal harmony that he patriotically identified as a peculiarly British achievement, bearing comparison with the more grandiose features characterizing treatment of the European scene, and providing a standard for the measurement of true value in art and architecture.

4. The 'picturesque' tradition also provided water-colourists with theories of art which had been worked out in the course of discussions about the nature and meaning of the distinctions drawn by critics between the beautiful, the sublime, and the picturesque. There was the eighteenth-century view, put forward by Hogarth, Burke, and Uvedale Price, that aesthetic qualities could be entirely identified with sensations and feelings stimulated by certain objective properties of natural and artistic form. Then there was the more modern view held by the philosopher Archibald Alison, who contended that the aesthetic quality of an object depends on the ideas and emotions with which it is associated in the mind of the observer. What might be called the 'sensualist' theory of the eighteenth century had led to a marked interest in abstract forms, impressions, and principles of composition of the kind popularized by the writings and sketches of William Gilpin, whereas the associationist aesthetic tended to encourage more naturalistic representation, since it was the particular object, rather than an abstract quality of form or impression, that would call up the most vivid trains of associations, and thereby appeal to the ordinary affections and emotions of human nature. Both theories laid stress on immediate sense-impressions and the emotional reactions of ordinary human nature as the basis of aesthetic experience, and this empirical, common-sense approach to art, growing out of eighteenth-century philosophy and psychology, provided an alternative to the idealism of traditional academic theory.

Water-colourists and drawing masters of the nineteenth century accepted both alternative theories, and tried to reconcile them in their teaching and practice. This synthesis was perhaps most successfully achieved by John Varley (1778–1842), a founder member of the Water-Colour Society renowned for the 'high, abstract principles' of his theory. In 1815 he published his influential book of art instruction, *A Treatise on the Principles of Landscape*, where the text stresses that an artist must organize his subject and effects so as to stimulate associations 'which have always delighted mankind in general'.[26] He also shows how to analyse and arrange pictorial

effects empirically, according to principles of contrast, balance, and eye movements, in a way that is intended to teach the student to compose associated ideas, and purely visual effects, simultaneously. He influenced the aims and methods of many members of the Water-Colour Society, including distinguished masters like Cotman, Cox, and De Wint, all of whom, early in their careers, practised a style like Varley's simplified version of the Girtin manner. This style retained the planar composition and regulated balance of the classical tradition, but it included new naturalistic elements in the elimination of the traditional pen outline, and the use of patches of colour and tone set down in a kind of mosaic, capable of more realistic modulation than the broad washes of the earlier technique; it was a method of handling the brush perpetuated for many years among amateurs by the richly illustrated treatise published in 1813 by David Cox.[27]

Ruskin later recommended a refined version of this style as the best means of recording the impressions of an 'innocent eye', and from the beginning of his artistic career was fascinated by the Varley method of compositional analysis. He became very learned in its principles, and delighted in showing off his expertise in his earliest publications as well as in his later *Elements of Drawing*. Eventually, however, he came to identify this approach with reactionary and rule-bound tendencies in English art, and in his later works, in which he put forward his own theories of artistic inspiration, he constantly attacked Varley's kind of academic rationalism.

The widespread influence of Varley and his followers which Ruskin came to deplore nevertheless helps to explain the great popularity of the exhibitions of the Water-Colour Society with middle-class patrons. Their ideas show that water-colour art was based on an aesthetic of sensation, emotion, and associated ideas, an aesthetic of the common man, as opposed to the cult of 'high art' fostered by the Academy, which enabled the Society to encourage the new notion that 'taste' need no longer be the exclusive privilege of the aristocracy. Every middle-class household could have a drawing master, pictures on the walls, and an album or portfolio on the parlour table in which to display accomplishments in sketching. Very quickly the exhibitions of the Society became occasions where many of the visitors were pupils of the artists, and the whole family could feel at home among pictures of familiar charm, modest size, and reasonable cost. With this kind of success the Society inevitably became conservative, and rigid in its rules, so that by 1834 it was no longer referred to as a 'little republic of art', but as 'this little self-constituted Academy'.[28]

Emphasis on pleasing the middle-class public deadened the initiative of many water-colourists, but there were also ambitious artists who tried to mould public taste in ways that had an important influence on English art criticism. Many members of the Society disseminated their views and methods in lectures, essays, and innumerable books of instruction, publications which contributed to a crucial change in artistic values in England, and allowed landscape to rise to a central place in any discussion of art. This is illustrated by the facts that in the first quarter of the century David Cox published his teaching methods in a book with the modest title *A Treatise on Landscape Painting and Effect in Water-Colours*, but thirty years later another leading member of the Water-Colour Society, J. D. Harding, chose a resounding and all-embracing title for a book with similar aims, also devoted chiefly to landscape, *The Principles and Practice of Art*. By this time critics and teachers like Harding were able to ignore the old academic prejudice against landscape and water-colour, and as specialists in these fields, they could even try to replace members of the Academy as the leading interpreters of the meaning and purpose of art. The most important event in this development occurred in 1843 when John Ruskin published the first volume of *Modern Painters*, a book praising and explaining not only Turner, but many members of the

Water-Colour Society, who are treated as leaders of the most progressive movement in modern art.

Of course, the absence in Ruskin's criticism of any concern for progressive trends on the Continent in the art of Delacroix, Courbet, and their followers surprises us today for the provincialism and prejudice such an outlook reveals, but it illustrates the nature of the self-contained art world from which he acquired many of his basic terms of reference. This was a world where preoccupation with expressive and imitative forms of art, combined with detachment from traditional values and concerns, provided a source of aesthetic energy that reached an important climax in Ruskin's conception of art. His criticism transcended the theories of the drawing masters, to provide one of the most significant formulations of a Romantic alternative to classical idealism, and it is against this background that his drawings should be considered.

2. The Gentleman Amateur (1834–1841)

1. When Copley Fielding became Ruskin's teacher in 1834 he had been President of the Society of Painters in Water-Colours for three years, and he continued in that position until his death in 1855. He had succeeded his master, John Varley, as the leading drawing master in London, but his style was more modern, incorporating some of Turner's effects of light, space, and atmosphere within the framework of basically classical arrangements and methods which Varley had adapted from Girtin. Fielding's subjects were usually sea pieces or misty views over rolling downs, and early in his career he was admired for his 'wild and romantic grandeur',[1] although later critics in the nineteenth century, such as Roget and the Redgraves, found his work repetitious and mannered (Plate 11). They said that his position as a fashionable teacher had required him to make showy drawings for his pupils, and that he depended too much on sponging and rapid brushwork for easy effects that enabled him to produce thirty or forty drawings for a Society exhibition.[2] Ruskin also came to regard him as a facile performer, complaining that Fielding only taught him mechanical methods of painting landscapes by using successive washes for sky, strips of light and shade for water, and 'scraggy touches' for foliage, foreground, and mountains.[3] However, he also acknowledged that Fielding had taught him to observe reflections closely, to study aerial perspective, and to realize that an artist like Prout sacrifices truth when he creates picturesque effects by 'Proutizing' (Fielding's term) his subjects with a mannered vocabulary of linear accents.[4] These were all steps toward more faithful observation of nature, and as a result Ruskin's early criticism in *Modern Painters* was full of praise for Fielding's 'faithful and simple rendering of nature'.[5] At that time he admired the luminous realism of his misty atmosphere, and his power of conveying deep spatial recession, a feature noted by an earlier critic, who commented in 1821 on the way Fielding omitted the conventional foreground plane for the sake of greater depth in his 'scientific and accurate imitations of nature'.[6] Thus it appears that within the circle of the Water-Colour Society Fielding's art was at first regarded as progressive in its expressive and naturalistic effects.

Furthermore, Fielding can be associated to a certain extent with advanced speculation among water-colourists about the nature of vision and pictorial effect, and their importance in education. His brother, T. H. Fielding, was a drawing master with scientific and philosophical interests, who published a book in 1836 called *On the Theory of Painting*, where he stated that imitation in art aims at discovering 'the reasoning power in the formation of things' which gives every object in nature a certain fitness of construction, creating an organic interrelatedness of all natural forms and forces.[7] The practice of drawing and painting can teach one to see this essential truth about nature, and as an example of how this knowledge might have practical utility he refers to Smeaton's design for the Eddystone lighthouse, patterned after the trunk of an oak tree to achieve a form with great natural resistance to the forces of wind and waves. This is an interesting restatement of the utilitarian purpose

11. A. V. Copley Fielding. *Rievaulx Abbey.* 1839. Water-colour. Bethnal Green Museum.

of art education, which had been defined by earlier drawing masters in terms of training the eye to measure forms and spaces accurately, a mechanistic and geometric aim appropriate to the eighteenth century, but here replaced by an outlook based on an organic conception of nature characteristic of the Romantic period. In addition, T. H. Fielding argued that, since clear thinking depends on the kind of clear seeing made possible by learning to represent natural forms, and since this art fostered a morally valuable habit of thinking about the wonders of creation, art should be a subject of study at the universities. These ideas were published while Ruskin was still following his prolonged series of lessons from the author's brother, and this suggests that Copley Fielding gave him access to stimulating currents of thought which have some importance in relation to the ideas found in Ruskin's criticism at a later date.

Ruskin's entry into the artistic world of the Water-Colour Society in 1834 represents only one aspect of the way his interests were ramifying in several directions at the age of fifteen. In that year he published his first prose piece in *The Magazine of Natural History*, a short article on the colour of the water of the Rhine, based on observations made during the tour of 1833, and it was soon followed by another on the geological strata of Mont Blanc, illustrated with engravings after his own sketches.[8] Scientific interests of this kind had been stimulated at a very early age by the children's books of Maria Edgeworth and by the early reading of works like Joyce's *Scientific Dialogues* and Jameson's *Minerology*.[9] He had started a mineral collection as a child, and asked for a copy of *Voyages dans les Alpes*, by Saussure, for his fifteenth birthday, so that he could begin serious study of the relatively new science of geology.[10] Much of Ruskin's drawing activity then, and in the future, was devoted to gathering information about this subject, and it had a critical influence in forming his concep-

tion of nature. He was further encouraged in this direction by his friendship with J. C. Loudon, editor of *The Magazine of Natural History*, who also stimulated his interest in architecture in a very important way. Loudon was much attracted to the young author, and described him as 'the greatest natural genius that ever it has been my fortune to become acquainted with'.[11] Ruskin often visited his home, where he found him engaged in all kinds of enterprises, most of them editorial, for he was then editor of no less than five magazines, and at the same time was busy revising his *Encyclopedia of Cottage, Farm and Villa Architecture*, first published the year before Ruskin made his acquaintance.[12] This book has been described by a modern architectural historian as the culminating anthology of 'picturesque' buildings, inspired by the long-standing concern among devotees of the picturesque to see and evaluate architecture in its relationship with landscape settings.[13] It was a subject with great appeal for Ruskin, who immediately began serious study of types of picturesque buildings, and eventually wrote his first ambitious critical essay on this theme for Loudon's magazine.

2. As a result of these widening interests, geology and architecture were important subjects of study during Ruskin's next Continental tour. This took place in 1835, when the family travelled across France to Switzerland, and spent three months making a very thorough exploration of the scenery of the Alps. Ruskin kept a diary crammed with geological observations and sketches, which was later offered for Loudon's inspection to see how much of it might be published in his magazines. He made many other drawings and sketches, with a unity of style that reveals a much greater maturity of purpose and method than the work of 1833. They show a renewed,

12. *Unterseen*. 1835. Pencil. $7\frac{3}{4}'' \times 10\frac{1}{4}''$. Bembridge School, Isle of Wight.

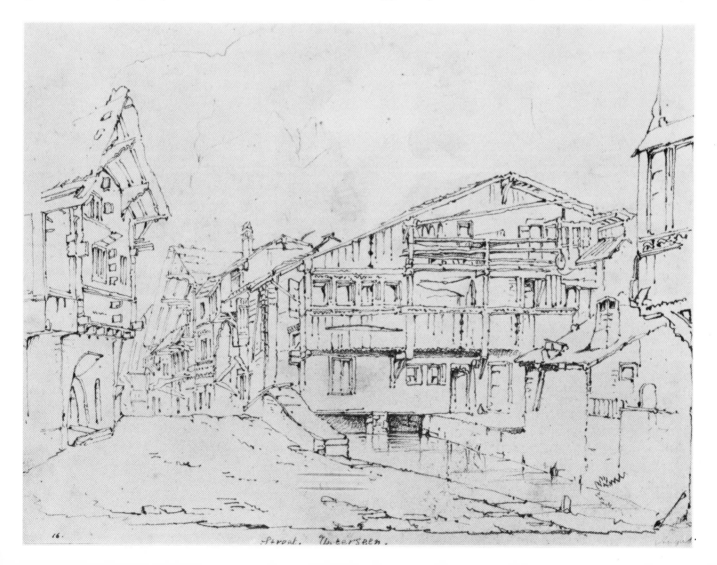

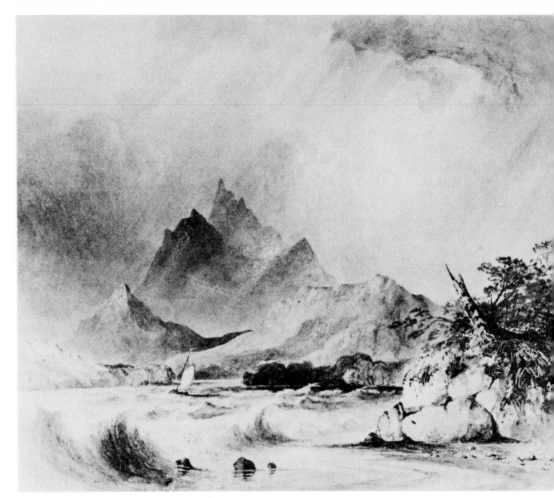

13. *Mount Pilatus.* 1835.
Water-colour. $9\frac{1}{2}'' \times 11\frac{3}{8}''$.
Bembridge School, Isle of
Wight.

14. (below) *The Jungfrau.*
1835. Pen. $6\frac{1}{2}'' \times 9''$. Ash-
molean Museum, Oxford.

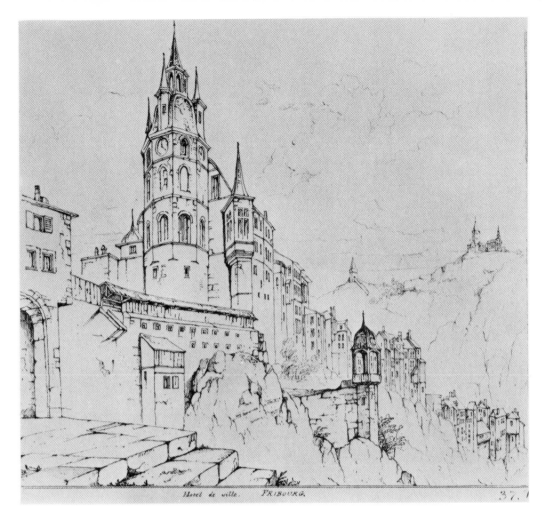

Hotel de ville. FRIBOURG.

15. *Fribourg*. 1835. Pen.
$10\frac{3}{8}'' \times 11\frac{1}{2}''$. Bembridge
School, Isle of Wight.

and more successful, attempt to imitate the architectural studies of Prout in many sketches of Swiss cottages, bridges, and towns, also intended to provide material for future articles in Loudon's *Architectural Magazine*. On the whole, these drawings are of surprisingly good quality, if we take into account the age of the artist and the nature of his training. Some pencil sketches in pure line achieve an almost professional standard of touch and composition, and most of the more finished and re-worked drawings are enjoyable for their decorative effect, in spite of a certain laboriousness and self-conscious elegance typical of an amateur entertaining himself and a small circle of admirers.

Three kinds of drawings can be distinguished. There are fresh pencil outlines from nature, which the artist preserved without re-touching (Plate 12), and there is at least one elaborate water-colour in the Fielding manner (Plate 13), worked up from one of these outlines, but the majority are elaborations in pen or pencil of a first sketch, with additional detail and sometimes careful effects of light and shade (Plate 14). Some of these are reminiscent of the Turner-like vignettes made after the journey of 1833, but most of them show close imitation of Prout's subject-matter, broken line, and compact composition, except that Ruskin translates the broad touches of Prout's crayon into a fine texture of pen strokes on a small sheet of paper. He was still thinking of his art as an imitation of engraved travel illustrations, and did not yet have the confidence to loosen his touch and use the larger pages characteristic of the newer, lithographed, books of the kind produced by Prout.

Many of these Proutesque drawings show a liking for powerful effects of spatial recession, created by means of a wide angle of vision, and in a drawing like the *Fribourg* (Plate 15) there is also a strong tension between receding diagonal accents and soaring vertical lines. This interest in the expressive possibilities of exaggerated

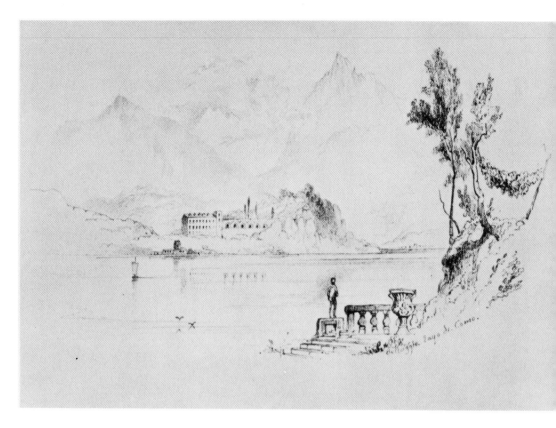

16. *Bellaggio, Lake Como*. 1835. Pen. $4\frac{1}{2}'' \times 6\frac{3}{4}''$. Ashmolean Museum, Oxford.

perspective recurs frequently in Ruskin's work from now on, and in this he departs from the more classical spatial balance of models like Prout and Fielding in favour of the dynamic and dramatic space that he had discovered at the heart of Turner's illustrations for Roger's *Italy*.

Another kind of expressive distortion can be seen in the Fribourg drawing and others, where Ruskin gives the buildings dramatic silhouettes and weather-worn textures analogous to those of mountain ranges and peaks. These can be contrasted with the mood and arrangement of a few Italian scenes sketched in the region of Lake Como later in the tour (Plate 16), where the architecture and landscape forms are set well back within the elegant oval of a vignette, and horizontal accents further emphasize a feeling of poetic tranquillity. In both cases the picturesque point of view prevails that stresses the sympathy between buildings and their landscape settings, with effects determined by the conventional response to the contrast between the sublime drama of the Alps, and the classical harmony of the Italian scene.

Equally conventional is Ruskin's choice of viewpoint and subject-matter throughout this series of drawings. There are a few uninhabited landscapes, but usually a cottage, villa, bridge, or church forms the centre of interest in views of open country. Then there are studies of towns or groups of buildings seen from a distance, and finally there are numerous street scenes and views of individual buildings within the towns. This kind of succession of points of view in relation to a traveller's picturesque destinations was first popularized as a framework for the description of scenery by the Rev. William Gilpin, in passages like his account of a visit to Tintern Abbey.[14] The widespread influence of this convention on art as well as literature helps to account for the amusing reaction of a critic writing in 1810 about the Water-Colour exhibition for that year. 'In pacing around the rooms the spectator experiences sensations somewhat similar to those of an outside passenger on a mail coach making a picturesque and picturizing journey to the north.'[15]

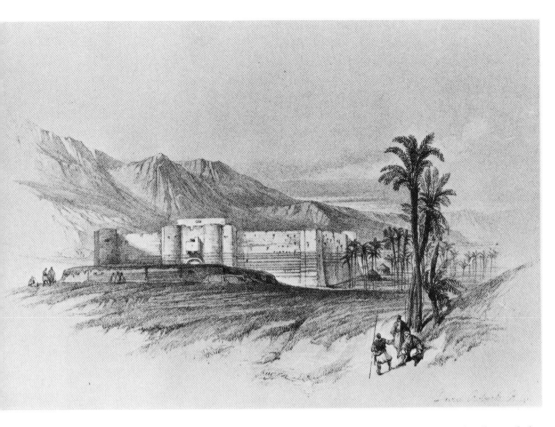

17. David Roberts. *Ruins of the Church of St. John Sebaste. c.* 1842. Lithograph. From *The Holy Land.*

In the same way, Ruskin's drawings from 1835 convey the slow rhythm of the traveller's progress from town to town in the nineteenth century. They show him assimilating this new and dynamic conception of landscape art, which he was to appreciate so vividly in the art of Turner, where each view is seen as one of a series beginning in nature and ending with architecture, thus establishing in a temporal sequence of visual experiences the intimate connection between man and nature that was a major theme of the Romantic movement.

3. On his return to England, Ruskin continued his lessons from Fielding, and soon reached a stage of proficiency in water-colour where he could produce the view of Mount Pilatus (Plate 13) referred to earlier, but for the next few years he concentrated on drawing in pencil and made very few water-colours. Perhaps they required an amount of time and concentration that he was not willing to spare from his increasing literary work, so he concentrated on improving the 'Proutism' of his earlier drawings into a somewhat over-refined form of expression, working almost entirely in pencil, with some grey washes and touches of opaque white, on larger sheets of grey, cream, or pale blue paper. The source of this new style was the art of David Roberts (1796–1864), the Scots travel illustrator whose most popular book was his volume of lithographs of the Holy Land, published in 1842. Ruskin first saw his work in engraved reproductions in 1834, but this style became available to him as a model for drawing only in 1837, with the publication of Roberts's volume of lithographed views entitled *Picturesque Sketches in Spain.* In the same year Ruskin's father acquired a Roberts drawing of Vittoria, presumably an original of one of the plates in this book, and as a result, during tours of the north of England in 1837, and in Scotland in 1838, Ruskin began to work toward what he described as this 'more rich and . . . true manner of delineation', with a sharper point and more careful attention to detail, a style which has a good deal of the spatial amplitude and linear

elegance of the pencil drawings of Roberts's close friend, J. M. W. Turner (Plate 17).

The change was not made all at once, for Prout's soft and broken line continues to dominate in some subjects from these northern tours, but a comparison between the heavy shapes and textures of the Proutesque view of Edinburgh of 1838 (Plate 18) and the finer line and lighter rhythm of the *Merton College* of 1838 (Plate 19) shows how Ruskin reacted to Roberts by stretching the lines of some of his compositions in horizontal or vertical directions, isolating details and surrounding them with empty paper to set off the sensitively delineated shapes of crumbling doors or windows, broken chimneys, and erratic roof eaves. At other times he surpasses Prout at his own game by exaggerating the lurching, twisted forms of old buildings packed together in dense masses to create powerful tactile effects (Plate 18), or he may set down the leading accents of a scene like *Dungeon Gill* (Plate 20) in a flowing, almost abstract pattern of curves. On the whole, the drawings of these years adapt the Roberts manner of transforming nature into sophisticated decoration, in a way which has its fascination but which is not undeserving of Ruskin's own later criticism that at the time he had fallen into 'an extremely stupid landscape conventionalism'.[16]

The refinement of Ruskin's style after 1835 ensured that by the time he entered Oxford in 1837 as a 'gentleman commoner' at Christ Church he would be recognized as a star graduate of the kind of art education provided for amateurs by the drawing masters of the Water-Colour Society. Among students and faculty he was soon well known as a talented artist, and he was often asked to bring out his albums of drawings for the entertainment of distinguished visitors. This was the goal toward which his training and the ambition of his parents had propelled him, a place in cultivated society gained by the development of his talents along lines dictated by fashion rather than a concern for professional development. To be sure, some of his Oxford friends gave him grounds for artistic self-criticism, such as Charles Newton,

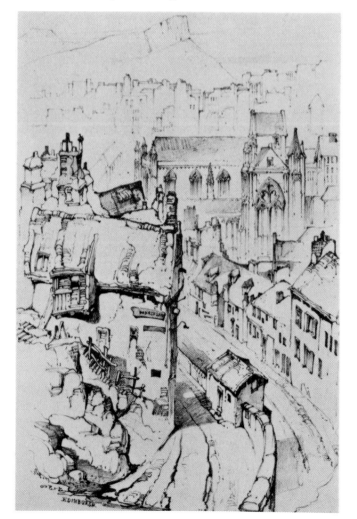

18. *Lady Glenorchy's Chapel, looking towards Edinburgh Old Town.* 1838. Pencil. 12½″ × 8¼″. City of Birmingham Museum and Art Gallery.
19. (right) *Merton College, Oxford.* 1838. Pencil and opaque white. 17½″ × 10½″. Education Trust, Brantwood, Coniston.

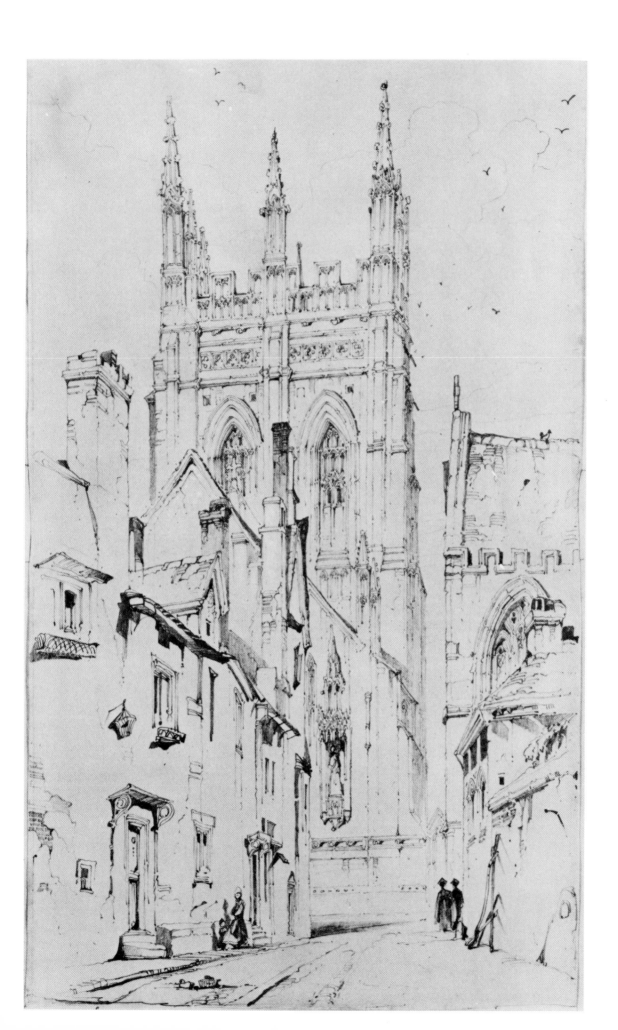

20. *Dungeon Gill, Langdale.* 1837. Pencil. $13\frac{3}{4}'' \times 10''$. Bembridge School, Isle of Wight.

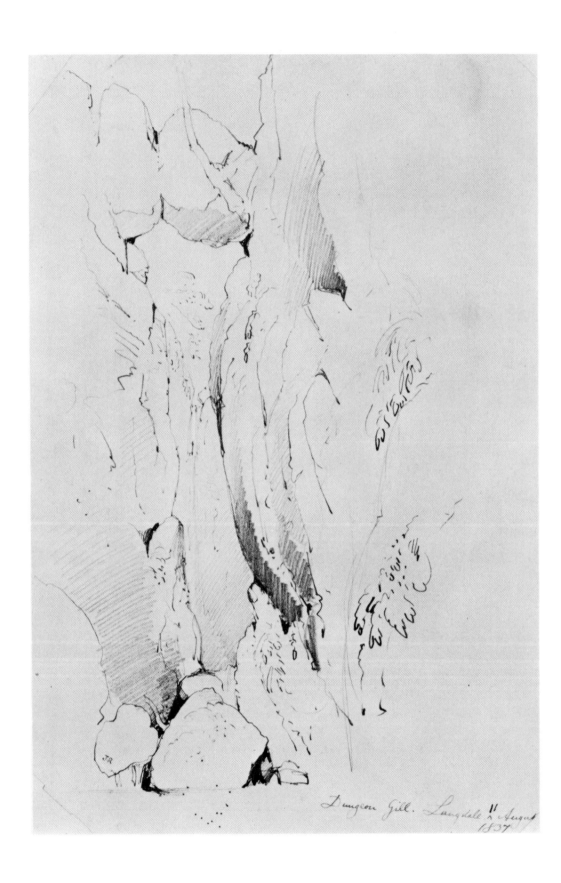

the future Keeper of Greek and Roman Antiquities at the British Museum, who told him that his picturesque studies of buildings were useless for serious study. This criticism, together with his acquaintance with J. H. Parker, the founder of the Architectural Society at Oxford, suggested the possibility of a more objective and archaeological approach to the drawing of architecture, but his numerous sketches of Oxford buildings and other Gothic monuments seen during his travels in the next few years continued to be completely picturesque in character.

The most complete expression of the approach to art that Ruskin had learned from his drawing masters is found in the series of articles he wrote for Loudon's *Architectural Magazine* under the title 'The Poetry of Architecture'. This, his most ambitious essay in art criticism before *Modern Painters*,[17] is a comparative discussion of the cottages of Switzerland and Northern England, based on study of the drawings that he made on the Continent in 1835 and in the Lake District in 1837. No doubt it was Loudon who encouraged this undertaking and urged him to set down his impressions in a series of articles illustrated with his own sketches. Their somewhat pretentious sub-title, 'The Architecture of Europe Considered in its Association with Natural Scenery and National Character', reveals the author's ambition to combine picturesque concern for the aesthetic value of a building as an element in the landscape with the old view, popularized by Wincklemann in the eighteenth century, that national character formed by environment was the major expressive content of art and architecture.

In pursuing this theme Ruskin finds that in comparison with English cottages (Plate 21) those in Switzerland (Plate 14) are unpleasing to both mind and eye, because of their neatness, rawness of tone, and decorative carving, which form an inharmonious contrast with the strength and majesty of mountain scenery. This weak visual effect is said to express a lack of national character in the Swiss people, resulting from the confusing variety of geographic and climatic influences which prevents them from acquiring a national language, or 'a characteristic turn of mind'. In contrast, Ruskin finds that the typical cottage of Westmorland has great 'ease of outline and variety of colour', since it is built of hand-shaped local stone, and falls into complete harmony with its surroundings, so that 'rock, lake, and meadow seem to hail it with brotherly affection, as if Nature had taken as much pains with it as she has with them'.[18] The form of the English cottage also expresses the gentleness and simplicity of its builders, who live in humble intimacy with nature, and, following his argument to a patriotic conclusion, Ruskin finds that from this circumstance they have derived a frame of mind and temperament quite superior to that of French, Swiss, and Italian cottagers. In this way Ruskin contrived to suggest an alternative to classical architectural standards which would enable Englishmen to claim that, although they could not rival the Continent in the higher walks of architecture, they could still rejoice in an important moral and aesthetic achievement in this architectural expression of 'the calmer flow of human felicity . . . consisting in everyday duties performed, and everyday mercies received'.[19] This is a completely Wordsworthian sentiment, and it has been pointed out that Ruskin might well have been influenced by passages in the poet's *Guide through the District of the Lakes* (1835) where he describes the local cottages as seeming to have grown out of the native rock, and appearing to have been 'received into the bosom of the living principle of things', expressing the tranquil course of Nature along which the inhabitants have been led for generations.[20]

However, it is a large part of Ruskin's business in this essay to base his conclusions not on poetic intuition but on detailed analysis of the visual relationship between architecture and landscape, and he declares that a harmonious relationship between

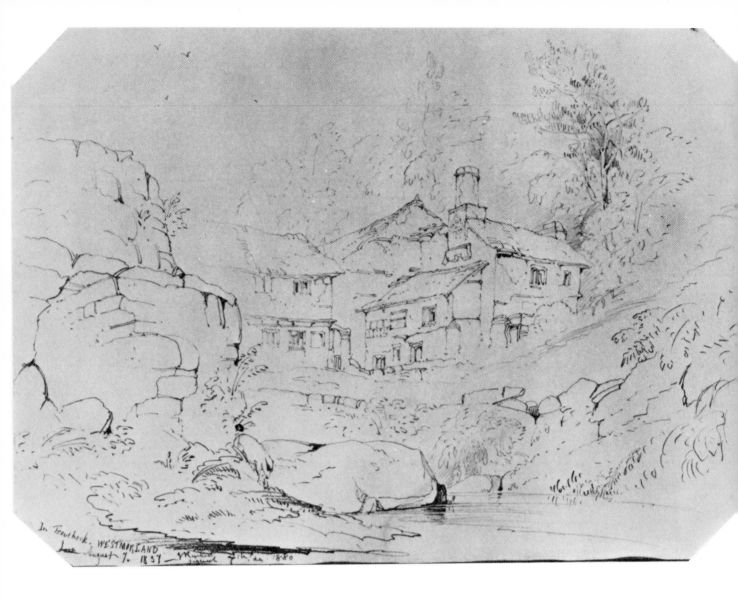

21. *Troutbeck, Westmorland.* 1837.
Pencil. $10\frac{1}{8}'' \times 14\frac{1}{2}''$. Education
Trust, Brantwood, Coniston.

the two results from 'gratification afforded to the eye, which we know to depend upon fixed mathematical principles, though those principles are not always developed'.[21] The chief principle that he describes is that of the contrast and similarity of visual impressions with their associated ideas. This is illustrated at some length with reference to an imagined painting of a stormy landscape where a cold bluish tonality predominates, and, like any drawing master of the period, Ruskin discusses whether one should add a red accent or a blue accent to this composition in the clothing of a figure. He argues that red will intensify the impression of blueness as well as its associated idea of coldness, but in a way that will make the effect enjoyable chiefly as an abstract visual impression. On the other hand, a touch of blue will create an effect more realistic than abstract, since it still heightens the impact of the associated idea of coldness, causing 'the idea of cold to pass over into the spectator, and make him so uncomfortable as to permit his fancy to place him . . . in the actual scene'.[22] In this somewhat obscure line of reasoning, much more tortuous in the full text, Ruskin adapts the aesthetic of sensation and association to his own purposes, with deliberate emphasis on the latter, since it is by means of associated ideas that he must make his bridge between natural scenery and national character.

Having described his method, Ruskin proceeds to analyse buildings in their settings with reference to the way lines, shapes, tones, and colours react on each other in eye and mind to create various kinds of picturesque unity, and convey different qualities of associated feeling. In the process, certain general conclusions

are reached that are not always convincing or consistent. For example, the forms of buildings must harmonize with the prevailing lines of nearby hills; in these Hogarth's line of beauty should be sought out as a guide to the appropriate shapes and proportions of the architecture. Also, the colour of a building should not be so raw as to interrupt the prevailing tone of the landscape (an old source of argument among theorists of the picturesque), and strongly vertical buildings should not be placed among the vertical lines of craggy mountains for fear of monotony.

The basic premises of this youthful essay clearly derive from the methods of pictorial analysis employed by John Varley and transmitted to Ruskin by Varley's pupil Copley Fielding, the President of the Water-Colour Society. The confident, didactic tone of the discussion shows that he already felt qualified to take on the role of drawing master in his own right, as we see further in two more papers, written for Loudon in 1838 and 1839, where he criticizes the use of three-point perspective, and comments on the limitations of the traditional rectangular shape for pictures.[23] In both cases he gives careful empirical and semi-scientific arguments entirely in the style of discussions within the circle of the Water-Colour Society.

4. The progress that Ruskin had made after 1835 in refining his artistic methods and ideas encouraged the confidence and self-satisfaction which are clearly evident in his work and writings of the time, but these were already beginning to be challenged by a growing awareness of the nature of the art of J. M. W. Turner. His enthusiasm for engravings after Turner's works led him to seek out and study the increasingly fantastic paintings which were appearing yearly in the Academy exhibitions, and he was overwhelmed by their strange imaginative power. His enthusiastic feelings boiled over in 1836, when he wrote a letter of reply to an article criticizing Turner and the modern English school of painting that had appeared in *Blackwood's Magazine*. (The letter was sent to Turner, who advised against publication.) In this article, *Mercury and Argus* and *Juliet and her Nurse*, shown in the Academy that year, were singled out for ridicule. Of the former work, the critic said,

It is perfectly childish. All blood and chalk. . . . Whenever Nature shall dispense with [shadows], and shall make trees like brooms, and this green earth to alternate between brimstone and white, set off with the brightest blues that no longer shall keep their distance . . . and when human eyes shall be happily gifted with a kaleidoscopic power to patternize all confusion . . . then will Turner be a greater painter than ever the world yet saw. . . .[24]

The author was the Rev. John Eagles, an amateur artist and art critic residing at Bristol, and his comments were typical of the violent opposition to Turner's art in the thirties. This was not an entirely new thing in the career of the great landscape painter. He had always been subject to severe criticism, but not without an admixture of praise for his contribution to the academic tradition. From the beginning of his career in the Academy in 1802 he had won great credit among connoisseurs and artists as a man who 'aspired to the grander powers of painting, and makes his canvas the source of moral emotions and classical taste'.[25] Works like his *Tenth Plague of Egypt* (1802) and *Hannibal Crossing the Alps* (1812) appealed to the traditional academic reverence for historical subject-matter, but at the same time there was always criticism of their failure to meet other academic standards regarding style and technique. It was Sir George Beaumont who took the lead in complaining about Turner's loose brush-work, lack of finish, and inattention to 'effect'. Significantly, he took special exception to a work like the *Frosty Morning* of 1813, because he thought Turner's light effects here showed an imitation in oil of effects attainable in the water-colour medium (cf. p. 18); it was on account of this lightening of the palette that Turner

and his followers soon became generally known as 'the white painters'. However, between 1810 and 1820 Turner still confined his most radical experiments in free handling and intense colour to his water-colours. This kept the conflict between academic subject-matter and experimental technique from unduly disturbing the public in these years, and in 1815 he enjoyed a triumph with the exhibition of two of his most classical compositions, *Crossing the Brook* and *Dido Building Carthage*. The situation changed with his first visit to Italy in 1819, followed by the exhibition of *Bay of Baiae* in 1823, when he began a series of works combining colouristic fantasy and classical themes in a way that led critics to revive and amplify the earlier strictures of Sir George Beaumont. *Mercury and Argus* was one of this series, and it can be seen as a fantastic transformation of *Crossing the Brook*. It was this kind of radical, romantic, revision of classical conventions that outraged Eagles but excited the young Ruskin, who had just returned from Verona and Venice, his imagination full of poetic visions that seemed to be realized with dream-like intensity in the Turner paintings.

The criticism voiced by Eagles reflects the conservative tenor of an earlier series of essays that he wrote for *Blackwood's*, with the general title 'The Sketcher', offering advice to amateur artists, together with comments on the state of landscape painting in England. In one article he distinguishes between two opposing and equally deplorable schools in modern English art. First there are the Naturalists, who care little about subject and rely on the exact imitation of nature, with attention to certain technical rules; and then there is another, nameless, group that trusts nothing but the imagination, producing pictures that are 'often mere dreams, and too often of the sick man'.[26] His first is evidently the group of painters including John Constable, Augustus Wall Calcott, and John Crome, who looked to Hobbema, Ruisdael, and the Dutch tradition for inspiration in establishing a naturalistic style in English painting. His other school centred on Turner and artists like John Martin or Francis Danby, who exploited and intensified the most sensational and imaginative aspects of the classical tradition, summed up for them in works like *The Deluge* by Nicholas Poussin. Against these innovations Eagles quotes the traditional authority of classical idealism, as found in Claude Lorraine and Gaspard Poussin, whose paintings he felt should still be used as guides to the noble features of English scenery. As for amateur practitioners, he warns them against the modern conception of the picturesque, with its 'ragged cottages, sheep and sheep dogs, and simpering children affecting the pathetic', all of which he attributes to the bad influence of Gainsborough, who painted English scenery 'as if elegance had been banished from the land'.[27] Instead of the sentimental rustic themes and mechanical rules recommended by the modern drawing master he urges greater idealism, following the principle that nature contains many pictures, one of which is always more forcible than the rest. If the sketcher can seize 'this soul of every scene' with a few broad dashes and sweeping lines, the result will be 'a kind of hieroglyphic poetry'.[28]

Ruskin certainly read these essays, which must have been important in providing a slow-working antidote to the naturalism and mechanical rules that he was learning from his own teachers. This can be seen in the paradoxical fact that when he was raised to 'the height of black anger' by the *Blackwood's* attack on Turner, his reply to Eagles shows an equally idealistic viewpoint, stressing elevated subject-matter, the imaginative improvement of nature, and a reverence for the essence of beauty; but he turns all this against Turner's critic by the vehemence of his youthful enthusiasm for the Romantic view that such qualities can be achieved only by an artistic imagination making its own laws, in independence from nature, tradition, and the principles of connoisseurs.

. . . Turner is an exception to all rules, and can be judged by no standard of art. In a wildly magnificent enthusiasm, he rushes through the aetherial dominions of the world of his own mind,—a place inhabited by the *spirits* of *things*; he has filled his mind with materials drawn from the close study of nature (no artist has studied nature more intently)—and then changes and combines, giving effects without absolute causes, or, to speak more accurately, seizing the soul and essence of beauty, without regarding the means by which it is effected.[29]

This first defence of Turner was the beginning of an all-absorbing interest. At Oxford Ruskin placed a large engraving after Turner on his wall, and pored over the engraved *Rivers of France*, making them, he said later, his criterion of all beauty. In January of 1839 he persuaded his father to visit Griffith, Turner's dealer, and acquire the water-colour *Richmond Bridge, Surrey* for the family collection. A year later two more Turner water-colours were bought from the same source, *Gosport* and *Winchelsea*, the latter as a twenty-first birthday present for Ruskin, and in the next two months *Harlech Castle* and *Nottingham* were added to the group. This made a total of five Turners acquired in a year and a half, all from those engraved in the 'England and Wales' series. In 1840 Ruskin met Mr. Godfrey Windus, a collector who owned more than 200 Turner water-colours; he was given free access to this collection, and was able to make studies that formed an important part of his preparation to write *Modern Painters I*. Finally, Griffith invited Ruskin to dinner on 22 June 1840, where he was at last introduced to the artist whom he described in his diary as 'the man who beyond all doubt is the greatest of the age; greatest in every faculty of the imagination, in every branch of scenic knowledge, at once *the* painter and poet of the day, J. M. W. Turner'.[30]

This enthusiasm soon began to influence the way Ruskin described his own aims and methods as an amateur artist, for in a series of letters written from 1840 to 1842, where he acts as a drawing master to a college friend, we see him moving away from the predominant concern of his teachers for compositional rules and imitative skill toward more emphasis on the amateur's need for sensitivity and imagination.

Now, when you sit down to sketch from nature you are not to compose a scene . . . from materials before you. Still less are you to count stones or measure angles. You are to imbue your mind with the peculiar spirit of the place (If it has none, it is not worth sketching). You are to give this spirit, at all risks, by any means. . . . Now, for instance, in my Coniston cottage, it happened, from the point where I sat, that I could not see an inch of mountain over the trees. I have, nevertheless, put in the whole mass of the Old Man—why? Because the eye, in reality, falls on the cottage when it is full of the forms and feeling of mountain scenery, and judges by comparison with it; it feels its peculiar beauty only as a *mountain* cottage. . . . I think you will find some truth in these principles, and you will soon emancipate yourself from any idea that artists' sketches are to be mere camera-lucidas, mere transcripts of mechanism and measurement.[31]

In this reference to one of his north of England sketches from 1838 Ruskin justifies his rearrangement of the scene not, as he might have done earlier, because of the need to 'gratify the eye' according to fixed principles, but because the change expresses a general, intuited, spirit of the place. Elsewhere in these letters Ruskin reiterates that the amateur artist must strive 'to receive . . . the impression of that mystery, which, in our total ignorance of its nature, we call "beauty" '.[32] If successful in this, the amateur's work will express the delicacy of thought and feeling that results from a love of beauty, and even though he may be no artist in the true sense of the term he will nevertheless be able to show that he has something in common with great artists like Raphael, Titian, and Velasquez.

Much of this recalls the language of the earlier defence of Turner, with its concern for ideal beauty, borrowed from Turner's academic critics and redefined

in Romantic terms. Furthermore, it is easy to see that many of Ruskin's own drawings of this period show a heightened consciousness of ideal beauty, conceived as a somewhat precious and abstract harmony of elegant curves and contrasting accents. Although very different in style, they are even comparable in spirit with the sketches of an older generation of amateurs, like the Rev. John Eagles and the Rev. William Gilpin, who aimed in their work at 'a kind of hieroglyphic poetry' that makes art great, without themselves aspiring to greatness; this it was that qualified the amateur for membership in the exclusive company of gentlemen and artists, united in their devotion to beauty. In this way the Romantic idealism of Turner's art, and the influence of his experience of a new social milieu at Oxford, combined to induce Ruskin to add idealistic and aristocratic ingredients to the neat and narrow conception of amateur art that had been tailored within the little world of the Water-Colour Society to meet the modest aesthetic requirements of its middle-class patrons.

5. In the spring of 1840 Ruskin was compelled to leave Oxford when he began to show symptoms of what was feared to be consumption. This disaster was largely due to the emotional strain of an unhappy love affair, precipitated when the daughters of his father's business partner visited the Ruskin household in 1839. The chosen girl did not return his love, and when his mother showed implacable opposition even to the idea of marriage with a Catholic, the hopelessness of the situation inflicted serious psychological and physical wounds. Ruskin had to return to London, where he rested and followed his own interests in a leisurely way for two months until, finally, his condition resulted in an order from his doctors to take a holiday in Italy. In spite of his condition he welcomed this as his first opportunity to pursue seriously the classic artistic objectives of European travel, and his careful preparations included the acquisition of new sketchbooks and other materials with 'hitherto unexampled stateliness of system',[33] so that he could make an appropriate pictorial record of the journey. He set out with his parents at the end of September 1840, and since he was forbidden any serious reading or study during this tour, he concentrated on drawing, kept a diary, and worked on a long Byronic poem on the theme of his blighted love.

In the diary describing this long tour of nearly nine months one sees Ruskin for the first time as the mature master of a flexible prose style, combining imaginative impressionism and precise notation with a warm personal tone; the drawings show a comparable increase of confidence and skill, though accompanied less by a radical change of style than by a further refinement of his previous methods. Before leaving London he had canvassed all his artist friends and acquaintances for advice on what technique he should use on his Italian tour, including J. D. Harding, Peter De Wint, David Roberts, and even Turner (who advised him to vary his materials and technique with the subject), but in the end he stayed with the methods of Roberts, whose latest drawings had been exhibited during the summer by his publishers. These were sketches of Near Eastern subjects that were to provide illustrations for his lithographed volumes on the Holy Land, and Ruskin was impressed once more by the precise drawing of architectural forms with a sharp pencil point, and the easy method of indicating light and shade with grey washes and touches of white on toned paper. This would enable him to achieve something of Turner's amplitude of space and richness of detail without having to attempt his complex effects of light and colour.

The first sketches were made in Chartres Cathedral and at Nice,[34] and they show that the Roberts exhibition had taught Ruskin not to overwork his drawings if he was to preserve the fresh and spontaneous response to visual experience which

had characterized some of his earlier pencil sketches, although there were to be times during this tour when he would lapse into his older habits and complain that his drawings were 'getting Proutish and hard'.[35] Then he was in Italy, following the classic route of the Grand Tour. He began to sketch industriously, usually working in the open seated on a wall or on a stool under an umbrella, sometimes spending a whole morning on a subject, at other times taking only long enough to 'catch an outline' of a building or a view; and when he found himself working in the same city square with a professional travel illustrator, the comparison would make him proud that he could 'manage his black lead as well as any artist'.[36] Sometimes he was too ill or the weather was too bad for work outdoors, and then he would keep to his room, but he was always drawing, either from his window or touching up earlier studies. His first instinct was to interpret the Italian scene in accord with his habitual interest in Gothic buildings and picturesque streets, so that at Genoa he sketched the interior of the cathedral and an irregular row of street dwellings,[37] but apparently made no attempt to draw the Renaissance palaces that were in great measure responsible for 'the large conception of all the features' of the city, and its 'general marble impression' which he noted in his diary.[38] Similarly, at Pisa the churches seemed ugly and cold, and he found 'nothing whatever in the least interesting',[39] except for the Cathedral and Santa Maria della Spina, whose Gothic intricacies he could appreciate and draw.[40] Florence also was disappointing, for there was 'not a single piece of this whole city thoroughly picturesque',[41] and the only subject that he could find to his taste was a view of the old shops on the Ponte Vecchio.[42] In Rome it was the same story. At first he admired St. Peter's and other churches for their great size and richness of materials, but they were not picturesque, and this

22. *Piazza S. Maria del Pianto*. 1840. Pencil and wash. 13½″ × 18″. Capitoline Museum, Rome.

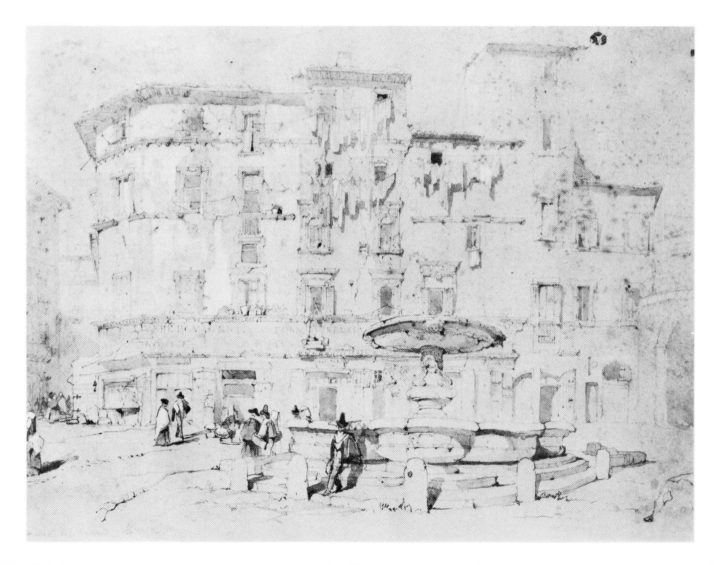

point of view was not challenged until he met George Richmond, the English portrait painter.

It was Richmond who introduced Ruskin to the studios of Rome and the world of the professional artists working there. Soon Ruskin was explaining to them the views on art that he had brought from amateur circles in Oxford and London, maintaining that the beautiful and the picturesque were synonymous terms. Significantly, this was an echo of an old argument between Richard Payne Knight and Uvedale Price in their controversy over the nature of the picturesque thirty years before, and such ideas naturally seemed old-fashioned and out of place to Richmond and his friends. They saw that this kind of devotion to the picturesque aesthetic, with its concern for irregularity of form, strong textural contrasts, atmospheric effects, and poetic sentiment, could be no help toward an appreciation of ideal grandeur in Roman architecture and figure composition. Even before this, older connoisseurs had noticed Ruskin's limitations in this direction, for the Dean of his college had made him study a painting in the Oxford collections attributed to Fra Bartolomeo in an attempt to introduce him to Renaissance art, but this, as well as the arguments of Richmond, failed to interest him. In Rome he refused to be impressed by the usual touchstones of a taste for classical art, Raphael, Domenichino, and the Apollo Belvedere, and as a defiant expression of this heresy (which he later attributed to his 'Proutism and Protestantism') he deliberately made 'a careful study of old clothes hanging out of old windows in the Jew's quarter'.[43] As he did so, he discovered that if the churches seemed pompous and dull, at least the back streets of Rome could yield the kinds of effect that he loved.[44] The drawing of Piazza Santa Maria del Pianto (Plate 22) is elaborate and somewhat overworked, but the picturesque mosaic of accidental textures and classical fragments along the house fronts, together with a corresponding diary entry, provide the best example of the way Ruskin first looked at the Italian scene.

. . . So completely is this place picturesque, down to its door knockers, and so entirely does that picturesqueness depend, not on any important lines or real beauty of object, but upon the little bits of contrasted feeling—the old clothes hanging out of a marble architrave, that architrave smashed at one side and built into a piece of Roman frieze, which moulders away the next instant into a patch of broken brickwork—projecting over a mouldering wooden window, supported in its turn on a bit of grey entablature, with a vestige of inscription; but all to be studied closely before it can be felt or even seen; and I am persuaded, quite lost to the eyes of all but a few artists.[45]

After two months in Rome the travellers proceeded to Naples, where Ruskin's health improved and the number of drawings increased. Some studies of old streets are in the usual picturesque mode, but something rather different can be seen in a sketch of the church of Sant'Anna a Capuana (Plate 23). Here he takes a more distant view of his subject, grouping the picturesque street architecture around the firm vertical axis of the church dome. The effect is repeated in another drawing, where the dome of Sant'Anna appears again as a stabilizing vertical mass above and behind details of the florid classical decoration of the Porta Capuana and its surroundings.[46] Both drawings show a combination of the picturesque with a new feeling for classical repose and monumentality, and this is seen again in the important drawing *Amalfi* (Plate 24), where the vertical axis of the heights behind the town gives the composition breadth and firmness. He now began to draw classical architecture with some enthusiasm at Paestum and Pompeii, although his appreciation of such subjects still depended on a mixture of the antique and the picturesque, for, as he said in his diary, he could only like classical remains if they presented 'a pretty . . . piece of ruinous composition'.[47] Nevertheless, the fact remains that Ruskin was

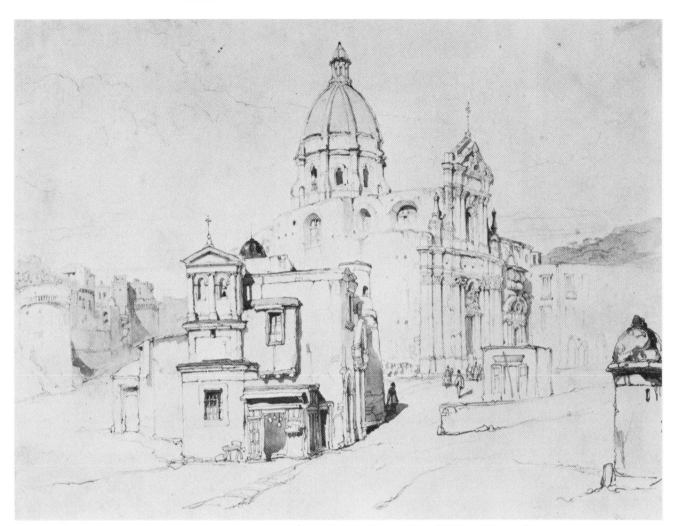

23. *Sant'Anna a Capuana, Naples*. 1841. Pen and wash. $13\frac{1}{2}'' \times 18''$. Sala Alessandrian, Vatican Library, Rome.

24. *Amalfi*. 1841. Pencil and wash. $13\frac{3}{4}'' \times 19''$. Education Trust, Brantwood, Coniston.

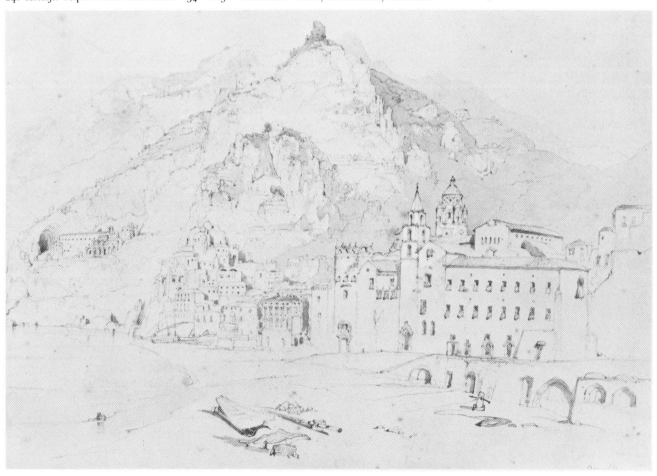

beginning to respond to the monumental aspects of the Italian scene, and perhaps this was made possible for him by the picturesque qualities of baroque churches like Sant'Anna, with rich details of niche, column, and capital mingling in harmonious contrast with the irregular forms of the street, but dominated by great domes that raise the eyes up to take a broader view, and impose a classic grandeur on the scene. This was the feeling that he now began to capture in drawings which he later characterized as his 'Proutesque or Robertsian outlines of grand buildings and sublime scenes'.[48]

Ruskin's changed outlook enabled him to say, during his brief return visit to Rome, that he was 'just getting into the feeling of the place',[49] and one interesting document in this regard is his study of one of the great baroque monuments of the city, *The Trevi Fountain* (Plate 25). This, together with the description in his diary, should be compared with his previous study, the *Piazza Santa Maria* (Plate 22). In both cases Ruskin was concerned with contrasts of classical and picturesque forms, but the Trevi Fountain gave these contrasts within a monumental composition which, according to his diary, Ruskin saw reflected in the surrounding square.

Today . . . I got on the mimicked rocks, and among the deep pools of this most noble fountain . . . [two tiny figures are placed on the rocks in the drawing] until I fancied myself among the gushing torrents of my own Cumberland—then to raise my head, and come gradually on the crowded and rich costumes of the surrounding market, the grey portico of the opposite church, and the white leafage of the Corinthian capitals above; it is one of the most surprising combinations, and sudden changes of feeling I have yet found.[50]

In his own way Ruskin had found elements of beauty and sublimity in the Roman scene, whereas before he had eyes only for the conventional picturesque. Now he

25. *The Trevi Fountain, Rome.* 1841. Pencil and water-colour. 14¾" × 19⅞". Bembridge School, Isle of Wight.

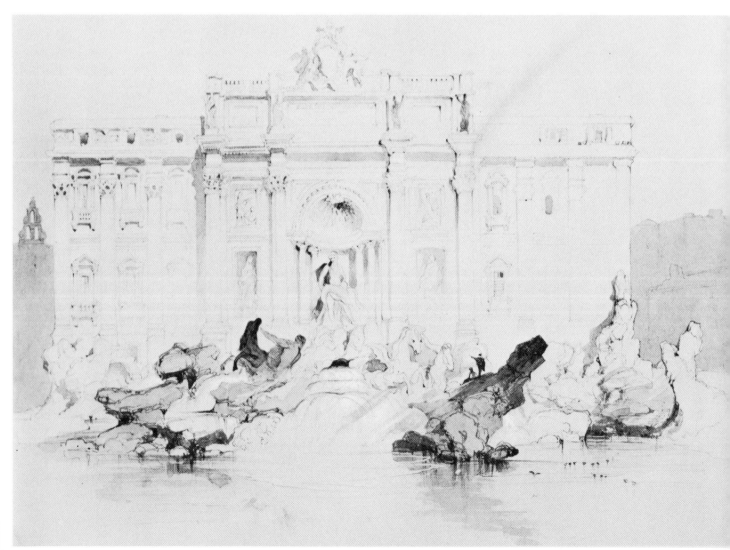

began to draw in the Forum, and his diary also records a growing appreciation of classical antiquity as well as an interest in Renaissance art which led him to spend a day studying Michelangelo in the Sistine Chapel. In other words, his second visit to Rome shows the broadening of mind and vision that was the traditional response of travellers to the experience of the Grand Tour.

For the rest of the journey Ruskin continued to make spacious, firmly composed drawings of the type developed at Naples. During ten days at Venice he sketched continuously along the canals and in the Piazza di San Marco, but he complained of an unlucky spell, and mentions a number of spoiled drawings. Perhaps he was over-excited by the exotic picturesqueness of what he described rapturously in his diary as 'the Paradise of cities'.[51] However, he was well satisfied with one study, the *Casa Contarini Fasan*, although it was one of those that tended to be 'Proutish and hard'; in fact, this drawing was much admired later by Prout, who actually borrowed it for a model to show his students (Plate 26). Another sketch of the courtyard of the Ducal Palace is more relaxed and evocative, and at nearby Verona he made one of his last and best Italian drawings of this time.[52] During the rush homeward he had no time to draw, not even in Switzerland, where all he could do was look at a number of subjects sketched on the tour of 1835.

Ruskin always thought highly of the drawings of 1840–1, describing them as 'entirely certain and delicate in pencil touch . . . living and like, from corner to corner'.[53] They represent the last refinement of what might be called his Oxford style, but behind this achievement there lay an unresolvable conflict between a technique that was primarily linear, and the colouristic vision of nature that he was acquiring from his study of Turner. Ruskin himself was to comment on the way he

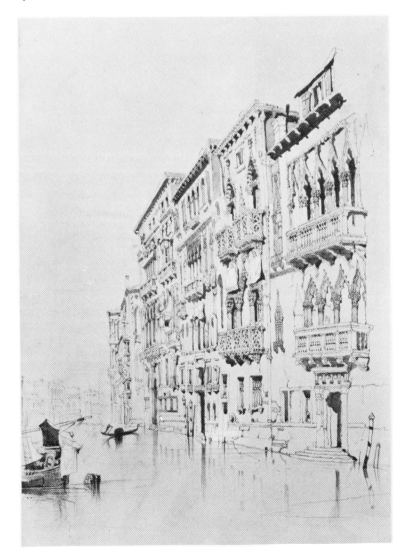

26. *Casa Contarini Fasan, Venice*. 1841. Pencil and wash. $17\frac{3}{4}'' \times 12\frac{1}{2}''$. Ashmolean Museum, Oxford.

saw everything at this time in colour, while he never drew anything but in pencil outline.[54] This is substantiated by frequent passages in his diary which give verbal equivalents for Turner's dynamic evocations of the play of light and colour in the atmosphere. An example is the following entry for 4 November 1840, at Sestri.

The clouds were rising gradually from the Apennines, which ran far round in lovely peaks, enclosing the noble bay. Fragments of cloud entangled here and there in the ravines, catching the level sunlight like so many tongues of fire; the dark blue outline of the hills clear as crystal against a pale, distant, purity of green sky, the sun touching here and there upon their turfy precipices and the white, square villages along the gulph gleaming like silver to the north-west; a mass of higher mountain, plunging down into the broad valleys dark with olive, their summits at first grey with rain, then deep blue with flying showers—the sun suddenly catching the near woods at their base, already coloured exquisitely by the autumn, with such a burst of robing, penetrating glow as Turner only could even imagine, set off by the grey storm behind. . . . [At] sunset . . . a tall, double rainbow rose to the east over the fiery woods, and as the sun sank, the storm of falling rain on the mountains became suddenly purple—nearly crimson; the rainbow, its hues scarcely traceable, one broad belt of crimson, the clouds above all fire.[55]

There are many similar passages, and they illustrate the fact that the journey of 1840–1 was in many respects a Turnerian tour from the very beginning, when he had stopped at Rouen to look for all the views that Turner had drawn there for *The Rivers of France*. Descriptions like the one above resulted from Ruskin's growing conviction that the essence of art was colourism, and however satisfactory his outlines might be in their own way he could not help but realize that this style and the way of thinking that went with it had been outmoded by the new developments in his ideas and interests.

Another challenge to his earlier views had come during his association with George Richmond and other artists at Rome. They gave him some insight into the narrowness of his own artistic background, and the gaps in his knowledge of Italian art and the classical tradition, so that after his return he began a course of reading and study in the London galleries and museums, to ensure that on his next Italian journey he would be better informed, and equipped with some of the traditional conceptions of 'the grand style' and 'high art'.

In addition, his discussions with Richmond and his friends must have joined with his reverence for Turner to make him realize the full measure of the difference between professional practice and his own, for he was soon to express the belief that conventional amateur methods were a mechanical simplification of the creative process, tending to downgrade the importance of genius, imagination, and hard work in the production of the greatest works of art. The result was, as we shall see, an effort over the next few years to reform his own amateur's style to make it more humble and meaningful in relation to the complex and inspired activity of true artists.

3. Truth and Imagination (1841–1851)

1. After his return to England in the summer of 1841 Ruskin spent several weeks in re-reading his diary for the previous months on the Continent, and as he did so, he attempted to express some of the impressions and feelings of this tour in his most ambitious attempts so far at romantic poetry and Turnerian illustration. The poem was the one that he had begun the previous summer on the theme of his lost love. It was entitled *The Broken Chain*, and since it was set in the Château of Amboise he applied himself to the task of elaborating a sketch of that subject (one that he had made because Turner treated it in *The Rivers of France*) into his first full-scale imitation of Turner's water-colour style (Plate 27).[1] The result was gently ridiculed by its author forty years later.

. . . I supplied myself with some . . . new cakes of colour wherewith to finish a drawing, in Turner's grandest manner, of the Château of Amboise at sunset . . . representing the castle as about seven hundred feet above the river (it is perhaps eighty or ninety) with sunset light on it, in imitation of Turner; and the moon rising behind it, in imitation of Turner; and some steps and balustrades (which are not there) going down to the river, in imitation of Turner; with the fretwork of St. Hubert's Chapel done very carefully in my own way,—I thought perhaps a little better than Turner.[2]

The sources of Turnerian inspiration for this work were numerous, including the comparatively prosaic English views in the Ruskin collection, glimpses of more exotic inventions in the hands of Griffith the dealer, as well as compositional hints from engravings in *The Rivers of France*. One can even trace its inspiration back to the oil painting *Mercury and Argus*, defended by Ruskin in his unpublished letter to *Blackwood's*, for in addition to the generally similar spirit of dramatic exaggeration in the treatment of light and colour, that work also has a romantic castle in the background, placed high on a rocky precipice overlooking a sheet of water. In other words, this water-colour summed up and expressed all Ruskin's current enthusiasm for the imaginative fantasy of Turner's art, and it also shows one of those periodic attempts that he made to cast his ideas and observations into elaborate imaginative forms imitated from other artists. Earlier examples were the *Dover Castle* (Plate 4), *Ehrenbreitstein* (Plate 10), *Mount Pilatus* (Plate 13), and there would be others later (Plates 35, 36). Yet Ruskin was always dissatisfied with these compositions, for he saw them as evidence of his own lack of independent creative imagination. Certainly they now seem less the product of happy creative effort than symptoms of emotional disturbance, with their self-conscious and elaborate exaggerations. For Ruskin, this type of drawing represented a false step in his work. At the same time, and for similar reasons, he was coming to the conclusion that *The Broken Chain* would be his last poem.

It was time to make a fresh start, and after it was certain that his health had been restored Ruskin began to study energetically again for his degree in November 1841. Simultaneously, he showed his determination to reform and improve his drawing style by enrolling as the pupil of a new drawing master, J. D. Harding

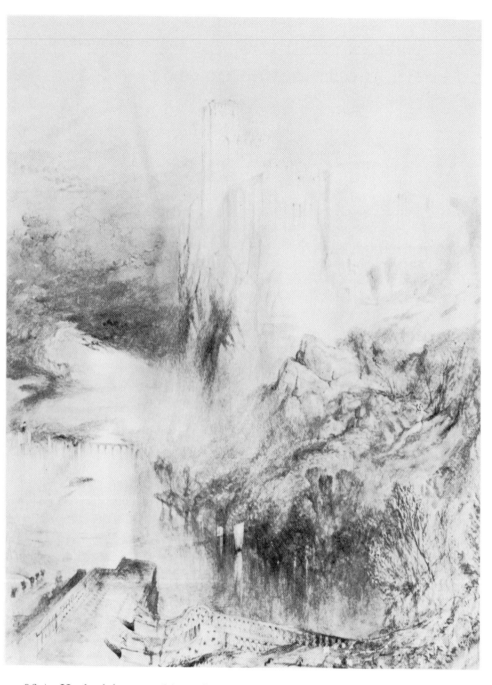

27. *Amboise*. 1841. Water-colour. $16\frac{3}{4}'' \times 11''$. The Cunliffe Coll.

(1797–1863). He had known this artist as a teacher and leading exhibitor at the Water-Colour Society from before 1840, for he had written to a friend from Rome to say that Harding, a former pupil of Samuel Prout, was the best landscape artist giving lessons in England.[3] In fact, Harding was replacing Copley Fielding in these years as the most successful teacher of amateur artists in London, and the Ruskins had shown their interest in his career by acquiring two of his water-colours, as well as one of his books of instruction for the family library. More significantly, Ruskin's new instructor can also be described as the leader of a younger generation of artists in the Water-Colour Society whose work shows a new phase of the influence of Turner on water-colour painting (Plate 28).

It has already been noted that Turner and Girtin had presided indirectly at the birth of the Society in 1805, but for some time afterwards Turner's water-colours

were seldom seen in public, and it was Girtin's influence that chiefly guided the ideas and aims of the members during its early history. This situation had changed, however, by the time the Society reorganized itself in 1820, in an attempt to stabilize its vacillating fortunes. In the previous year artists and critics had attended a public exhibition of the collection of Mr. Walter Fawkes, Turner's close friend and patron, and there they had seen something quite different from the large dark-toned compositions in the spirit of Richard Wilson that had been characteristic of his most ambitious earlier work. Fawkes owned many sketches, including the famous series illustrating the scenery of the Rhine, which displayed all the virtuosity of Turner's mature technique, with rich but still relatively sober colour, vibrant light and atmosphere, and a radical freedom of handling. They completely overshadowed the works by other artists in the same collection, and Turner was enthusiastically acclaimed by all the critics as one who had carried water-colour to 'so singular a degree of beauty and expression of nature', and who had done more 'to stamp the character of this art upon the general attention, than was effected by any other effort within recollection'.[4]

Equally influential were the exhibitions held from 1822 to 1824 in the gallery of Turner's publisher, W. B. Cooke. These were intended to illustrate the history of the English water-colour tradition from Sandby to the modern masters, and the critics concluded that the progress of the whole school had reached a triumphant climax in 'the completely understood and perfectly satisfying effects of Turner'.[5]

28. J. D. Harding. *Bergamo, Italy. c.* 1835. Water-colour. Victoria and Albert Museum.

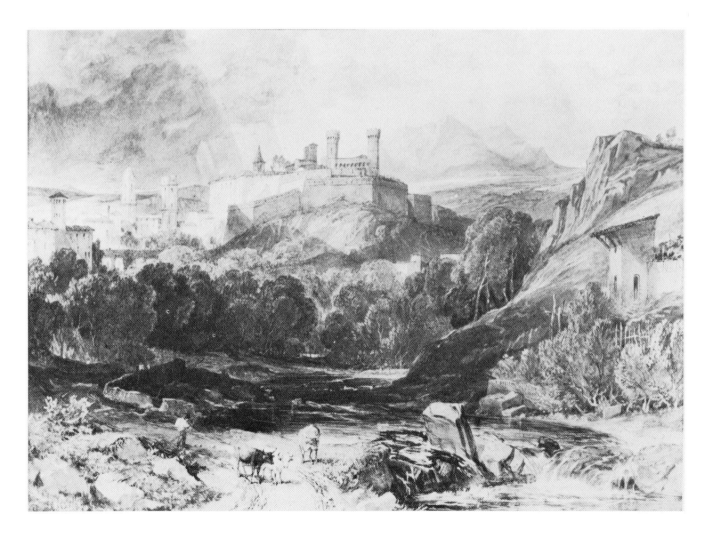

29. J. M. W. Turner. *Aesacus and Hesperie.* 1819. Mezzotint. From the *Liber Studiorum.* The Metropolitan Museum of Art, Harris Brisbane Dick Fund, 1928, New York.

These revelations transformed the practice of older artists like Cox, Cotman, and De Wint, who soon developed personal versions of Turner's sketchy execution and colourism, while younger artists like Harding sought to analyse and explain this new style in terms that would enable them to make it the basis of their teaching as well as their own practice. The result was that a new generation of drawing masters began to replace the careful outlines, washes, and compositional regularity of the Varley method with versions of the technical freedom and impressionism of Turnerian naturalism.

Harding believed that the *Liber Studiorum* was the key to an understanding of Turner's art (Plate 29). This series of etched and mezzotinted prints, which had appeared between 1806 and 1823, were highly regarded by him as lessons on all the varieties of landscape, and he urged his students to use them as copy material. Their great advantage was that they enabled him to offer models from Turner's art that would avoid the problems of the new colourism, which Harding felt was too difficult for amateurs to master. Instead, he recommended pencil sketching and mono-chromatic compositions in light and shade after the manner of the *Liber* in order to achieve the essentials, if not the full range, of Turnerian naturalism. First of all, this meant the abandonment of the old method of outline drawing taught by Prout and others. In his books of instruction Harding maintained that the aim of drawing was not to transcribe outlines but to set down swiftly accents that would encourage the eye to rest on the surface of things, to sense the texture and roundness of objects.[6] A course of tree drawing was suggested for the development of this skill, and Harding's book, *The Park and the Forest* (1842), was intended to illustrate, with its lithographed plates, how a full, broad touch of the pencil could be broken and varied to render different types of branches and foliage with a kind of graphic impressionism (Plate 30).

30. J. D. Harding. *Tree Study*. 1842. Lithograph. From *The Park and the Forest*. The New York Public Library, Prints Division.

A similar emphasis characterizes Harding's discussion of pictorial composition, where he says the main problem is to create the impression of 'permeable, infinite space'.[7] This can be achieved by placing objects so as to avoid any horizontal or vertical alignments, and thus create a network of diagonals for the eye to follow into space. The result was to be very different from the planar arrangements and spatial stability of the typical Varley composition, and Harding's methods carried him so far from the classical basis of earlier water-colour art that in his *Principles and Practice of Art* (1845) he gave an outline of a painting by Claude Lorraine together with a revised version of the same composition, 'corrected' according to his own principles of composition.[8]

Even so, Harding owed a great deal to the example of Varley's method, since they both sought to define rules for a codified language of visual form based on an aesthetic of sense impressions and associated ideas. In fact, Harding was even more

31. J. M. W. Turner. *Sketch
of the St. Gothard*. 1841.
.Water-colour. The British
Museum.

explicit in his associationist view of aesthetic value, for he stated that the merit of a
picture depends on 'the vividness with which pleasing or painful recollections of
Nature are roused and aided by the pictorial influences of Art'.[9]

Like Varley, Harding was an interesting and influential exponent of the empiri-
cal analysis of visual form in art. (Some of his conclusions anticipate Wölfflin's
distinctions between 'linear' and 'painterly', 'classical' and 'baroque'). His books
were popular because they were successful in translating the new naturalism of Turner
and Constable, with its subtle compromise between impressionism and idealism, into
a teachable vocabulary of artistic form, and his success was instrumental in trans-
forming public taste and habits of vision in a way that endures to the present day.

Ruskin's lessons from Harding began in November 1841, and continued inter-
mittently for about three years. He soon came to be very critical of what he regarded
as Harding's mechanical draughtsmanship and tricks of composition, but the marked
change in his style during these years evidently owes much to Harding's stress on
faithfulness to immediate impressions and his recommendations to study the *Liber
Studiorum*, and the forms of trees. Ruskin later attributed this change to the influence
of an almost visionary discovery of the inherent beauty of natural form, and he
always tended to contrast the beauty that he had found *in* nature with the kind of
rationalized beauty imposed *on* nature by his own earlier methods, and by drawing
masters like Harding. Yet it was undoubtedly Harding, with his criticism of the old
style of picturesque drawing and composition, who showed him the way to this
revelation, even though it finally carried him to the point where he regarded his
teacher's work as artificial. After all, he experienced this insight while he was making

a careful drawing of a tree at Fontainebleau during the Continental tour of 1842,[10] and this was just the kind of rather humble exercise that followed from Harding's advice in his just-published *The Park and the Forest*, rather than from Ruskin's usual practice of sketching 'Robertsian outlines of grand buildings and sublime scenes'. As he drew an aspen tree at Fontainebleau, he discovered that its branches 'composed themselves', and did not need to be adjusted to conform to his own theories of pictorial harmony. This was noted very briefly in his diary,[11] and it took three more years before it led to the final abandonment of his elegant drawing-master's style, but the experience grew in his memory until it was described in *Praeterita* as a semi-religious realization of the unity and harmony given to the forms of nature by divine laws of far greater authority than the human laws of art by which he had formerly judged the beauty of things.

Languidly, but not idly, I began to draw [the aspen tree]; and as I drew, the languor passed away: the beautiful lines insisted on being traced,—without weariness. More and more beautiful they became, as each rose out of the rest, and took its place in the air. With wonder increasing every instant, I saw that they 'composed' themselves, by finer laws than any known of men. . . . The woods, which I had only looked on as wilderness, fulfilled I then saw, in their beauty, the same laws which guided the clouds, divided the light, and balanced the wave. 'He hath made everything beautiful, in his time,' became for me thenceforward the interpretation of the bond between the human mind and all visible things; and I returned along the wood-road feeling that it had led me far;—Farther than ever fancy had reached, or theodolite measured.[12]

It should also be noted that another important influence had prepared Ruskin's imagination for this experience at Fontainebleau. Until shortly before then he had known only Turner's engravings, the exhibited oil paintings, the water-colours in the collection of Godfrey Windus, and those that his father had bought for him. Then, in the spring of 1842, Turner's dealer showed him a group of sketches for a proposed series of Swiss subjects to be finished on commission. These sketches had been made during the artist's last Continental journey, and they represented the final stage in his progress towards complete freedom in using the water-colour medium to transcribe his vision of the absolute unity of colour, light, form, and space (Plate 31). Ruskin was greatly impressed by these 'straight impressions from nature', and he persuaded his father to let him commission two finished versions from the artist (views of Lucerne and Coblentz). They strengthened his growing conviction, soon to be finally confirmed at Fontainebleau, that all art should be based on this kind of truth, achieved when it seemed that 'Nature herself was composing with the artist'.[13]

2. The tour of 1842 was undertaken as a holiday after Ruskin's Oxford examinations. The goal was Chamouni, the place he was to celebrate so often in word and picture after his first visit in 1833, when he had admired 'the rich luxuriance of the cultivated valley, the flashing splendour of the eternal snow, the impending magnificence of the bare, spiry crag, and the strange, cold rigidity of the surgy glaciers so dreadfully and beautifully combined'.[14] The family spent about three weeks there in June and July, while Ruskin, as he later recalled, thought over his Fontainebleau thoughts, studied rocks and plants, and made a few drawings. He was also beginning to turn over in his mind the possibility of writing an extensive explanation and defence of the art of Turner. Then they moved slowly northward to finish their Swiss travels for that year near the end of July, at Schaffhausen.

Few drawings were executed during this time, and the surviving examples suggest that Ruskin was suffering from a certain confusion of aims and methods, due to his new and conflicting ideas about truth to nature, the sketchy impressionism

of Turner and Harding, and his former elegant style. There are studies of the valley of Chamouni in his best Roberts style,[15] but at the same time he tried sketching freely with a brush, imitating the strong contrasts of Harding's monochrome sketches from nature.[16] On his way home, at Cologne and Saint Quentin, he made some architectural studies that combined his growing interest in stronger effects of light and shade with the monumental linear style that he had developed in Italy,[17] but it was landscape, and the details of landscape, that chiefly interested him now, as he began to think of the first volume of *Modern Painters*.

At Schaffhausen he made two studies of the turbulent falls of the Rhine that again suggest the liberating influence of Harding and Turner in their boldness of composition, movement, and brushwork. One is painted in gouache, on paper of a creamy hue that warms the spaces between the thick splashes of blue and white used to suggest surging masses of water (Plate 32). In its free technique it marks a complete break with the cautious methods that he had learned from Fielding, and this enables him to achieve something in the spirit of Turner's early view of the same subject, painted in 1806, even though the work was unknown to Ruskin at the time.[18] That is why, as he later reported, this was 'the only [drawing] of mine I ever saw Turner interested in. He looked at it long, evidently with pleasure, and shook his finger at it one evening, standing by the fire in the old Denmark Hill drawing room'.[19]

The other drawing of the falls at Schaffhausen is a sketch on brown paper, with the water painted in white, green, and blue to form a dazzling contrast against the dark rocks and trees of a river island in the background (Plate 33). This looks forward to the famous word-picture of the same subject in *Modern Painters I*, where the flash of light captured in his drawing becomes a great fireworks display.

Watch how the vault of water first bends, unbroken, in pure polished velocity, over the arching rocks at the brow of the cataract, covering them with a dome of crystal twenty feet

32. The Falls at Schaffhausen.
1842. Pencil and gouache. $13\frac{1}{2}'' \times 19''$. Fogg Art Museum, Harvard University.

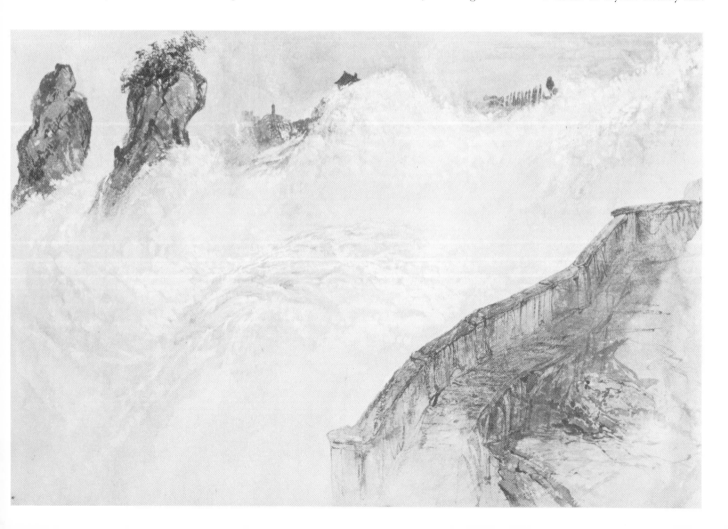

thick, so swift that its motion is unseen except when a foam-globe from above darts over it like a falling star; and how the trees are lighted above it under all their leaves, at the instant that it breaks into foam; and how all the hollows of that foam burn with green fire like so much shattering chrysoprase; and how, ever and anon, startling you with its white flash, a jet of spray leaps hissing out of the fall, like a rocket, bursting in the wind and driven away in dust, filling the air with light. . . .[20]

This kind of celebration of natural beauty was the chief attraction of the book that Ruskin wrote after his return to London, *Modern Painters*. Here he finally realized his earlier project of writing a defence of Turner that would show his superiority over every other landscape artist by demonstrating the essential truth of his vision of nature. Of course, complete truthfulness to nature was something that Ruskin had only just begun to adopt as the principle governing his own art, and he felt that he was learning to draw all over again, with his eyes opened to the harmonious beauty of every detail and accident of nature. This, he believed, was also the basis of Turner's art, except that Turner had passed beyond the years of apprenticeship to the truth of nature, and was now able to use his knowledge as the starting-point for soaring flights of the imagination.

This conviction that a long period of devotion to truthful representation must precede attempts at free and imaginative invention was also an important part of the thinking of many drawing masters in the Water-Colour Society. They had based their reform of amateur art on this idea, and it had led them long ago to maintain that the sketchy ideal compositions so much admired by enthusiasts for the picturesque, while indeed very admirable, should not be attempted by amateurs before they had undergone a thorough training in accurate drawing. The same principle lay behind Ruskin's famous advice, given to the young artists of England at the end of *Modern Painters I*: 'they should go to nature in all singleness of heart . . . neglecting nothing, selecting nothing, and scorning nothing', and then, in the seldom quoted

33. *Falls at Schaffhausen*. 1842. Pencil and watercolour. $13\frac{1}{2}'' \times 19\frac{1}{2}''$. Fogg Art Museum, Harvard University.

but essential continuation of this thought, he urges that 'when their memories are stored, and their imaginations fed', they should 'take up the scarlet and the gold, give the reins to their fancy, and show us what their heads are made of'.[21]

Ruskin's own apprenticeship to nature as a draughtsman had just begun, but his command of language enabled him to be very free with 'the scarlet and the gold' in the descriptive passages of *Modern Painters*, so that the relationship between his drawings and his writing shows a movement from truth to imagination comparable with his conception of Turner's creative process, and with his idea of the direction a young artist's studies should take. A comparison between the sketches of Schaffhausen and the word-picture quoted above shows that he described everything imaginatively in terms of colour, atmosphere, and movement, even though the drawings contain only hints of these qualities; yet the drawings provided the vital focus for a complex response to nature that was intensely visual in its origins, no matter how much these visual impressions were elaborated and combined with associated memories and ideas in Ruskin's imagination as he wrote.

Indeed, Ruskin always insisted that his drawing activity was the foundation of his literary work, and he was grateful to his art teachers for their initial guidance. As a result, his first book praised all the 'modern painters' from Prout to Harding who had helped him towards an appreciation of Turner. Later, when he became conscious of the insular character of the English water-colour school and more aware of his reputation as a critic, he omitted much of the praise, and even added severe criticism, of Harding; but in all his books from this time forward his general method of combining accurate analysis of light, colour, and space with intense poetic feeling remains a reflection of aims and ideals in the circle of the Water-Colour Society.

Ruskin's father rewarded him for the success of *Modern Painters I* with a shower of new Turners, including two more finished versions of the Swiss sketches that Ruskin had so admired in 1842 (*Goldau* and *St. Gothard*), six additional water-colours, and finally, the spectacular oil painting, *Slaver Throwing Overboard the Dead and Dying*, which he received as a birthday gift on New Year's Day 1844. Thus encouraged, and further gratified by the praise of reviewers and his Oxford friends, he began to work on a second volume. Since it was to be founded, as before, on knowledge gained through his own practice, he tried hard to enlarge the scope of his art and to resolve the uncertainties of aim and method that had appeared in 1842. To further this end, he renewed his lessons from Harding, who encouraged him to imitate the style of Turner's plates in the *Liber Studiorum* with pen and sepia wash. Then, perhaps as a counterbalance to this kind of practice in broad rhythmic patterns of light and shade, he began to execute careful studies of plants and foliage, 'foreground details', some of which were to be engraved for the new book. At the same time he made copies of a few of Turner's oils and water-colours, and even undertook some experiments in oil painting. He also produced a series of water-colours which showed that he was now proud enough of his knowledge of nature and of Turner to attempt imitations of the imaginative effects that he admired in his newly acquired water-colours of Swiss subjects (Plates 35, 36).

As might be expected, this varied programme was slow in achieving the desired results, especially since Ruskin was involved in many other projects at the same time. He had to take one summer to complete the residence requirements at Oxford for his degree, and as he began to work out his ideas for the new book, a second edition of the first required revisions and new material. There were many art collections and scholarly books to be studied for the broader background of connoisseurship and art historical knowledge that Ruskin felt he needed, and there were new social obliga-

tions to be met as a result of his appearance on the literary scene. All this activity produced alternations of bewilderment, elation, and depression, and neither his book nor his art made much progress for two years.

Consequently, the drawings made in Switzerland in the summer of 1844 show the same fluctuations of style that are found in those from his last visit to the Alps in 1842. There is an elaborate drawing of the valley of Chamouni in his most elegant pencil style, with delicate washes of colour (Plate 34), but during this month at Chamouni he also made at least one brush drawing in the manner of the *Liber Studiorum*.[22] The rest are fragmentary studies of rocks, trees, plants, and views, with a lack of finish and formal arrangement that was to become increasingly characteristic of Ruskin's studies from nature, as he tried to submit his drawing activity to the laws of natural form, rather than to the compositional principles of drawing masters.

Exactly opposite in tendency are the slightly earlier compositions that Ruskin deliberately and self-consciously produced for an audience, to show that his success as an interpreter of Turner was based on an artistic talent that was itself of Turnerian dimensions. For example, during the winter of 1843–4 he spent days over two small water-colours that were to appear as engraved illustrations for some of his poetry in *Friendship's Offering*, a periodical of sentimental literature to which he had first contributed as an adolescent. Ruskin laboured to make them worthy of the 'Graduate of Oxford', in one case imitating, and even exaggerating, the vertiginous spatial effect of a vignette of mountain scenery by Turner in a volume of Samuel Rogers's poetry (Plate 35).[23] Both studies are like the earlier *Amboise*, in that they all have the compulsive quality that an early critic described as 'morbid Turnerism'.[24]

The most interesting example of the Turnerian work of this period is the larger water-colour *Amalfi*, executed in February 1844 for Sir Robert Inglis, Member of Parliament for Oxford University. He had entertained Ruskin at a party one evening, and hearing of his guest's skill as a draughtsman, apparently asked him for a drawing.

34. *Mont Blanc with the Aiguilles from above les Tines*. 1844. Water-colour. $16\frac{1}{2}'' \times 10\frac{1}{2}''$. The Harry Elkins Widener Collection. By permission of the Harvard College Library.

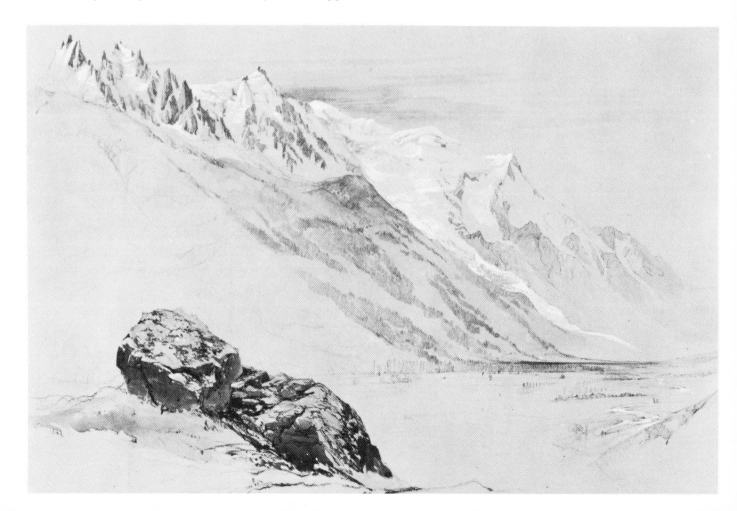

35. *Glacier des Bois*. 1843–4. Water-colour. 12⅝″ × 8½″. Education Trust, Brantwood, Coniston.

No doubt he expected that it would show the influence of the young critic's already famous enthusiasm for Turner, and Ruskin was evidently determined not to disappoint his distinguished host. His subject was based on the pencil drawing of Amalfi that he had made in Italy in 1841 (Plate 24), but in the new version the view is transformed almost out of recognition, with a fantastic sunset effect magnified by reflections in a sea that is brought up to the foundations of the town just for this purpose (Plate 36). Loosely brushed on buff paper in vivid tones of blue, yellow, white, and pink, the buildings and hills become luminous apparitions directed into space along the curving diagonal of the shore. In this dream-like vision Ruskin uses the earlier sketch as a scaffolding for effects of light, colour, and atmosphere intended to recreate and heighten the poetic impressions of Amalfi that he had recorded in his diary on 11 March 1841.

Saw no more of Amalfi than I sketched, but that was glorious. Far above all I ever hoped, when I first leaped off the mule, in the burning sun of the afternoon, with the light behind the mountains, the evening mist doubling their height—I never saw anything, in its way, at all comparable. Moonlight on the terrace before the inn very full of feeling, smooth sea and white convent above, with the keen shadows of the rocks far above and the sea dashing all night in my ears, low, but impatiently and quick.[25]

It is tempting to associate this water-colour and other Turnerian exercises of the period with Ruskin's work at this time on a draft of the second volume of *Modern Painters*, for the new book was to adopt quite a different point of view from that of the first, which had been largely devoted to demonstrating the 'truth' of Turner's 'straight impressions from nature'. Now he meant to undertake a more theoretical

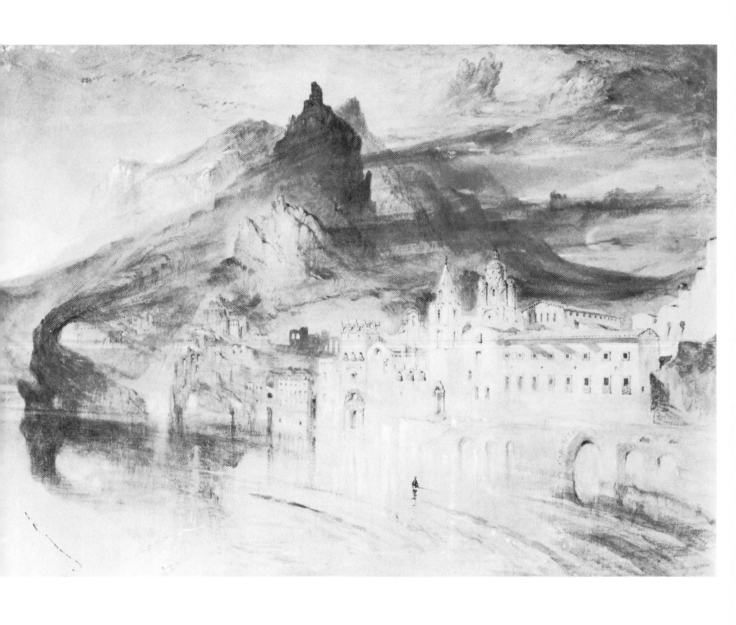

nalfi. 1844. Pencil and water-colour. $15\frac{3}{4}'' \times 19''$. Fogg Art Museum, Harvard University.

discussion of the manner in which imaginative associations of ideas and feelings in Turner's art transformed these impressions into expressions of the sublime and the beautiful. One can see the *Amalfi* and similar works as exercises in making this progress from topographical impression to imaginative vision in his own drawing activity, so that he could experience for himself what he later called the 'mental chemistry' by which Turner's imagination 'summons and associates its materials'. To clarify his understanding of this process he was shortly to visit the site of his own drawing by Turner of the St. Gothard Pass, so that he could find the artist's viewpoint, and make topographical drawings of the scene for comparison with Turner's version.

3. Since his return from Italy in 1841 Ruskin had been preparing for a return visit, and this became particularly urgent after the publication of *Modern Painters I*, for his friends had begun to make him aware of the narrowness of the views expounded in his book. Ruskin was impressed by their superior knowledge of Renaissance art and Gothic architecture, and he also encountered among them a new enthusiasm for the art of the Italian quattrocento. This so-called 'primitive' painting of 'the old religious artists' was especially admired by George Richmond, who had guided his first approach to Italian art in Rome, and Ruskin's Oxford acquaintances were also interested in the new field, so he studied Rio's *Poetry of Christian Art*, copied engravings after Raphael and Fra Angelico, and for more general background read books by Kügler and Waagen from the new German school of art historical scholarship.[26]

His second motive for this journey, in addition to the study of Italian art and architecture, was to seek out the sites of his Turner water-colours in Switzerland, and in order to record them he had further developed his new method of sketching in pen and sepia wash, based on study of the *Liber Studiorum*.

Thus equipped with new knowledge and a new style, Ruskin set out in the summer of 1845 on a tour that invites comparison with the journey of 1840–1 for its significance in the development of his art and ideas. The earlier journey had seen him visiting Italy in ill-health, closely watched by his parents, and handicapped by picturesque and puritan prejudices. In 1845 he was more confirmed than ever in certain of his prejudices (he still refused to express conventional enthusiasm for Renaissance art), but he had found an alternative to the Renaissance that he could admire, he was in exuberant good health, and, most important of all, he was free of his parents' supervision as, at the age of twenty-six, he travelled without them for the first time. The result was an exciting voyage of discovery, recorded in drawings that are less numerous and unified in method than those of 1840–1, but show greater originality and range of interest. It is at this point that Ruskin's art becomes interesting for its individuality and expressive power.

Many of the drawings in the new style show the influence of Harding in subject-matter, for trees and foliage dominate many compositions. This is the case with studies of pine trees at Sestri (Plate 37), trees and underbrush at Florence (Plate 38), twisted trees in the Alps (Plate 39), and others, all combining rhythmic pen accents and a new attention to the details of twig, leaf, and pebble, with dramatic contrasts of light and shade. There is no longer an interest in the generalized contours and reposeful spatial effects of his old Roberts style, for these designs are essentially 'foreground studies', where tree trunks and branches form flowing arabesques interwoven with the contours of rock and cloud, nervously outlined by the pen in flat patterns of considerable decorative elegance. Yet the effect is not simply decorative, for there is a flame-like agitation in the rhythm of pen and brush stroke that conveys

37. (right) *Stone Pine at Sestri.* 1845. Pen, pencil and wash. $17\frac{1}{2}'' \times 13\frac{1}{4}''$. Ashmolean Museum, Oxford.

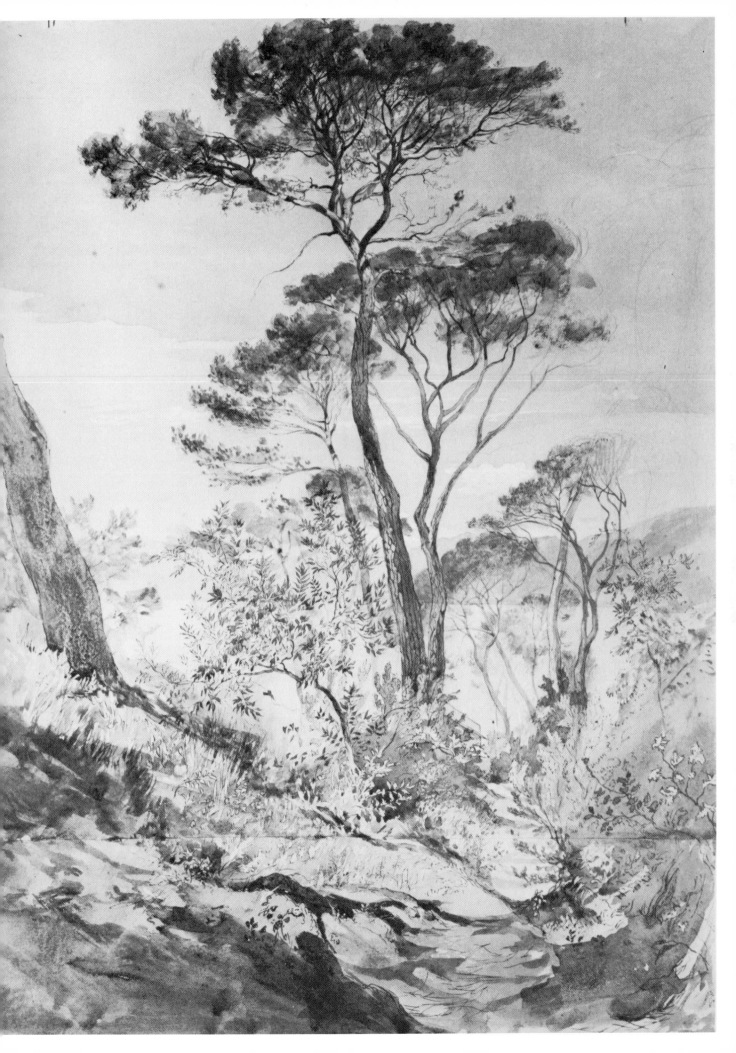

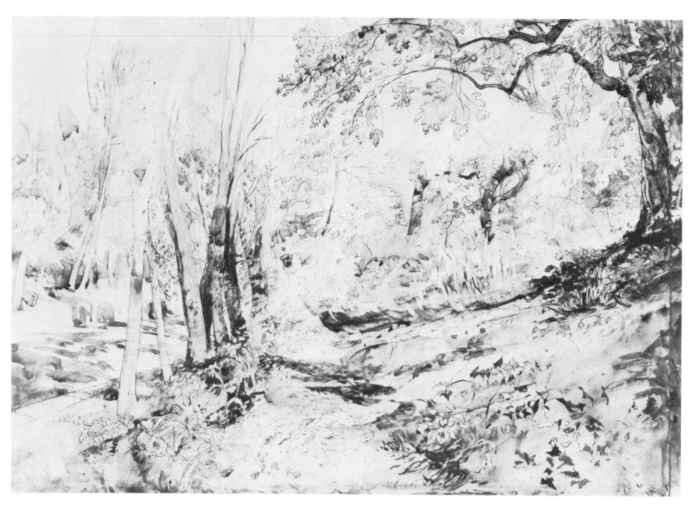

38. *Road to Florence.* 1845. Pen, pencil and wash. 15″ × 21¼″. Bembridge School, Isle of Wight.

intense emotional excitement, and from now on this expressive quality is a distinctive feature of Ruskin's studies from nature. An unfinished sketch made near Genoa shows the graphic process by which Ruskin created this visual excitement, arrested, as it were, in mid flight (Plate 40). The first scribbled pencil accents are partly reworked with pen and wash along the main lines of a composition where trees and rocks are caught up in a swirling movement radiating from the centre of the page.

It is this kind of rhythmic design, where all the elements of the composition are bound together in a dynamic and often dramatic pattern of curving accents that gives the drawings of this period their expressive impact. Naturally it was Turner who inspired this effect, especially with his water-colours of Goldau and St. Gothard, which Ruskin owned (Plates 61, 31). Then, the plates of the *Liber Studiorum* taught him to see these rhythms in more ordinary aspects of landscape, and at Fontainebleau he had found them in the harmonious lines of an aspen tree, lines which he interpreted as visible signs of an impulse that moves everywhere, in accordance with the divine law that 'governs the clouds, divides the light, and balances the wave'. Ruskin now saw this vital current widespread, so that to his eyes, nature was no longer a more or less haphazard collection of forms, waiting to be transformed by the artist into images of ideal harmony, but a living organism shaped from within by forces that imposed a common harmonious visual rhythm on rock, and cloud, and wave. From now on this rhythm was to be, for Ruskin, the essence of beauty, and at the same time, the essential truth of nature.

This identification of truth and beauty explains why Ruskin referred to the

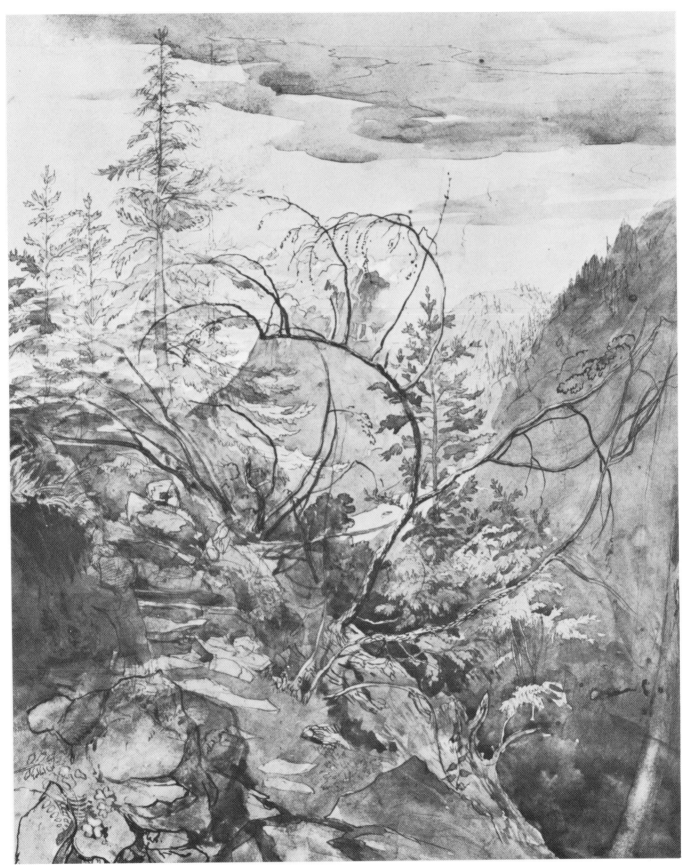

39. *Trees on a Mountainside*. 1845. Pencil, pen and wash. $13\frac{1}{4}'' \times 11''$. Bembridge School, Isle of Wight.

drawings under consideration simply as exercises in a more objective and truthful form of naturalism, even though they show heightened expressive and imaginative intensity. His attitude is shown with particular clarity in a letter from Italy to his parents, where he comments revealingly on a meeting with Harding during this tour.

Harding does such pretty things . . . that when I looked at my portfolio afterwards, and saw the poor result of the immense time that I have spent—the brown, laboured, melancholy, uncovetable things that I have struggled through, it vexed me mightily; and yet I am sure I am on a road that leads higher than his . . . his sketches are always pretty because he balances their parts together and considers them as pictures; mine are always ugly, for I consider my sketch only as a written note of certain *facts*, and those I put down in the rudest and clearest way, as many as possible. Harding's are all for impression; mine all for information.[27]

His intention was to devote himself humbly to the facts of nature, in accordance with the spirit of his vision at Fontainebleau, but in making this break from the methods and aims of the drawing masters Ruskin achieved not just the 'truth' that was his stated aim, but individual expression as well.

Ruskin's new concern for 'the certain facts' of nature intensified his interest in the way the imagination absorbed and transformed these facts in the creation of art. We have already seen him studying the relationship between imitation and imagination during the creative process in his attempt to transform his topographical sketch of Amalfi into a Turnerian fantasy. Now, during the summer of 1845, he was to work on the same problem from the opposite direction, by seeking out the view-point for his water-colour of the St. Gothard in order to compare an accurate drawing of the

40. *Trees and Rocks at Sesti.* 1845. Pencil, pen, wash and water-colour. $12\frac{5}{8}'' \times 17\frac{7}{8}''$. The Art Institute of Chicago. Gift of Mrs. Chauncy McCormick.

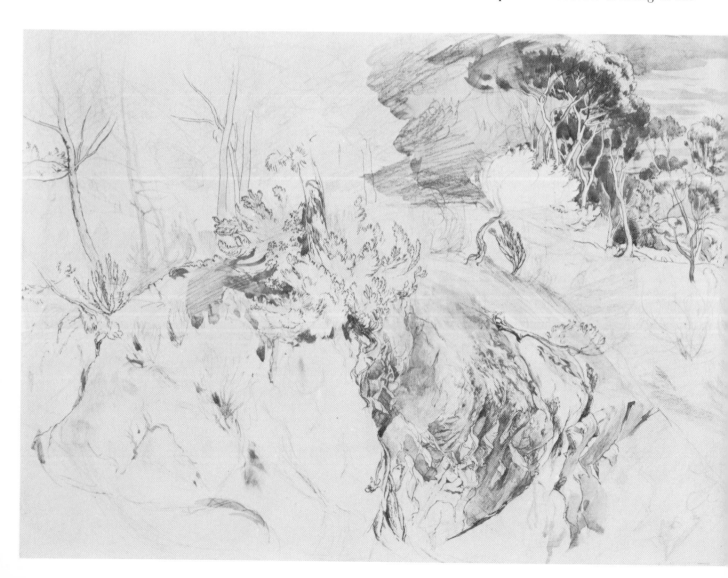

scene with Turner's interpretation. He made a series of sketches on the spot, and one of them, in brush and sepia on brown paper, shows that he was too moved by the wild grandeur of the scene to be entirely objective in his topographical rendering (Plate 41), for there is an agitated rhythm in the composition, and in the linear accents that define rocks, hills, and rushing water. Nevertheless, such drawings enabled him to make a study of the way Turner had altered and recomposed the elements of the scene in a much more radical way for his own expressive purposes.

The conclusions of this study were not published until 1856, because the Italian tour of 1845 turned his thoughts away from Turner for a time, but when he took up the problem again he made a careful etching of the main lines of Turner's *St. Gothard*, another of one of his own drawings of the scene, and then published them together in *Modern Painters IV* to illustrate his discussion.[28] He wanted to reconcile his belief in the artist's duty to imitate the truth of nature with the expressive freedom that he admired in Turner, and the conclusion he reached was that Turner's distortions are justifiable as the necessary means of expression of one who, like all artists of the highest order, works under the influence of an 'involuntary, entirely imperative dream'. In this creative dream the imagination combines fresh visual impressions with those stored in the memory, so that the subject is finally transformed into a work of 'imaginative topography', with a grand and universal effect transcending the impression of the original scene.[29]

Ruskin then compares this process with the method of the artist who 'invents a picture' by following conventions and rules governing choice of subject and arrange-

41. *Pass of Faido on the St. Gothard.* 1845. Wash and opaque white. $9\frac{3}{4}'' \times 13\frac{1}{2}''$. Fogg Art Museum, Harvard University.

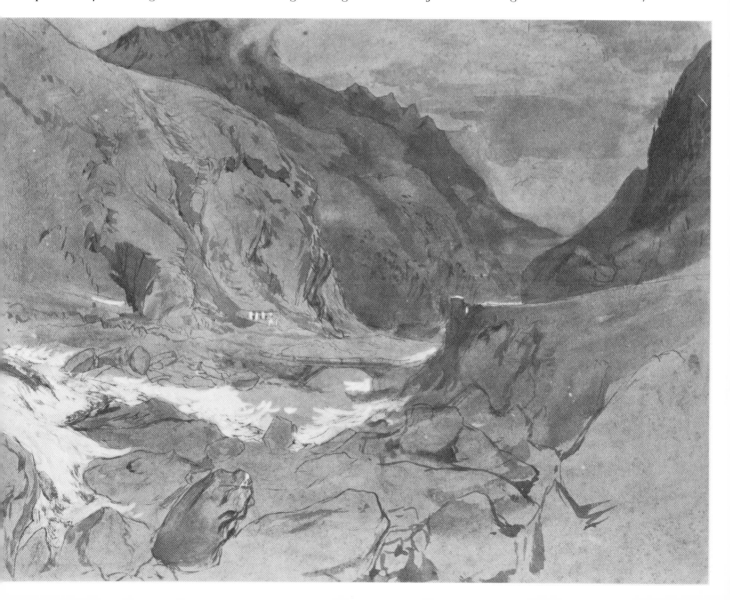

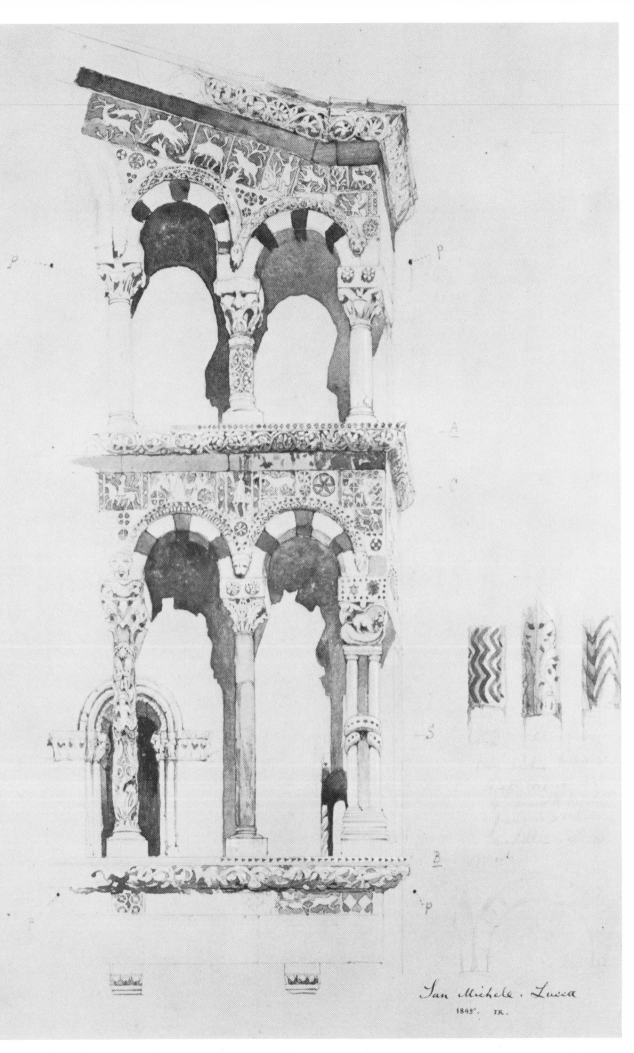

San Michele. Lucca
1845. JR.

ment of details. Here he refers to the drawing masters—Fielding, Harding and the rest—who taught their pupils to achieve a picturesque effect by means of principles based on an aesthetic theory that defined art in terms of the more or less mechanical interaction of visual stimulation and the association of ideas. Ruskin had long since come to believe that such rules were a sterile and self-deceptive substitute for true creative ability, and that this theory did nothing to resolve the profound contradiction between imitation and expression at the heart of the creative process. His own studies had now led him to identify the imagination as the key to the understanding of this mystery.

In adopting this view Ruskin meant to reject the classical belief that art, life, and nature were governed by ideal and rational patterns. Instead, he followed the Romantic tradition in critical thought which had found its most influential English exponent in Coleridge, who extolled the power of the imagination to create images revealing the free intermingling of the spirit of man with the life of nature; it was this integration that, for the Romantics, constituted the essence of reality. The necessity of this approach for an understanding of Turner was impressed on Ruskin as he made his drawings of Amalfi and the St. Gothard, trying in this way to experience for himself the process by which Turner's imagination 'summons and associates its materials' for the paintings where dream and reality were mingled in such ecstatic and awesome forms.

4. Ruskin's fragmentary sketches from Italian paintings and architecture during the tour of 1845 reflected ideas and insights that were even more important for the immediate future of his literary work than the landscape studies. At Lucca, Pisa,

42. (far left) *Part of the Façade, San Michele, Lucca.* 1845. Pencil and water-colour. 16″ × 8½″. Ashmolean Museum, Oxford.
43. *Part of Santa Maria della Spina, Pisa.* 1845. Water-colour. 20″ × 14¾″. Graves Art Gallery, Sheffield. Reproduced by permission of Sheffield Corporation.

and Venice his new interest in medieval Italian architecture was excited by buildings like San Frediano at Lucca, where he drew the gloomy nave in his best pen-and-wash style,[30] and then turned to water-colour to record the façade of the church of San Michele, with its delicate sculpture and coloured marbles sparkling in the sunlight (Plate 42). In the latter work, decorative contrasts of texture and colour are indicated with a loosely applied mosaic of thin washes that recalls the early training under Copley Fielding, a technique stretched to its limit in the most elaborate architectural study of this time, depicting a portion of the chapel of Santa Maria della Spina at Pisa (Plate 43). Both works show the survival of something like his old picturesque outlook, for in spite of the influence of his Oxford friends, with their concern for structural order and logic as the basis for the professional study of architecture, Ruskin now tended to look at buildings as a series of surfaces which might be viewed individually and in close-up, where basic architectural materials and forms, like marble, mosaic, column, and capital, were combined in what we might now almost call a kind of collage, with a purely *visual* logic in the decorative sequence of colours, textures, and details. This was the kind of thing that had entranced him while making his drawing of the Piazza Santa Maria del Pianto in Rome four years earlier (see p. 40), except that now he was concerned with a particular architectural style as a source of picturesque delight, and, as in his landscape studies, he had largely given up trying to compose such effects within comprehensive views, concentrating instead on detailed studies in the kind of painstaking technique that was to lead to *The Stones of Venice*.

Much time was also spent in making sketches of Tintoretto's paintings in Venice and outlines of quattrocento frescoes in Florence and Pisa. The Tintoretto studies were executed in pen and sepia wash like the landscape sketches (Plate 44), and their aim was to suggest the dramatic contrasts and free handling of an artist whose imaginative power in figure composition rivalled and, in Ruskin's view, complemented the achievement of Turner in the field of landscape. On the other hand, the sketches of works by Fra Angelico, Benozzo Gozzoli, and the master of the Campo Santo frescoes are essentially linear, and were meant to indicate simplicity and naïveté of expression, qualities at the opposite pole from the sophisticated invention and technique of Tintoretto (Plate 45).

Ruskin responded enthusiastically to both modes of expression. Turner had prepared him for the romantic colour and emotional excitement of Tintoretto, while in his appreciation of pre-Renaissance art he showed his response to the new taste for late medieval painting that had reached England from Germany early in the nineteenth century. This kind of religious painting was believed to derive much of its spiritual effect from a foundation of simple line-drawing, the most 'primitive' and direct means of artistic expression. Ruskin's devotion to line-drawing from the beginning of his own amateur career made him sympathetic to this view, so that when, in 1843, his friend George Richmond introduced him to the work of the modern English master of spiritual design, William Blake, he was even persuaded to buy some of his drawings. He was forced to return them when his father intervened, but the fact that he had gone so far in his appreciation of an artist completely beyond the pale of conventional taste throws some interesting light on the nature of the concern for religious art which he pursued in his outlines of Italian frescoes of the quattrocento.

The second volume of *Modern Painters* was written after Ruskin's return from Italy in November 1845. Much of it was a deliberately dry discussion of the so-called theoretic faculty by which man perceives beauty, and its relationship with the power of the imagination that transforms this perception into art. Tintoretto, not Turner, was the hero of the new book, but it also contains many references to the quattrocento

artists recently studied by Ruskin, and after it was published in the spring of 1846 he set out with his parents to recapture and share with them the exciting discoveries of the previous summer.

This journey was not a success, for Ruskin's enthusiasm was dampened by his father's incomprehension, not only of the new objects of his enthusiasm but of his new method of study. As Ruskin later remembered, he deplored his 'now constant habit of making little patches and scratches of the sections and fractions of things in a notebook . . . instead of the former Proutesque or Robertsian outlines of grand buildings and sublime scenes'.[31] Ruskin senior's own words in a letter to a friend were that his son's work was 'all true—truth itself, but Truth in mosaic', and to the common eye 'a mass of hieroglyphics'.[32]

Certainly many of the innumerable details of landscape and architecture that now began to accumulate in Ruskin's sketch-books have little independent aesthetic interest, and can only be interpreted by tracking down their relevance to his writings. One example among hundreds is a diagram of some mouldings sketched in Switzerland during this tour of 1846 (Plate 46). This records his discovery of what he called 'intersectional mouldings', where line is substituted for mass as the main element of decoration in Gothic architecture. In *The Seven Lamps of Architecture* he was to argue that this was a critical departure from the 'truth' of Gothic, leading to the collapse of the great tradition of medieval architecture. Here he was applying a version of the archaeological method found in the book by R. Willis on *The Architecture of the Middle Ages*, a work that he had greatly admired, and which was to turn his attention now from quattrocento painting to Gothic architecture; but characteristically, he centres his attention on a decorative detail that was for him the key to the subject, rather than on the problems of structure treated by Willis.[33]

44. *Copy of the Central Portion of Tintoretto's Crucifixion.* 1845. Pen and wash. $14\frac{1}{2}'' \times 21''$. Bembridge School, Isle of Wight.

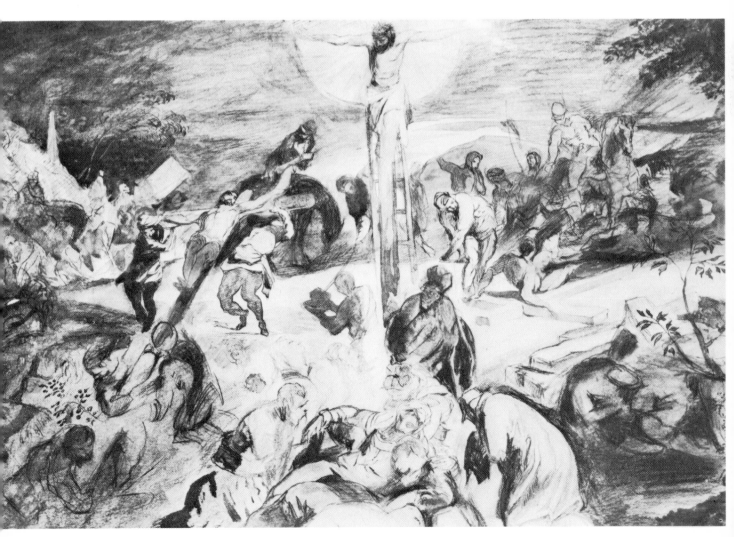

68

45. *Abraham Parting from the Angels*. Copy of a fresco in the Campo Santo, Pisa. 1845. Pencil. 17″ × 10″. Ashmolean Museum, Oxford.
46. (below) *Mouldings at Lucerne*. 1846. Pen and wash. 7″ × 5″. Fogg Art Museum, Harvard University.

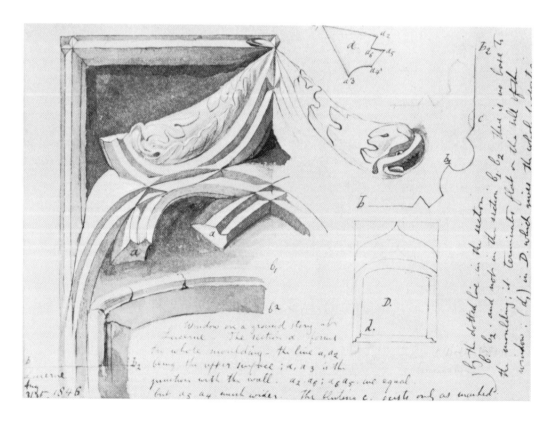

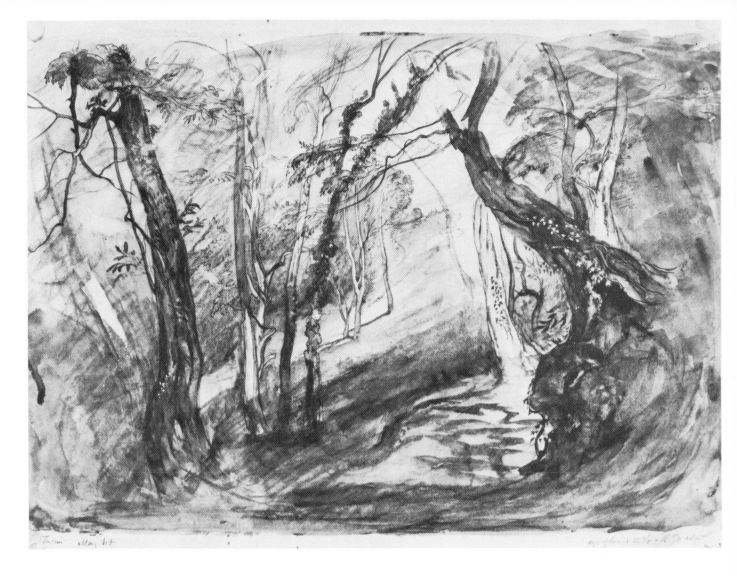

A few pen-and-wash studies of Swiss and Italian subjects in the manner of the previous year were completed during this tour (Plate 47), but comparatively little new work was done, beyond making vague plans for further study of Gothic architecture. However, this project had to be abandoned momentarily, for after his return to England Ruskin showed symptoms of incipient physical and mental breakdown, and much of 1847 was spent in an attempt to rest and refocus his energies. His parents were alarmed, and they came to believe that marriage would have a settling effect, so with their encouragement Ruskin began to court young Effie Gray, the distant cousin for whom he had written *The King of the Golden River* when she was a child of thirteen. They were married in April 1848, and four months later left for France, where Ruskin settled down in Normandy to the study of medieval architecture. The drawings made at this time were an important part of his research for *The Seven Lamps of Architecture*, where for the first time he included illustrations etched after his own studies. Many notebooks were filled with notes and sketches, but there were also a few more comprehensive studies of larger details of the churches under examination. In style they resemble the architectural studies of 1845, like the detail of Santa Maria della Spina (Plate 43), except that he abandoned the water-colour required to render the coloured marbles of Italian Gothic, and made his studies in a monochromatic combination of pencil and wash. The drawing at St. Lô in the Harvard collection is perhaps the most elaborate work from this time (Plate 52), sketchy and lacking in finish compared with the earlier study, but successful in conveying a very vivid impression of sunlight playing over the crumbling, delicately carved stonework.

47. *Trees Near Turin*. 1846. Pen, pencil and sepia. 14″ × 18¾″. Education Trust, Brantwood, Coniston.

With its loose technique it also achieves a truth of atmosphere and three-dimensional form that is new in Ruskin's drawings.

The patchy, impressionistic pattern of light and dark in this study has a photographic quality pointing to Ruskin's interest in the camera, which he had first encountered in Venice in 1845, an event immediately reported in a letter to his father. 'I have been lucky enough to get . . . some most beautiful . . . Daguerreotypes of the palace I have been trying to draw. It is very nearly the same thing as carrying off the palace itself, every chip of stone and stain is there. . . . I am very much delighted with these and am going to have some more made of pet bits.'[34] Later, when he described his aim in the Normandy drawings, it appeared very much as though they were a response to the challenge of photography: '. . . their truth is carried to an extent never before attempted in architectural drawing. They represent that architecture with its actual shadows at the time of day at which it was drawn, and with every fissure and line of it as they now exist.'[35] In another letter he commented further on his progress toward this kind of truth. '. . . I have improved in my drawing in these three months considerably; the different style of Gothic quite beat me at first, and still it does in a great degree. I have not yet once succeeded in giving the *true* effect of a highly ornamental flamboyant niche, though I think I have come nearer it than most people.'[36]

The letters also show that he finished each study confronting the subject, working only an hour or so from any one viewpoint, and then moving to a new position to take up another drawing when the light changed. These aims and methods enabled Ruskin to create something quite different from the usual kinds of architectural illustration in the nineteenth century, like the picturesque views by Prout and other travel illustrators, the Piranesi-like drama of Cotman's antiquarian book illustrations, or the mechanical line-drawings of architectural historians like A. C. Pugin. Only Ruskin tried to surrender himself without preconception or artifice to his impression of a building as it actually appeared at a particular moment.

Yet this faithfulness to the impression of the moment was combined with an intense concern for the expressive character of the Gothic building under examination, an emotional appeal that Ruskin now felt through patterns and gradations of light and shade. As he explained later, that was why he had abandoned picturesque outlines for chiaroscuro in his architectural studies. 'There is yet one very important fact to be noted of outline drawing in general, that it entirely refuses emotion. The work must be done with the patience of an accountant, and records only the realities of the scene—not the effects on them. Prout's towns are all in forenoon sunshine, mine in tranquil shade. . . .'[37]

In his mature view, architectural light and shade evoke ideas and feelings in the observer's imagination that are associated with states of mind basic to human nature, thus conveying the individual character of a building and its builders,[38] and when he wrote *The Seven Lamps of Architecture* his aim was to group and describe such intuitions as they related to 'certain states of moral temper' expressed by the Gothic style. This approach helps to account for the emotional impact of these drawings, with their ragged shadows spotted like expressive ink blots across the page, and the quivering touch of brush and pencil recording the excitement of a highly strung sensibility probing with both delicacy and determination into an intricate web of impressions.

After the publication of *Seven Lamps* in the spring of 1849 Ruskin's centre of Gothic studies shifted from Normandy to Venice. He had loved the city since his first visit in 1835, a fascination that can in large part be associated with Turner, who had exhibited increasingly radiant visions of Venice since 1833. Ruskin's first

defence of Turner in 1836 had discussed a subject set in Venice, *Juliet and her Nurse*; he had hung a large engraving after a painting of the Grand Canal in his rooms at Oxford; and his father acquired an oil painting by Turner of a Venetian scene in 1847. Serious study of Venetian architecture began in 1845, when he began to accumulate detailed drawings and photographs of favourite monuments, so that it seemed natural for him to follow up his discussion of French cathedrals with an examination of Venetian palaces and churches.

His aim was to illustrate in more detail the thesis of *Seven Lamps* that certain states of moral temper were necessary to the production of good architecture, this time through a comparison of Gothic and Renaissance structures. He wanted to show 'that the Gothic architecture of Venice had arisen out of, and indicated in all its features, a state of pure national faith, and of domestic virtue, and that its Renaissance architecture had arisen out of, and in all features indicated, a state of concealed national infidelity and of domestic corruption'.[39]

This called for careful study of Venetian history, and an arrangement of the monuments in chronological order, with comparative illustrations. The enormous amount of research that had to be undertaken allowed no time for the kind of meticulous drawings that he had produced in Normandy. For the most part, he made hasty sketches of details of columns, capitals, windows, and arches in his notebooks, with only a few attempts at more careful work, relying on the skill of the engravers to work them up into presentable plates for his book (Plates 48, 49). Hundreds of such pages survive, and the work of analysis that they represent almost destroyed Ruskin's delight in Venice. After three years of this kind of labour, he was glad to return to the completion of *Modern Painters* and the landscape drawing that this entailed.

48. (far left) *Capital at Venice.* c. 1851. Pen, pencil and water-colour. $10\frac{3}{4}'' \times 7\frac{3}{8}''$. Education Trust, Brantwood, Coniston.

49. *Byzantine Sculpture at Venice.* c. 1851. Pen, pencil and wash. $8\frac{7}{8}'' \times 5\frac{3}{8}''$. Education Trust, Brantwood, Coniston.

4. Switzerland: Mountains and Towns (1849–1866)

1. The landscape drawings that Ruskin made in 1845 were, as we have seen, dominated by trees and foliage in remembrance of his lessons from Harding and his vision at Fontainebleau, where the lines of an aspen had seemed to offer a clue to the visual harmony of all natural forms. The pen-and-wash technique that he had developed in emulation of the *Liber Studiorum* at first encouraged him to organize these rhythms in rather flat and decorative patterns, without probing very deeply into the mass or substance of his subjects, but this is not the case with some drawings made in 1847 during a holiday in Scotland. Here his geological interests were revived by a countryside which he later described as 'one magnificent minerological specimen'.[1] The rocks and boulders that dominate his drawings there are charged with the same kind of rhythm that animates the vegetation clinging to their sides, but they are treated as fully rounded, monumental, masses (Plate 50). Particularly impressive is the *Coast Scene near Dunbar*, where the sluggish surge of the rocks draped with seaweed gives the view a note of gloomy menace that accords with Ruskin's mood during a time of mental and physical depression (Plate 51). These drawings mark the climax of his *Liber Studiorum* style, where we can see the careful adjustment of light, shade, and contour to create relief and solidity, a concern that becomes an increasingly important feature of his work in the following years.

The architectural drawings made in Normandy during 1848 show him loosening this style with a sketchy combination of pencil and wash to create the subtle contours and atmospheric effects needed for a full rendering of three dimensional form (Plate 52), and a landscape sketch of the coast of Normandy from the same year shows a comparable technique (Plate 53). This panoramic view is as different in composition as it is in execution from the pen-and-sepia patterns of the *Liber Studiorum* style, for the eye is drawn into deep, atmospheric, space along the undulating planes of the hills which radiate from a central point in the composition. This foreshadows the mountain drawings of the following year, where Ruskin found comparable effects in more sublime and monumental subject-matter.

After the architectural work that had culminated in the writing of *The Seven Lamps of Architecture*, Ruskin travelled to Switzerland in 1849 to renew his landscape studies and make plans for the next volume of *Modern Painters*. He later remembered this long session of leisurely mountain and cloud watching as the time when he had acquired the core of what he 'had to learn and teach about gneiss and ice and clouds',[2] but it was also a means of escape from a domestic problem that was becoming acute. His wife was beginning to break down under the strain of their marriage, so she was sent to her home in Scotland while Ruskin sought to recapture his boyhood delight in the Alps. He was largely successful in this, but he also thought sadly that it might be his last visit to the mountains as a young man with his parents, and he brooded over the Alpine sunset as a symbol of fading youth.[3]

A great many drawings were made this summer, and·they convey the excitement of discovery, like those of 1841–2 and 1845. Ruskin noted in a letter to George

50. (above) *Study of Thistle at Crossmount*. 1847. Pen and wash. 18″ × 23″. Collection Mr. G. T. Goodspeed, Boston, Mass., U.S.A.

51. *Coast Scene Near Dunbar*. 1847. Pen and water-colour. 12½″ × 18″. City of Birmingham Museum and Art Gallery.

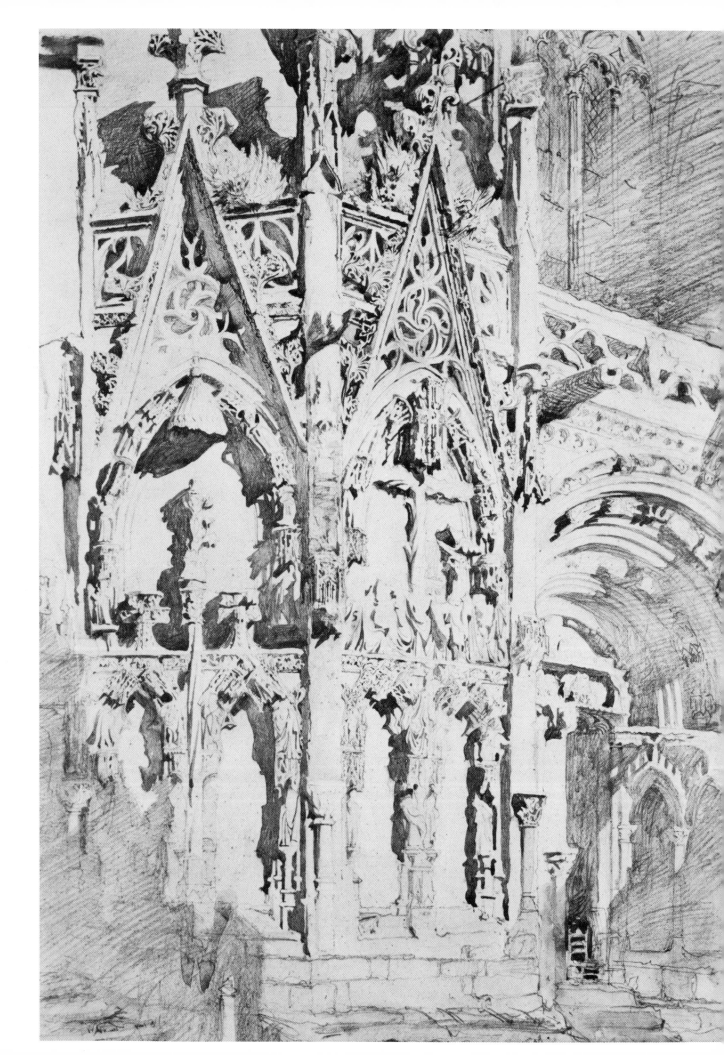

Richmond shortly after his arrival at Chamouni that this was the first time he had stayed there since he could draw trees,[4] and he was evidently anxious to apply the lessons learned through his *Liber Studiorum* style to the study of the Alps. He began with a pen-and-sepia study of the view from his rooms in the Hôtel de l'Union, looking over the rooftops of the village toward the Glacier des Bossons.[5] He apparently worked on it for many evenings, to achieve a realism of detail and light and shade that is almost photographic. In fact, it shows him responding again to the challenge of photography, for during this period of mountain study he took numerous daguerreotypes and used them to correct his drawings.

Quite different in character is a series of sketches also made from his hotel window, but looking east across the valley instead of south. These show the Aiguilles of Mont Blanc, and the wooded hills beneath them, with the Cascade de la Folie. There are at least five of the same subject, from slightly different points of view and with different parts of the scene emphasized, all drawn and partly shaded in pencil, with washes of transparent water-colour and touches of opaque white in the clouds. One of them is only a beginning, with sketchy pencil work, carefully outlined *aiguilles*, and initial washes of pale colour (Plate 54), but another is highly finished, with a rich blue tonality (Plate 55). Compared with the more conventional study of the Glacier des Bossons, with its careful detail and clear distinctions between foreground, middleground, and distance, these drawings have a more free and original style.

In all of them the artist looked up at his subject, ignoring the traditional parallelism between the line of sight and the ground plane. One cannot locate the horizon, so that these grassy slopes and masses of rock and ice hang in the sky (Plate 56) with an effect like that of the cloud studies of Turner and Constable. They have a comparable animation as well, for again the planes and contours radiate from a central point with a slow swirling rhythm, and the forms seem to expand within their limitless spatial environment, advancing toward the eye with a convincing sense of mass and roundness.

This escape from the rectilinear spaces and static forms of traditional landscape art enabled Ruskin to perceive the dynamic structure of his environment with renewed

52. (far left) *Part of the Church at St. Lô.* 1848. Pencil, pen and wash. $17\frac{7}{8}'' \times 12\frac{7}{8}''$. Fogg Art Museum, Harvard University.
53. *Normandy, View on the Coast.* 1848. Pen, pencil and wash. $13\frac{3}{4}'' \times 20''$. Education Trust, Brantwood, Coniston.

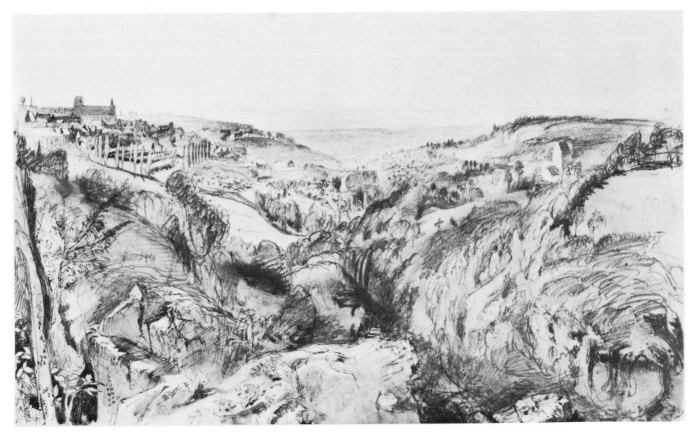

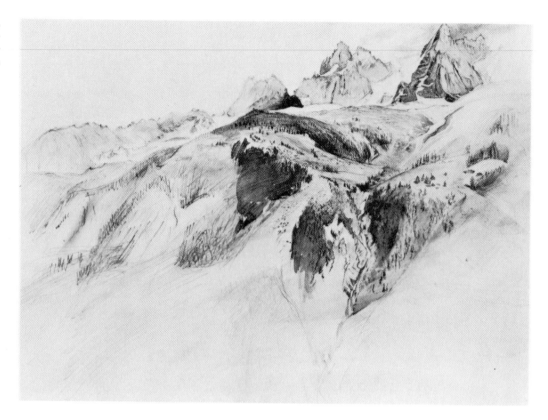

freshness. As usual, much of the inspiration came from Turner, whose water-colours of the St. Gothard and the Goldau gave the scenery of the Alps an intensely dramatic animation of form, space, and atmosphere, showing the most radical kind of depar-ture from the classical stability and orderliness that had always formed the basis of earlier mountain painting, even in the Romantic interpretations of artists like J. R. Cozens and Caspar David Friedrich.

Ruskin did not achieve this new perception without a struggle. His diary refers to difficulties with these drawings of the *aiguilles*, and he complained at one point that his Chamouni work on the whole had been disappointing. Near the end of his stay he wrote, 'I can't do it yet, but I have the imagination of it in me, and *will* do it, some day.'[6] In fact, he did not again undertake so intensive a course of study among the mountains, but in 1854, after the long digression away from his landscape work that had resulted in *The Stones of Venice*, he returned to the drawings of 1849, studied them carefully, and in the next year wrote the chapters in *Modern Painters IV* that explain what his imagination had perceived and expressed in these sketches. In doing so he was returning to a theme that he had treated much earlier in the section entitled 'Of Truth of Earth' in *Modern Painters I*, but this time his approach was determined by a much more extensive knowledge of the art of Turner and the science of geology.

In the earlier book his account of mountain form had been broad and general, making use of relatively few scientific terms in his descriptions of stones, hills, and peaks, which he considered as pictorial elements belonging in the foreground, middleground, and distance of paintings by Turner and the old masters. The difference between this approach, which treats the mountains as static elements in a composition, and the new interpretation is summed up in his statement that now it was 'not so much what these forms of the earth actually are, as what they are continually becoming, that we have to observe'.[7]

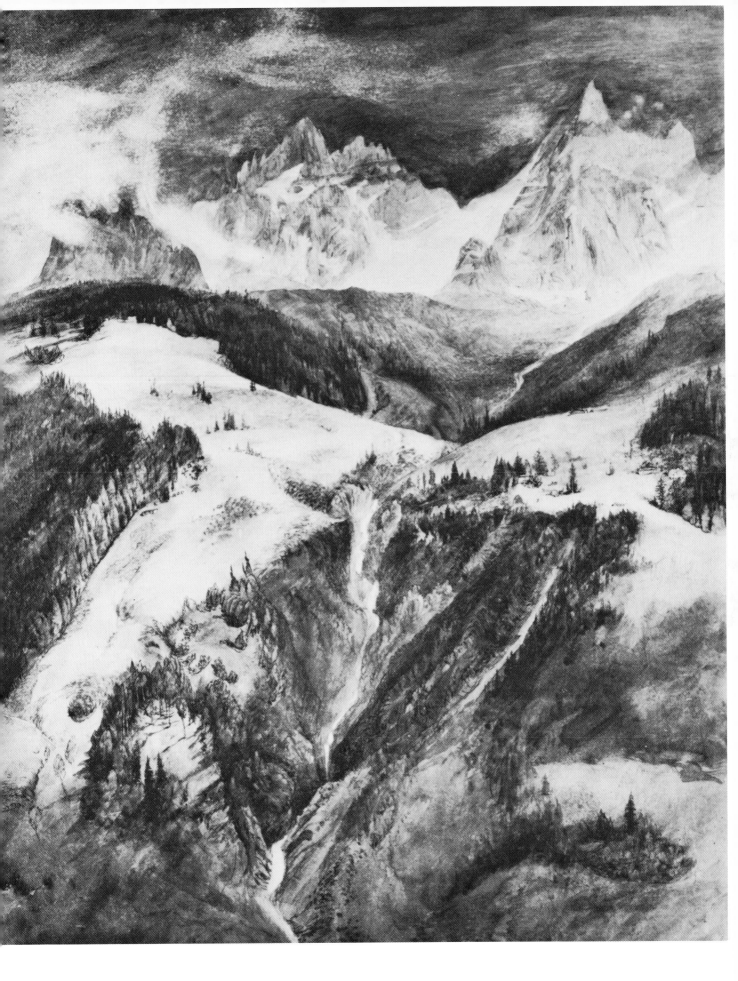

The change to a more dynamic conception of his subject reflected in large part a new scientific approach, for when Ruskin wrote the first volume of *Modern Painters* his knowledge of geology owed much to his association with Dr. William Buckland, the Reader in Geology at Oxford, who represented a conservative branch of the science in England. Buckland supported the theory that geological formations were the result of a series of cataclysmic events in the remote past, and since this permitted the preservation of the Biblical time-scale, his publications were widely welcomed by those who did not wish to see religion contradicted by science. In fact, he published a survey of geological knowledge with the aim of proving 'The Power, Wisdom, and Goodness of God as Manifested by the Creation'.[8] This traditional outlook had an influence over all Ruskin's geological writings, but hints of cataclysmic origins are particularly strong in *Modern Painters I*, where he writes of the vast pyramids of the mountains, springing up and flinging their garment of earth away from them on each side to form the hills.

At this time, however, cataclysmic theories were being superseded by the doctrine of uniform causes expounded by Buckland's pupil, Charles Lyell. In his *Principles of Geology* (1833) Lyell opposed Buckland and those who subordinated the observation of the facts of nature to scripture. He dispensed with the Biblical time-scale and proposed that the earth was very ancient, but still undergoing a transforming process of change through the operation of natural forces, an evolutionary theory that looked back to the similar ideas of Dr. James Hutton in the eighteenth century, and forward to Darwin's application of a similar principle to biology. Ruskin never accepted this theory completely, but its influence is clear in *Modern Painters IV*, for when he informs us that one small stream flowing into the valley of Chamouni carried away eighty tons of mountain in a single year, his purpose is to make us 'begin to apprehend something of the operation of the great laws of change, which are the conditions of all material existence, however, apparently enduring'.[9] (Lyell had given a similar account of the action of water in his *Principles of Geology* in 1833.) This was the basis of his new account of mountain form, for peaks and hills and stones are shown to be a sequence of intimately related and changing forms resulting from the gradual breakdown of the central peaks. The discussion employs a greatly enriched geological vocabulary and is no longer dictated by pictorial considerations. Rather, as Ruskin says, he 'shall adopt the order, in description, which Nature seems to have adopted in formation'.[10]

This new sense of the interrelatedness of mountain forms was reinforced by his struggle to draw the Aiguilles of Chamouni in 1849. His sketches led him to conclude

56. *Junction of the Aiguille Pourri with the Aiguille Rouge.* 1849. Pencil and water-colour. 5″ × 8⅛″. Ashmolean Museum, Oxford.

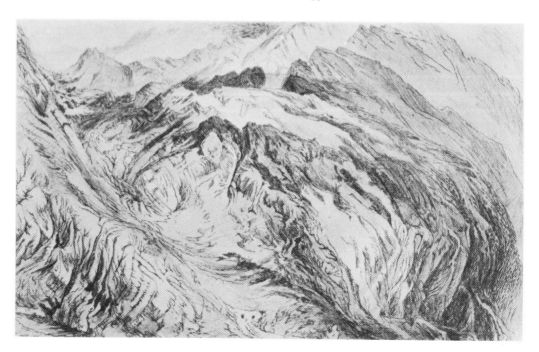

that the main characteristic of these rugged peaks is the way the main lines of cleavage in the rock form a system of harmonious curving lines that, 'like those in the grain of the wood in a tree trunk, . . . rule the swell and fall and change of all the mass'. He continues:

In Nature, or in a photograph, a careless observer will by no means be struck by [these curves] . . . and an ordinary artist would draw rather the cragginess and granulation of the surfaces, just as he would rather draw the bark and moss of the trunk [of a tree] . . . but . . . as an artist increases in acuteness of perception, the facts which *become* outward and apparent to him are those which bear upon the make and growth of the thing. . . . [The] keenness of the artist's eye may almost precisely be tested by the degree in which he perceives the curves that give [the *aiguilles*] their strength and grace, and in harmony with which the flakes of granite are bound together, like the bones of the jaw of a saurian.[11]

These remarks were written with reference to one of his best mountain sketches, a study of the Aiguille Blatière made from a point high up on the Montanvert, where Ruskin had climbed for a close-up view (Plate 57). It has an inscription like a front-line communiqué, 'showing finest conchoidal-riband structure. J. R. on the spot, 1849', and the harsh landscape of the high peaks is given a remarkably expressive impact by rhythmic accents that bind the whole design together, 'like the bones of the jaw of a saurian'.

It will be noticed that in this passage Ruskin criticizes photography and Harding's kind of draughtsmanship, with its emphasis on surfaces and textures, for their failure to bring out the curvilinear structure of mountain form. In Ruskin's view, simple impressionism was unable to reveal the rhythmic unity of nature, which he

57. *Aiguille Blaitière*. 1849. Water-colour. $9\frac{3}{4}'' \times 14\frac{1}{16}''$. Fitzwilliam Museum, Cambridge. Reproduced by permission of the Syndics of the Fitzwilliam Museum, Cambridge.

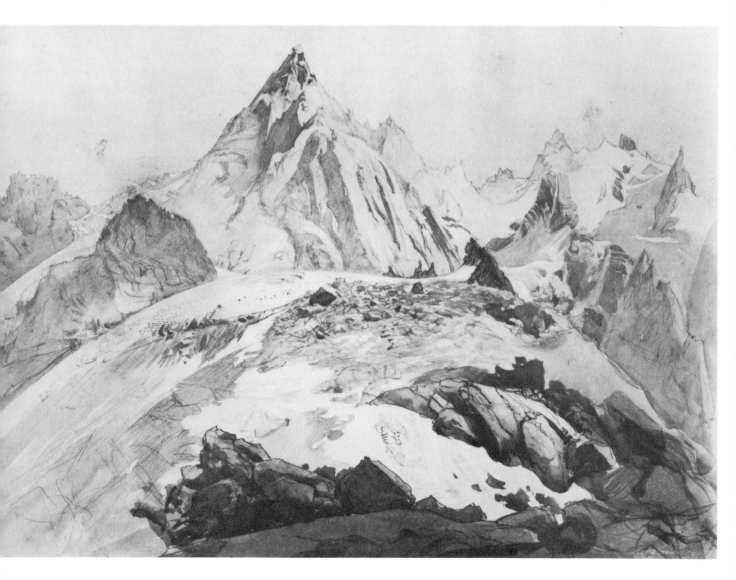

always seems to have understood in linear terms. It was something that could only be discerned by an imagination capable of penetrating to the inner forces of growth and development. Turner had achieved this, and Ruskin felt that he could too, for, as he had said of his efforts to give graphic expression to his conception of mountain form, 'I have the imagination of it in me.'

The discovery of curvilinear rhythms in the high peaks of the Alps was regarded by Ruskin as an important scientific observation. He saw these lines as visible evidence of action according to 'the great laws of change', operating through gigantic atmospheric forces to mould the primeval rock into its present mountain form. But of course the whole discussion is directed not only toward the description of scientific truth, but toward 'the observance of the nature of *beauty*, and of the degrees in which the aspect of any object fulfills the laws of beauty stated in the second volume of *Modern Painters*'.[12] In the earlier book it had been laid down 'that curvature was essential to all beauty', and Ruskin had set himself the task of proving that curvature was a constant element in all natural forms whatever.

This enterprise shows what some have regarded as a traditional English preference for curvilinear design. Hogarth had described an undulating curve as the essence of formal beauty, an idea supported by Italian art theory of the sixteenth century, but this preference in England can be traced even further back, to the characteristic 'undulating line' of English Gothic art in the fourteenth century, and further still to what may be Celtic sources for the design of metalwork and manuscript decoration before A.D. 800. This fundamentally anti-classical tradition, with its emphasis on intertwined curvilinear patterns to express spirituality and fantasy, can also be recognized as a noteworthy element of Turner's art, and this helps to explain why Ruskin, in his defence of Turner as a 'truthful' painter, continually sought to bring all landscape forms under Hogarthian laws of beauty.[13]

In his chapter on *aiguilles* for *Modern Painters IV* he felt that he had made an important step in this direction. With the aid of his drawings he could demonstrate that the *aiguilles*, composed of the hardest and least tractable substance, where 'we might have anticipated some correspondent ruggedness and terribleness of aspect' and a 'refusal to comply with the ordinary laws of beauty', do, in fact, show the curvilinear accents common to all beautiful forms. The result is that, instead of a violent contrast between the jagged peaks and the soft waves of bank and wood in the hills beneath them, the attentive observer can discern that 'as their true character is more and more understood, the tender laws of beauty will be seen more and more to influence the inmost beings of the aiguilles, and their true strength and nobleness to rest at last in the same harmonies of curve which regulate the stooping of the reed and the budding of the rose.'[14]

The last passage seems to refer us directly to the drawings of 1849 depicting the *aiguilles* and hills at Chamouni, and we can see that they reinforced Ruskin's Fontainebleau vision of 1842, when he had found that the laws of beauty were the same laws that 'guided the clouds, divided the light, and balanced the wave'; but now he saw further into the relationship between these laws and the reality of change that lay everywhere behind the seeming permanence of even the grandest features of the landscape. The curved line that expressed the essence of beauty in both art and nature had become at the same time a symbol of the dynamic exchange of growth and decay that now formed the basis of Ruskin's conception of reality.

In the artist's repertoire of landscape forms, the mountain has always embodied the most permanent and awe-inspiring aspects of nature. The mountains that Ruskin drew were no less sublime, but he succeeded in converting them into dynamic images of change and growth, an undertaking that might be contrasted with the precisely

opposite achievement of Cézanne at the end of the century. The French artist made Mont St. Victoire the central feature of many works, where his aim was to restore to painting the classical values of permanence and stability, values which Ruskin, like many others during the periods of Romanticism and Realism, had succeeded in banishing from his conception of nature and art.

2. In 1851 Ruskin's attention was drawn to the fact that the group of young painters who called themselves Pre-Raphaelites were undergoing critical attacks as savage as those once aimed at Turner, in the days before his art had been glorified in *Modern Painters*. John Everett Millais, the most talented painter in the group, appealed through friends for Ruskin's assistance, in hope that he would recognize the extent to which the Pre-Raphaelites were endeavouring to follow Ruskin's advice to the young painters of England that 'they should go to nature in all singleness of heart . . . rejecting nothing, selecting nothing, and scorning nothing.'[15] He was not disappointed, for Ruskin took time from his work on *The Stones of Venice* to write a series of letters and articles praising the young artists for their truthful rendition of nature, something that quite outweighed the fault he found with their supposed Romanist tendencies, ungraceful figure drawing, and the 'common' faces of their heroes and heroines.[16] Subsequently, Ruskin became a personal friend and benefactor of several members of the group, especially the handsome, gay and talented Millais, who was soon asked to join Ruskin and his wife on an ill-fated holiday excursion to Scotland in the summer of 1853. During this time Millais began work on his famous portrait of Ruskin standing thoughtfully beside a mountain stream at Glenfinlas, and the experience of watching the artist as he painted (he always regretted that Turner had not allowed him to do this) established new standards of patience, skill, and detailed finish for Ruskin's own art. He made notes in his diary that give a close account of Millais' progress, and at the same time he made his own meticulously detailed pen-and-wash study of the rocky bank of the stream, ostensibly to guide Millais in painting the background (Plate 58). There is no precedent in Ruskin's work for quite this kind of minute detail, but it recurs frequently in later drawings as a result of Pre-Raphaelite inspiration.

The Scottish holiday set in motion a train of events that ultimately led to the annulment of Ruskin's marriage and his wife's acceptance of a proposal from Millais. In April 1854 Ruskin was served with a citation that initiated his wife's suit, and in the following month he travelled to Switzerland with his parents, leaving the scandal behind, and the legal details in the hands of his lawyers. His intention was to take up again the work that would enable him to continue *Modern Painters*, and with a typical effort to keep his career and private life in separate compartments, he settled down at Chamouni to work on an elaborate water-colour of a mountain boulder, which was intended to render with Pre-Raphaelite detail the kind of subject that he had first sketched in 1849 (Plates 59, 60). Set against green foliage and blue mountains, the great rock is stained with warm tones of orange, yellow, and red. The texture of the stone and the smallest leaves of the plants that creep along its sides are treated with exquisite minuteness and delicacy of touch in a truly Pre-Raphaelite manner, but the details are unified by Ruskin's characteristic perception of an all-pervasive rhythmic current that moves through the Alpine rock as well as the foliage around it.

The medium is handled with uncertainty here and there, for Ruskin was inexperienced in managing a full range of colour, but the subject and style show an impressive continuation and extension of the kind of work begun in the previous summer by the side of Millais. For this reason one cannot believe that it was under-

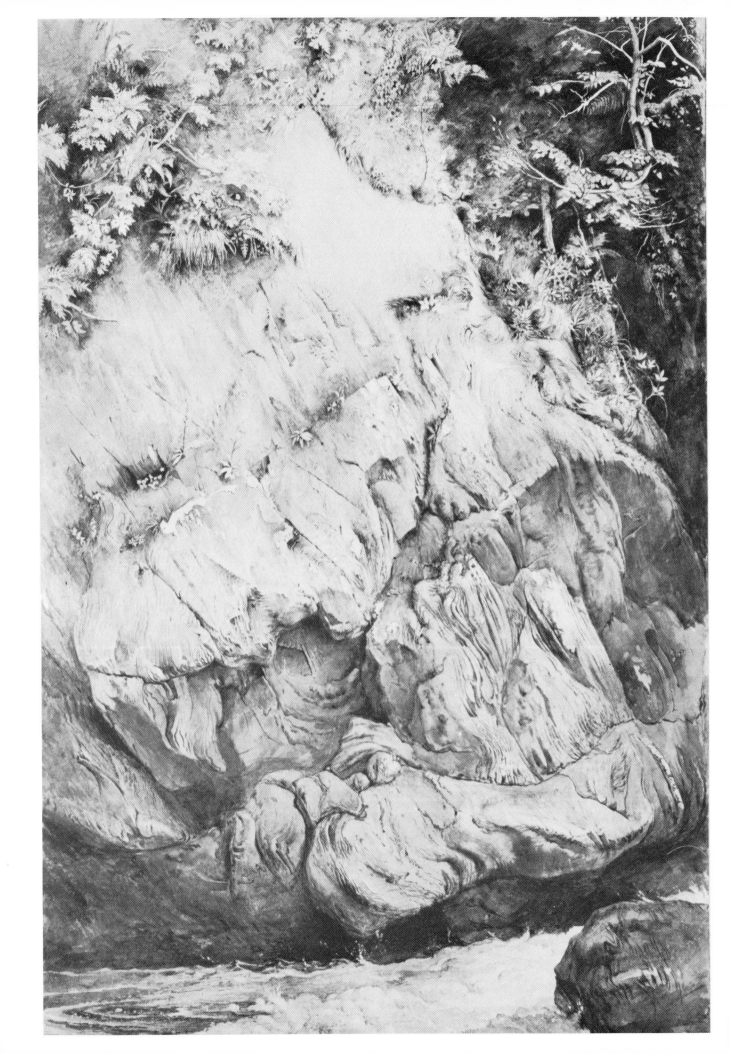

59. *Rock at Maglans, Savoy.* Probably 1849. Pencil and water-colour. $5\frac{3}{4}'' \times 8''$. Ruskin Museum, Coniston.

58. (left) *Gneiss Rock at Glenfinlas.* 1853. Pen and wash. $18\frac{3}{4}'' \times 12\frac{3}{4}''$. Ashmolean Museum, Oxford.

60. *Fragment of the Alps.* 1854. Water-colour. $13'' \times 19\frac{1}{4}''$. Fogg Art Museum, Harvard University.

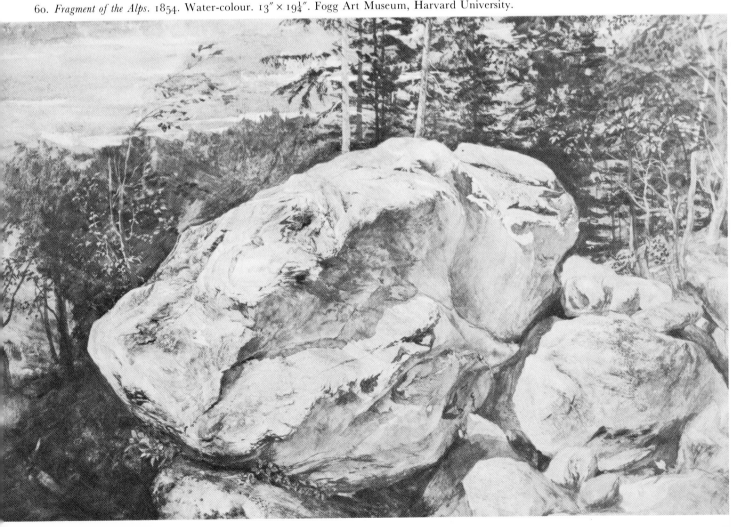

taken without some memories, at least, of emotional distress. In fact, much of this summer was understandably a time of disillusionment and sadness, a mood which led him to draw pessimistic conclusions from the renewed mountain studies represented by this boulder.

When he came to write about such subjects in *Modern Painters IV* it was in the context of a discussion that had turned from the high peaks of the Alps to a consideration of 'resultant forms', the precipices, banks, and stones that result from the breakdown of the central core of a mountain. In the final section on 'Stones' the macrocosm is seen reflected in the microcosm to complete his vision of the absolute harmony and unity of all natural forms.

There are no natural objects out of which more can be thus learned than out of stones. They seem to have been created especially to reward a patient observer. . . . For a stone, when it is examined, will be found a mountain in miniature. The fineness of Nature's work is so great, that into a single block, a foot or two in diameter, she can compress as many changes of form and structure, on a small scale, as she needs for her mountains on a large one; and taking moss for forests, and grains of crystal for crags, the surface of a stone . . . is more interesting than the surface of an ordinary hill; more fantastic in form and incomparably rich in colour.[17]

His drawings of stones show that he had found in them the same kinds of visual rhythms that he had discovered in the high peaks, and they may be seen as a further illustration of the universal presence of curvilinear beauty in nature. However, when we look further into Ruskin's chapter on this subject, it brings us to another aspect

61. *Study from Turner's Goldau.* 1855. Pencil and wash. $5\frac{1}{2}'' \times 8\frac{1}{2}''$. Ashmolean Museum, Oxford.

2nd drawing for plate 50. Vol 4. MP. 1855

of his later geological studies. He tells us that stones are the result of gigantic natural forces operating on the Alps, forces which one can study in miniature in the action of the small mountain stream carrying away tons of rock in a single year. Such a stream reveals the laws of change that create the visual rhythms of curvilinear beauty in all natural forms, but these laws also ensure that nothing in nature will endure. 'The hills, which, as compared with living beings, seem "everlasting" are, in truth, as perishing as they; its veins of flowing fountain weary the mountain heart, as the crimson pulse does ours . . . and it is but the lapse of the longer years of decay, which, in the sight of its Creator, distinguishes the mountain range from the moth and the worm.'[18]

This is a far cry from the optimism of *Modern Painters I*, where we read of 'the fiery peaks which lift up their Titan heads to heaven, saying, "I live forever!" '[19] In fact, Ruskin's art and geology were leading him to a spiritual crisis caused by his increasing inability to see nature as an eternal witness of divine solicitude for mankind. This new pessimism dominates the passage near the end of his chapter on stones, where he discusses his Turner water-colour, *The Valley of Goldau* (cf. Plate 61). He uses it to illustrate the forms resulting from the ruin of the mountains, which in this case are also associated with human tragedy, for the boulders in the foreground cover five villages destroyed in the Rossberg landslide of 1806. The rocks depicted by Turner are therefore sepulchral stones, and his drawing becomes a symbol of death, leading us on to the realization that 'it is cunning self-deception to see only beneficence in the natural creation.'[20]

The boulder that Ruskin drew at Chamouni may be understood to include this new awareness as one of the dimensions of its meaning, and as such it illustrates the way his mountain studies began to undermine the religious faith and optimism of his youth. In 1851 he had written to a friend, 'If only the Geologists would let me alone, I could do very well, but those dreadful Hammers! I hear the clink of them at the end of every cadence of the Bible verses.'[21]

More and more the spectacle of nature led him to ponder human mortality and suffering, so that there is anguish as well as beauty in the later mountain drawings (Plates 62 and frontispiece), and, in common with many others of his time whose faith had yielded before the onslaught of nineteenth-century science, Ruskin came to realize the importance of improving the social and material conditions of this life, with the result that he soon began to turn from the criticism of art to the criticism of society.

Nevertheless, the final chapters of *Modern Painters IV*, written in 1856, show that he still managed to retain his essential faith in the benevolent design of nature, for they open with the assertion that his examination of the Alps has shown that mountains are calculated for the delight, advantage, and teaching of men, since the most accidental shapes are governed by laws that produce forms of perpetual beauty. This leads him to consider in more detail 'what actual effect upon the human race has been produced by the generosity, or the instruction of the hills'.[22] Two chapters on 'The Mountain Gloom' and 'The Mountain Glory' are devoted to this theme, in the first of which he points out that men are not invariably good or happy in their mountain homes, for the most beautiful Alpine region may be inhabited by peasants doomed to a life of ignorance, suffering, and fear. However, this pessimistic note only serves to introduce the final, rapturous sermon where religion, art, and literature are all shown to have been inspired, at their best, by mountain influence.

In addition, Ruskin finds that the best 'practical ideal of life', combining 'domestic and military character', originated in the earlier history of the Swiss republics, when 'the liberty of Europe was first asserted, and the virtues of Christianity were best practised by a handful of mountain shepherds around the Lake of Lucerne',

who made this region 'a complete centre of the history of Europe in politics and religion as Venice is a centre of the history of art'.[23] He went on to show that the connection between the virtue of the people and the beauty of their country could be demonstrated with reference to the visual character of cities like Fribourg. Several pages are devoted to a description of the landscape around that city, and the way its buildings, 'with a peculiar carelessness and largeness in all their detail, harmonize with the outlawed loveliness of their country'.[24]

Here Ruskin returns to the theme, and reverses the verdict, of his earliest critical essay, 'The Poetry of Architecture' (see above, p. 33), where he had first discussed the way one can read the spirit of a people in their architecture and its relationship with nature. Of course, the same idea had been pursued in *The Seven Lamps of Architecture* and *The Stones of Venice*, but in the passages quoted above we see him beginning to re-examine, in the light of his later discoveries and accumulated knowledge, the problem that had started him on this long course of study. It seems that he now intended to write a history of the towns of Switzerland, illustrated with etchings made from his own drawings, and one of the chief reasons for the Swiss tour of 1854 had been to begin the research for this project. The plan was never realized, but it provided the motive for many of Ruskin's best drawings, made over the next twelve years during a series of Swiss tours, and there are scattered comments in his later writings that indicate the nature of the projected work.

In Ruskin's view, his study of the shape and history of the Swiss towns on the lower hills was an essential complement to the earlier studies of the high peaks. He still believed in the moral influence of nature on man, and he asserted that this influence was exerted to a large extent through historical associations inserted in the landscape by architecture. A landscape without buildings expressing the influence of nature on human life and history would be morally and aesthetically deficient, hence the need for an examination of the Swiss buildings to round out one's understanding of Alpine scenery. (This was also the reason for Ruskin's lack of interest in visiting North America, where the landscape could not be beautiful, since it was devoid of truly historical architecture.)

But if history was necessary for the full appreciation of landscape, the reverse was also true. History could not be comprehended rightly without careful reference to the moral influence of the landscape and the buildings in which its events took place, for it is here, as Ruskin had said in *The Seven Lamps of Architecture*, that one finds the most enduring basis for an understanding of the ideals and ambitions motivating the men of past ages. Of course, this conception of the moral and spiritual meaning of history placed Ruskin in conscious opposition to the outlook of an eminent nineteenth-century historian like H. T. Buckle (1821–62), whose scientific and evolutionary approach led him to account for the course of human events with reference to the purely material influence of environmental factors. Ruskin's model was his friend Carlyle, the only modern historian, he said, to show the motives and movements of men's minds, and perhaps the beginning of Carlyle's work on his *Frederick the Great* in 1853 had something to do with Ruskin's own historical project, for in this connection it is worth noting that at a later date he was to suggest that *Frederick* should be illustrated, like his own projected history, with views of the old castles and towns that had been the cradle of German life.

The Swiss-towns drawings can also be associated in style and subject-matter with Ruskin's last extensive study of the work of Turner. He was named an executor of the artist's estate after his death in 1851, but at the time he was busy with his work in Venice, and when Turner's next of kin began to contest the will, he took the opportunity to renounce his executorship. However, as soon as *The Stones of Venice*

62. (far left) *Mer de Glace, Chamonix. c.* 1860. Watercolour and gouache with pencil. $15\frac{1}{4}'' \times 12''$. The Whitworth Art Gallery, University of Manchester.

was out of the way, he turned his attention once more to the huge bequest of Turner's work in the National Gallery and offered to assist in the arrangement and display of the drawings. This work was begun in the autumn of 1856, although it is very probable that Ruskin made a preliminary examination of the drawings sometime between 1852 and 1856.

Ruskin's reaction to the bequest, even before he had seen it, was conditioned by the development of his own collection in the decade from 1842 to 1852. It has already been noted that he attached great importance to his acquisition of a number of Swiss subjects from 1842 onward, and after that he was always convinced of the superiority of these late mountain drawings by Turner. Then, when he thought that all Turner's works might be sold after the artist's death, he aimed a barrage of letters at his father from Venice, pleading to be allowed to buy all the mountain drawings that they could afford, especially those after 1841. When he subsequently studied the bequest he was chiefly interested in the Swiss subjects, and his initial selection of Turner sketches for exhibition was cast in the form of a tour from town to town along one of Ruskin's favourite travel routes through Switzerland. By 1856 his own Swiss-towns project had merged with a scheme to supplement Turner's drawings with his own sketches. Scenes that had been transformed into imaginative fantasies, like his own *St. Gothard*, were to be 'illustrated' by accurate topographical sketches for comparison with the Turner work, to clarify the artist's imaginative process. First sketches that were vague and tentative were to be 'realized' by drawings giving more detail of the original scene, in order to show the truthfulness in essentials that was characteristic of Turner's quick impressions. In both cases, Ruskin's own drawings were meant to provide realistic reference points, enabling the spectator to appreciate both the imaginative and the naturalistic aspects of Turner's art.

The Swiss-towns project, with its historical and Turnerian motivation, enabled Ruskin to revisit and reinterpret the scenes that he had first described with such joy and enthusiasm during the Swiss tour of 1835, but he was no longer a rather naïve and self-satisfied young amateur cultivating a pleasant talent. He was a bitter and saddened individual, inflicted with deep emotional wounds, struggling to redirect his life by travelling again along paths first explored in happier days. At the same time he was suffering from intense excitement caused by seeing the whole of Turner's mind and achievement unfolded before him, and from a constant sense of his own artistic inferiority as he drew at the master's sites. The result was a series of remarkably expressive drawings, showing a marked change of style, and containing much of his best work.

At this point Ruskin began to base his methods much more directly on Turner than ever before. Previously his regular way of sketching from nature had depended on the guidance of a succession of drawing masters whose work showed different degrees of familiarity with Turner. Prout had adopted the drawing style of the early Turner and Girtin; Fielding imitated some of Turner's effects of space and atmosphere; Roberts employed the more free and sweeping pencil style of Turner's maturity, and Harding based his methods on the *Liber Studiorum* and Turner's watercolours of about 1820. Ruskin's development shows him progressing from one degree of Turnerism to another until finally, with his study of the bequest, he began to absorb Turner's methods into his own art from the source.

Among the thousands of works in the Turner bequest, Ruskin was particularly interested in the sketches that he described as 'delight drawings'. These were outlines taken directly from nature, and coloured from memory, 'for Turner's own pleasure, in remembrance of scenes or effects that interested him; or else with a view to future use, but not finished beyond the point necessary to secure such remembrance

or service, and not intended for sale or sight'.[25] They were chiefly water-colour sketches from the late thirties or forties, especially of Switzerland, like the sketch for *The St. Gothard* in Ruskin's own collection (Plate 31). It was from such works that he chose the first hundred for exhibition, and he always placed them at the centre of his later discussions of Turner's drawings. In large part this was because they seemed to provide the best models for the realization of his own artistic aims, which could have been characterized at that time in the words quoted above, used by Ruskin to describe certain of Turner's sketches: 'delight drawings'. Consequently, the style of his Swiss-towns work shows a direct response to this aspect of Turner's art.

A sketch of Lucerne from 1846 gives an example of how Ruskin treated this type of subject in the earlier *Liber Studiorum* style, with washes of tone over a pen-and-pencil outline, but the effect is relatively flat and uncertain (Plate 63). This should be compared with the more unified and convincing atmosphere of a sketch of Fribourg from 1856, where varied and broken touches of colour with opaque white are touched over sketchy pencil work on blue paper (Plate 64). Here we see him using colour mixed with Chinese white on toned paper, in an attempt to achieve the kinds of impressionistic effect in Turner's water-colours for the *Rivers of France* engravings (Plate 65). Ruskin had long felt particular admiration for these sketches, and he always regretted having missed the opportunity to acquire the whole series from Turner years before.[26] He owned several examples, ranked them with the Swiss sketches as Turner's best kind of work, and recommended their technique highly when he wrote the *Elements of Drawing* in 1857.

After 1858, the year Ruskin finished his examination and arrangement of the Turner bequest, his drawings lose the last traces of the firm line, even tone, and regular shapes that derived from his earlier preference for flat and decorative patterns. Colour is applied in drier, more broken touches, and opaque white is used liberally for glowing patches of light softly blended with colour (Plate 66). Architectural forms become less rectilinear, and a preference is shown for irregular masses with broken planes and contours of a highly picturesque character (Plate 67). Deliberately

63. *Lucerne*. 1846. Pen, pencil and water-colour. $4\frac{3}{4}'' \times 7''$. Bembridge School, Isle of Wight.

64. (above) *Fribourg*. 1856.
Pencil and water-colour.
$3\frac{1}{4}'' \times 6\frac{5}{8}''$. Bembridge
School, Isle of Wight.
65. J. M. W. Turner. *Blois*.
1830. Water-colour. $5\frac{1}{4}'' \times$
$7\frac{1}{8}''$. Ashmolean Museum,
Oxford.

66. (above) *The Walls of Lucerne*. *c.* 1866. Water-colour. $13\frac{3}{4}'' \times 19\frac{1}{8}''$. Bembridge School, Isle of Wight.
67. *Bremgarten*. 1860. Pencil, pen and water-colour. $4\frac{7}{8}'' \times 6\frac{3}{4}''$. Bembridge School, Isle of Wight.

broken and hesitant accents with pen and pencil further help towards unity of form, colour, and atmosphere (Plate 78). By this means the sketches from 1858 to 1866 achieved, under the inspiration of Turner, an impressionistic effect where the curvilinear rhythms that had first provided a method of achieving harmony of form are supplemented by a new understanding of the unifying function of light and colour.

Despite the obvious debt to Turner, this phase of Ruskin's art remains a very personal and original achievement. These fragmented visual records often ignore conventional methods of composition to a far greater extent than the sketches of Turner himself. In Ruskin's drawings the horizon may drop out of sight as he adopts unusual and un-picturesque angles of vision. Landscape planes, *repoussoirs*, and centres of interest may be omitted in arrangements of almost oriental suggestiveness and irregularity. The final result may be a broken patchwork of crumbling walls and roofs, as in the remarkable *Fribourg* in the British Museum (Plate 68), or a swirl of hills and trees with a half hidden village (Plate 69), or a wandering trail of details, textures, and colours (Plate 66). Such works exist side by side with more conventional kinds, but they show the extent to which Ruskin could give up the attempt to grasp a scene as a carefully composed whole, and how the resultant freedom 'allows him to include an incredible amount of detail without dryness of formality'.[27]

The inclusion of so much Pre-Raphaelite detail gives these works another individual trait, for there is nothing in Turner like the manner in which minutely

68. *Fribourg*. 1859. Pen and water-colour. $8\frac{3}{4}'' \times 11\frac{3}{4}''$. The British Museum.

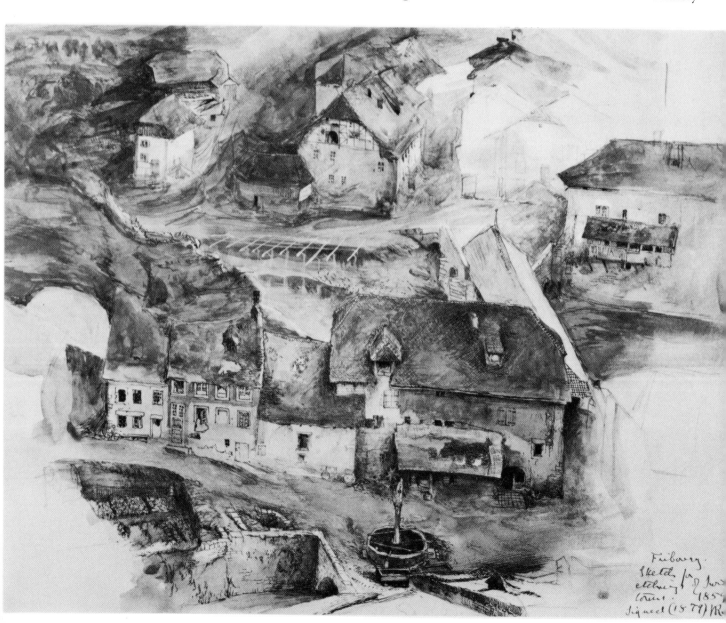

detailed colour and form may suddenly start out of blank paper, or materialize in the midst of vaguely pencilled currents moving across the page, the direction and degree of finish always seeming to be governed by emotion and instinct rather than pictorial considerations. It is a feature of Ruskin's work that shows him trying to achieve in his own practice some kind of reconciliation between his apparently contradictory enthusiasms for Turnerian impressionism and Pre-Raphaelite realism. This was a feature of his criticism that had always puzzled his readers, and the question was particularly acute at this time, owing to his simultaneous involvement with the Turner bequest and his defence of the Pre-Raphaelites. In many works he was able to create an expressive tension between these two styles, but he was to become less willing or able to hold them in balance as he moved toward the more personal manner of his later years, when drawings tend to be either minute studies of small objects, or sketchy impressions of larger forms.

Similar considerations affected the development of Ruskin's draughtsmanship in the 1850s and afterwards, where we can also see in more detail the varied interests that gave his works their individuality. His drawing style had been loosening since 1845, especially when he became interested in indicating mass and atmosphere in his renderings of Gothic architecture in 1848. The related etchings he had made for *The Seven Lamps of Architecture* contained a marked element of what he called 'Rembrantism', and when he wrote *The Elements of Drawing*, Rembrandt's etchings were highly recommended as examples of how to achieve rapid effects of light and shade with line. This was a style that he continued to use and develop, especially in his

69. *Lucerne. c.* 1856. Pencil and water-colour. 8″ × 10½″. Bembridge School, Isle of Wight.

94

70. *Kempten*. 1859. Pen and pencil. 5⅛″ × 7⅞″. Bembridge School, Isle of Wight.

later works (Plate 88), but when he studied the Turner bequest, he also became aware of the pencil style used by Turner in his later sketch-books, and this added another kind of graphic impressionism to his repertoire (Plate 70).

At the same time, he retained his old habit of reworking pencil sketches with a pen or sharp pencil point, and between 1859 and 1866 he made a series of elaborately detailed line-drawings in this way, with winding spatial recession of a type often seen in Turner compositions. Several works of this variety were engraved for *Modern Painters*, in a context that makes it possible to relate them to another graphic model, the engravings of Dürer. Ruskin's interest in this artist had been much stimulated by a visit to Germany in 1859, which led him to treat the German master in a chapter in *Modern Painters V*. This was illustrated with an engraving after one of his own drawings of Nuremberg, to show the character of the towns and landscapes found in Dürer's prints,[28] and an interest in Düreresque qualities of detail and picturesque form can be traced in a number of the Swiss-towns drawings (Plate 67). Earlier, Ruskin had written in *The Elements of Drawing* that Dürer provided the highest standard of precision in outline and modelling, but the student was urged to aim for something *between* Rembrandt and Dürer, advice that illustrates again Ruskin's consciousness of the need to reconcile realism of impression with realism of detail in his own practice.[29]

In spite of his attention to the analysis of visual experience, the drawings of Swiss towns show that Ruskin continued to be intensely concerned with the *meaning* of his subjects. He still emphasized the time-worn aspect of buildings that seem to ride easily on the surging rhythms of the earth, settling into the protective hollows or rising up on the ridges with defensive towers and old walls 'that have long been washed by the passing waves of humanity',[30] revealing by historical association, as well as by visual character, the way Swiss history had been moulded by the spirit of mountain scenery. This is the old concern for the picturesque, with its combination of visual delight and associated ideas, but now the moral and expressive meaning of his subjects began to take on a tragic tone. His easy enjoyment of visual effects was now likely to be interrupted by pangs of guilt, as we see from a diary entry made at Amiens in 1854 after an evening walk along the Somme.

All exquisitely picturesque, and as miserable as picturesque. We delight in seeing the figures in the boats pushing them about the bits of blue water in Prout's drawings, but, as I looked today at the unhealthy face and melancholy, apathetic mien of the man in the boat, pushing his load of peats along the ditch, and of the people, men and women, who sat spinning gloomily in the picturesque cottages, I could not help feeling how many suffering persons must pay for my picturesque subject, and my happy walk.[31]

He began to wonder if the old-fashioned enthusiast for the conventional picturesque, as he had once been, should not be regarded as a monster in human form, and it became difficult for him to recapture the spirit of *The Seven Lamps of Architecture*, with its celebration of the heroic human qualities which historical associations confer on architecture. It was his heightened consciousness of the dark side of the human condition that added a new dimension of meaning to his Swiss-towns project, and this helps to explain the expressive intensity of so many of these drawings. They were produced during a crisis that had led him to find horror in mountain beauty and suffering in the 'picturesque', so that his passion for nature and art had become mixed with a tormenting need to give, and receive, the consolation of human sympathy.

The awakening of social conscience that accompanied these thoughts and feelings led to some very practical action on Ruskin's part when he returned from Switzerland to London in the autumn of 1854. He began to teach drawing in the Working Men's College founded by Frederick Denison Maurice and other leaders of the Christian Socialist movement. This led him to review the course of his own development as an amateur artist, in order to spell out in detail how his view of the aims and methods of art education for the masses differed from the teaching of his own drawing masters. Some of his conclusions were incorporated in the early chapters of *Modern Painters IV* in 1856, and in the following year the subject was treated comprehensively in *The Elements of Drawing*. In these pages we see a strange mixture: there is vehement opposition, yet acknowledgements of his indebtedness to his Water-Colour Society teachers together with emphasis on the need for a complete reform of art teaching.

As might be expected, the goals that Ruskin envisaged for his students were drawn from aspects of his own practice after 1845. First of all, they were to draw only landscape, for he did not think that figures 'could be drawn to any good purpose by amateurs'.[32] Then he recommends four ways of working from nature, depending on the time available, and the nature of the subject. The first is the completely detailed study in pen and monochrome wash, presumably like his 1847 drawing *Coast Scene near Dunbar* (Plate 51). Finished drawings in colour are said to be too difficult for most amateurs, whose use of colour should never aim at more than 'pleasant helps to memory, or useful and suggestive sketches',[33] a rule that Ruskin himself broke only occasionally. Another method, used when time is short or the subject complicated, involves sketching the general effect of a scene quickly with soft pencil and wash, giving the rest of the time to 'a Düreresque expression of the details'.[34] Many of Ruskin's works from this period show such a combination of general impression with detailed passages (Plate 71). Thirdly, when the amateur has 'neither time for careful study nor for Düreresque detail', [35] he is told to sketch outlines and shadows vigorously with pen and wash, in the *Liber Studiorum* style that Ruskin had adopted in 1845 (Plate 47); and finally, as an afterthought, he recommends making memoranda of the shapes of shadows.

These are all ways of making direct studies from nature, not methods of composing pictures, for it is the central point of Ruskin's teaching that the amateur must concentrate his efforts on learning to make useful records, and to sharpen his perception of beauty in the natural world. He need never try to invent a composition,

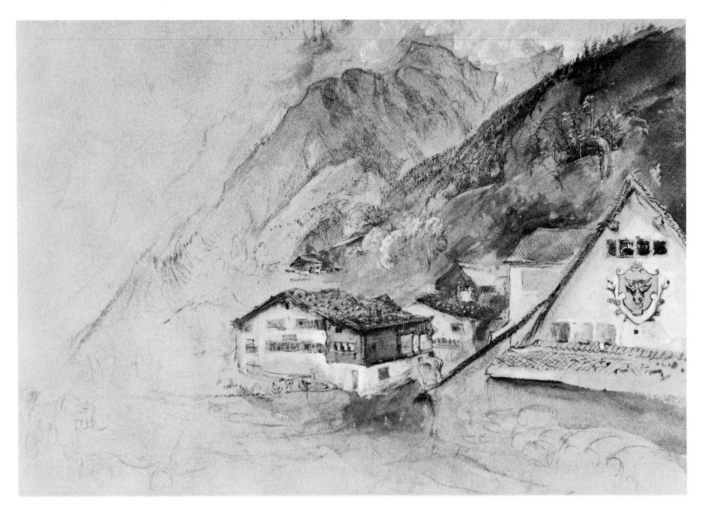

71. *Houses and Mountainside at Altdorf.* 1861. Water-colour. $14'' \times 20\frac{1}{2}''$. The Harry Elkins Widener Collection. By permission of the Harvard College Library.

and this makes *The Elements of Drawing* a complete denial of the old 'picturesque' point of view, where nature was always conceived within the framework of generalized and ideal compositions. This was the outcome of the Fontainebleau vision of 1842 that made him reject the usual kind of compromise between naturalism and the picturesque found in John Varley and his followers, and he was even less sympathetic with the kind of sketchy generalization practiced by drawing masters like J. D. Harding. Pages are devoted to demonstrating that Harding's methods teach a technique based on imitative mannerisms rather than knowledge of nature. At this point his comments remind the reader of criticisms of the sketching methods of the Rev. William Gilpin by earlier reformers like W. M. Craig; and in exactly the same way Ruskin was objecting to the careless attempt by drawing masters to teach amateurs a sketchy manner before they had learned accurate drawing. The only difference is that in Craig's time the admired master of sketchy effect had been Gainsborough, while in Ruskin's time it was Turner.

To correct this tendency, the aim of Ruskin's course of study for the amateur was uncompromising naturalism. The student's first essay in drawing was to trace exactly the pattern of tree branches seen against the sky, an echo of Ruskin's Fontainebleau experience. His second was to copy the gradations of light and shade that give roundness to the form of a small stone, and in Ruskin's assertion that, 'if you can draw that stone you can draw anything',[36] we see a connection with his own drawings of stones at Chamouni. ('A stone, when it is examined, will be found a mountain in miniature.') As he undertakes these tasks the student must strive to recover the

'innocence of the eye' that will enable him to see the world simply as 'an arrangement of patches of different colours variously shaded',[37] a famous injunction that owes much to Ruskin's study of Turner and the Pre-Raphaelites; but it can also be seen as a reflection of the scientific ideas and analytic techniques that formed such an important part of the water-colour tradition in which Ruskin was first trained.

Note especially Ruskin's suggestion about the way the amateur can use water-colour to translate the visual experience of the innocent eye into a kind of mosaic of hues and tones carefully copied from nature.[38] This technique is exactly comparable with that found in the early works of Girtin and Turner, a method that had been simplified almost out of recognition in the instruction of drawing masters like Varley, Cox, and Fielding. Ruskin returned to their original source of inspiration, and found an almost pointillist kind of impressionism that he felt was applicable to the needs of the amateur. His own technique tended to be freer and more imaginative, but his students were never to attempt to go further than his kind of exact imitation in the handling of colour, although they should, of course, learn to *appreciate* the colour-istic genius of artists like Turner and Veronese.

Both colour and composition, in their higher reaches, were subjects that Ruskin felt to be beyond the ordinary amateur, but he should 'know what they mean, and look for and enjoy them in the art of others'.[39] In this connection he introduces some comments that contrast strikingly with his exhortations to the exact imitation of nature, for they show that the basis of this appreciation included an aestheticism very similar to the love of abstract beauty found among old-fashioned connoisseurs of the picturesque. For example, his discussion of colour contains the following note on the use of white: 'When white is well managed, it ought to be strangely delicious,—tender as well as bright,—like inlaid mother of pearl, or white roses washed in milk. The eye ought to seek it for rest, brilliant though it may be; and to feel it as a space of strange, heavenly paleness in the midst of the flushing of the colours.'[40]

This kind of precious tonal harmony could hardly result from the imitative technique recommended for his students, although it might well be found in some of Ruskin's own drawings (Plate 66). Similarly, in his chapter on composition all the emphasis is placed on an extremely refined and delicate perception of abstract harmonies existing independently of representational form. This discussion is entirely in the tradition established by Varley, with special attention to centres of interest, contrast, repetition of accents, and so forth, but it centres finally on Ruskin's special concern for beauty of curvilinear design, as governed by what he calls the laws of radiation, consistency, and inter-change.

However, it must be emphasized again that Ruskin forbids his students any ambition to create this kind of colouristic and compositional beauty in their own work. His own experience as an amateur artist had led him to believe that the problems of reconciling imitation and beauty, truth and imagination, could be resolved only by an artist of genius who has devoted his life to creative work. The amateur must appreciate beauty in art, but be satisfied in his own work with the imitation of nature. Of course, Ruskin could hardly think of himself as a typical amateur, and so we often find him departing from his rule, to experiment with the creation of aesthetic harmonies like those he holds up for admiration only, in the pages of *The Elements of Drawing*.

5. The Late Drawings (1860–1887)

1. The year 1860 saw the publication of the final volume of *Modern Painters* in which Ruskin tried to complete his long discussion of the relationship between art and nature with a characteristically wide variety of examples, ranging from Venetian painting to cloud formations and leaf structure. The unifying links which he sought between these subjects could still be discerned in his own mind through the old vision of a law of beauty governing the whole of creation, but he found it increasingly difficult to sustain and communicate this vision as his growing consciousness of social evils began to undermine his faith and peace of mind. The same year saw the publication of *Unto this Last*, and from now on his activities were dominated by a new sense of mission as a critic and reformer of society. He had lost his old delight in nature, and had acquired a sense of guilt about the private enjoyment of art, but in spite of the radical change in his interests he continued to draw. In fact, he felt a deep need for the relief that this activity could give him from the mental excitement of the fight against bitter opposition to his radical ideas among family, friends, and the public. Consequently, his output of drawings in the second half of his life was as high as, if not higher than, the first, but there was a vital difference in the fact that he no longer drew in the old way, as a means of defining and communicating what he considered basic truths about art and nature. That work of discovery was finished. For example, the major sessions of intensive drawing in this period were at Abbeville and Verona in 1868–9, and at Venice in 1876–7. In the first instance he was returning to the old architectural interests of *The Seven Lamps of Architecture*, and in the second his aim was the preparation of a new edition of *The Stones of Venice*. On both occasions he was escaping into the past, from personal problems and from the difficulties caused by his teaching and reforming activities. Indeed, it is characteristic of all his late drawings that they were made in the hope of regaining self-confidence and mental balance through the re-examination of subjects that had earlier provided happiness and security. That is why the work of this period has an intensified personal quality in its purpose, development, and style, which provides a striking contrast with the earlier drawings.

Symptoms of this change can be found by examining Ruskin's later methods of draughtsmanship. For a long time he had shown a liking for a firm line to trace the contours of picturesque buildings and define the curvilinear rhythms of the landscape, rhythms that were for him an objective link between the divine impulse in nature and human ideas of beauty. But in his last period he no longer makes bold and precise statements of linear truths. Instead, he tends to suggest his impressions with hesitant touches, or by means of a wild scribbling calligraphy which builds up flickering effects of chiaroscuro and colour (Plates 96, 102). More than ever before in Ruskin's work we feel his concern to record not only the sensations of the eye, but their reactions on the mind, sympathies, and emotions of the artist. Furthermore, we feel that the broken and ragged accents in these drawings are a direct expression of his loss of confidence in the continuity of divine action in nature, and his ability to perceive it.

Another feature of the later drawings is the striking contrast between these expressive sketches and the minutely detailed studies of feathers, shells, gems, and other objects related to his minerological and biological studies (Plates 72, 73, 74). Earlier essays in minute imitation had usually taken place within the unifying context of a landscape sketch, but now it is as if the ability to maintain this balance between detail and impression had broken down, so that the two kinds of vision have to be adopted separately, with the still-lifes showing a desperate attempt to achieve total realization of a small fragment of nature by means of the most intense analysis. They remind us of his advice in *The Elements of Drawing* that students should begin by drawing a stone, avoiding dashes or blots or vigorous lines, and try only to produce 'the plain, unaffected, and finished tranquillity of the thing before you'.[1] This must have been Ruskin's own aim in the later still-lifes, but the effect is not entirely tranquil. His subjects often seem to tremble with an alien and sometimes menacing life that imbues them with personal significance (Plate 75).

Both styles in the later work may be regarded as expressions of a feeling of alienation from nature, and interpretation can be extended further to a consideration of their relationship with Ruskin's mental health. R. H. Wilenski was the first to document the case for regarding Ruskin as a mental invalid all his life.[2] He charted the rhythmic swings between elation and depression, marking him as the victim of a manic-depressive species of illness which became much more acute around 1860, and led finally to the first serious breakdown, in 1878. One can find examples of drawings with abnormal tendencies as far back as 1844, but after 1860 there are obvious connections between periods of manic excitement and the most expressionistic sketches; between periods of depression and the meticulously detailed still-lifes.

In his literary work, too, there are well-known instances of the way he came to project his own morbid condition into nature. The lectures on 'The Storm Cloud of the Nineteenth Century', given in 1884, described what he claimed was a new form of cloud that blew out of the south-west on a trembling 'plague of wind', darkening the sky with poisonous vapour.[3] His 'proof' for its growing incidence since 1870 con-

72. *Coral Oysters.* · 1868. Water-colour. $5\frac{1}{2}'' \times 8''$. Fogg Art Museum, Harvard University.

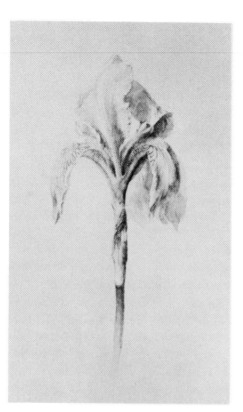

73. *Iris Florentina*. 1871. Water-colour. 11″ × 7″. Ashmolean Museum, Oxford.

74. (far right) *Pheasant's Feather, Magnified*. 1879. Water-colour. 6″ × 9¾″. Fogg Art Museum, Harvard University.

sisted of drawings which were engraved to illustrate the printed lectures (Plate 96), and excerpts from his diaries, where we can indeed find that day after day he complained of wind and darkness; but there are also hints in these entries that he was not able to persuade others to see this phenomenon, and on one occasion he exclaimed, 'The bad weather is the very Devil in visible form to me.'[4]

The storm cloud was an obsession, 'a confusion of his own altered response to nature with an imagined decline in nature herself'.[5] At the same time a strange gloom descends on many of his drawings as shadows darken and spread, and the trembling, hurried flow of the broken pencil accents comes to suggest a graphic expression of the storm-cloud delusion (Plate 76).

These are far from being insane drawings, but their neurotic sensitivity and vehemence may be compared with similar qualities in the work of artists like Van Gogh, Munch, and Ensor, who also reached a pitch of mental excitement that enabled them

75. *Lily's Dress Necklace*. 1876. Pencil. 5¼″ × 7¼″. Bembridge School, Isle of Wight.

to break through the materialistic conventions of their age to express the irrational forces of modern life.

2. From 1860 to 1866 Ruskin continued to draw for his Swiss-towns project, but with a declining sense of purpose, for he had decided to concentrate his energies on the study of political economy. In the summer of 1860 he went abroad for a rest, after the production of *Modern Painters V*, and travelled in Switzerland, but he seems to have drawn little, working instead on the essays that were shortly to be published as *Unto this Last*. He soon felt himself slipping into an ever deepening mood of depression, which was aggravated the following year as he become deeply worried about the progress of his new kind of literary work, and increasingly agitated about the course of a new love affair with the young girl named Rose la Touche. His parents disapproved strongly of both preoccupations and relations with them became very strained. Late in 1861 he escaped to Switzerland again, and under the influence of the mountains recovered some of his delight in drawing, as he worked on a series of splendidly free sketches in the Bonneville region, including a fine drawing of an old bridge (Plate 77), and a panoramic view from above Bonneville (Plate 78). These are in the style that had been developed around 1859, with free underdrawing on tinted paper, blotted touches of water-colour with opaque white for the high-lights, and some accents in pen. Their soft and vibrant atmosphere creates a unity in depth that shows him to be completely free of his old tendency to organize his views as two-dimensional patterns.

A number of drawings were also begun in November at Lucerne, and this work, together with other activities, kept him busy until the next month, when he showed his growing sense of estrangement from his home by refusing to return to London until after Christmas. Within a few months he was back in Switzerland, and in August he recorded in his diary a decision to reject the domination of his parents once and for all. 'Resolve to have some more Turners, and if I live, some of my own way at last. Stay here accordingly.'[6] After that, he settled at Mornex near Geneva, and stayed there alone for nearly two years, during what he described later as 'the time of the great sadness'.[7]

At the beginning of his residence at Mornex Ruskin seems to have drawn very

76. *Cloud Study*. 1880. Water-colour. $8\frac{1}{4}'' \times 15\frac{1}{8}''$. Education Trust, Brantwood, Coniston.

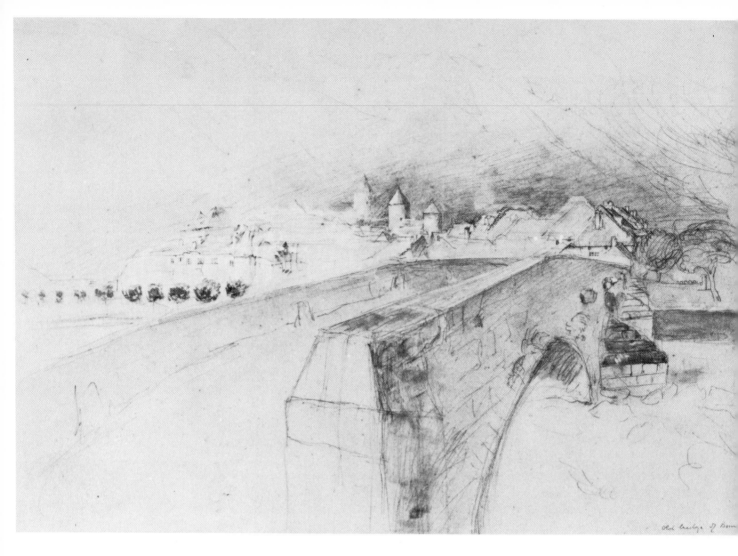

77. *Old Bridge at Bonneville. c.*
1861. Pencil, wash, and opaque
white. 13½″ × 19½″. Bembridge
School, Isle of Wight.

little, again concentrating on political economy and suffering from deep depression, but toward the end of the year another swing back towards elation took place. During the summer of 1863 he made extravagant plans to build residences at Chamouni and Bonneville, and made a sketching tour in northern Switzerland, visiting Lauffenbourg (a Turner subject) and two of the places that were to figure in his Swiss-towns project, Schaffhausen and Baden. At Lauffenbourg he made some free and excited sketches that look forward to the most expressionistic kind of late drawing (Plate 79), and at Baden he began work on one of the most impressive products of his studies of Swiss towns, a large view of the city, now lost, except for preliminary sketches (Plate 80), made on numerous sketchbook pages joined together.[8]

These activities came near the end of his exile in Switzerland, for his father was ailing, and in December of 1863 he returned to London to be with him until his death in March of the following year. For the next two years he worked hard at political economy and drew very little, but in 1866 he was back in Switzerland for a holiday and drew at Lucerne again. The two studies, *The Walls of Lucerne* and the *Kapellbrücke* (Plates 66, 81), which probably date from this time, are virtually the last of the drawings made for the projected history of Swiss towns.

In 1867 the long affair with Rose la Touche reached a crisis, as she refused either to accept Ruskin's proposal of marriage or to end his hopes, so that for a year he was unable to do much serious work. For Ruskin it was a winter of black skies and wild winds, as he laboured over numerous small drawings of flowers, shells, birds, and feathers, fighting all the time against melancholy and suffering from menacing dreams.

Early in 1868 he was again refused by Rose, but luckily his American friend

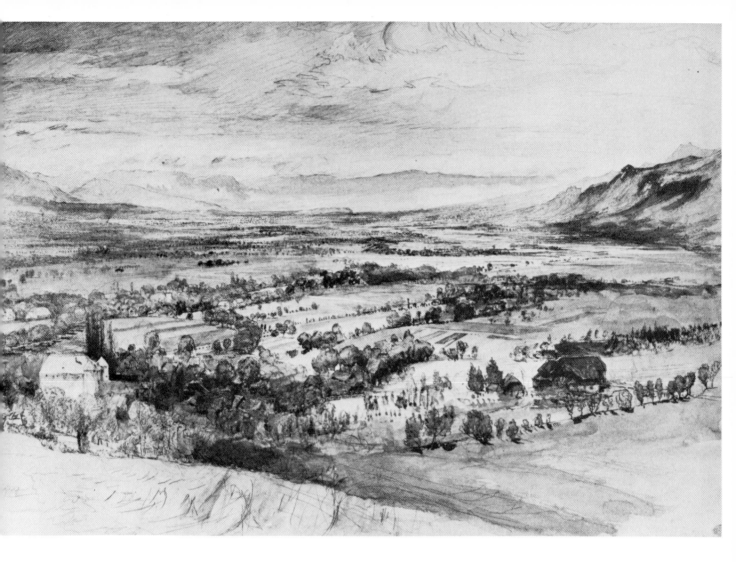

iew from the base of the Brezon, above Bonneville. 1862. Water-colour. $13\frac{9}{16}'' \times 20\frac{1}{8}''$. Bembridge School, Isle of Wight.

auffenbourg. 1863. Pencil, pen and water-colour. $5\frac{3}{4}'' \times 14''$. Education Trust, Brantwood, Coniston.

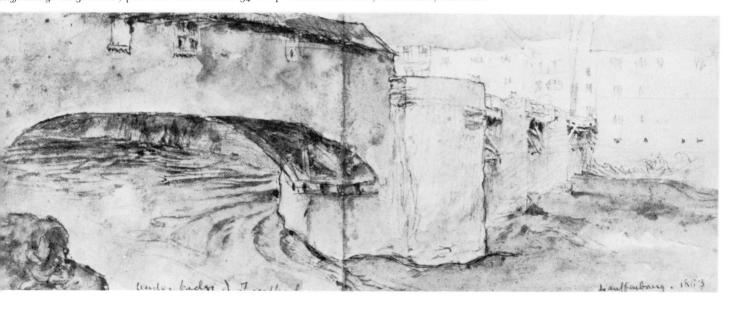

Charles Eliot Norton arrived in England at this time of emotional disaster, and his presence diverted Ruskin's attention to his old architectural interests. He had first met Norton in Switzerland in 1856, and was much attracted to this young intellectual from New England who shared his interest in the relationship between art and history. Their friendship was sustained by a voluminous correspondence, punctuated by Norton's frequent visits to Europe, until the end of Ruskin's life. It was natural for Norton to ask his friend about buying Turner drawings and other aspects of his collecting activities, and soon this advice came to be illustrated with loans of items from Ruskin's own collection. Included were examples of Ruskin's drawings, and Norton admired them so much that in 1858 he received as a gift the large water-colour called *A Fragment of the Alps* (Plate 60). From that time onward Ruskin sent parcel after parcel of his sketches to Massachusetts, apparently in response to frequent urging and continuous praise, for Norton valued them as expressions of a vivid artistic temperament. But it was also Norton's conviction that they represented the most enduring aspect of his friend's work, and when Ruskin turned to social and economic questions he shared the belief of many others that this change of direction was a mistake. As he explained in his letters, he urged him to draw, because 'Your influence will be made deeper, more permanent, and more helpful by patient work of this kind, than by your impassioned and impatient appeal to men who will scoff at your words.'[9] Furthermore, he was concerned to help Ruskin avoid the excitement of controversy that seemed so dangerous to his mental health, and he acted on his belief that drawing was restful and steadying for his friend. In his journal for 1872 he wrote, 'I use whatever power I have with him to keep him steadily and busily at his work',[10] and in a letter to Ruskin he said, 'I am like one of the bells in the old nursery rhyme, always dinning the same tune in your ear. Stick close to your art.'[11]

Norton's influence did much to encourage the retrospective spirit of Ruskin's art in these years, something that begins to be evident during Ruskin's seven weeks' stay at Abbeville in 1868, when he made a linear drawing of the town square in the

80. *Baden, Switzerland.* 1863. Pencil, pen and water-colour. $16\frac{1}{2}'' \times 13\frac{3}{8}''$. Education Trust, Brantwood, Coniston.

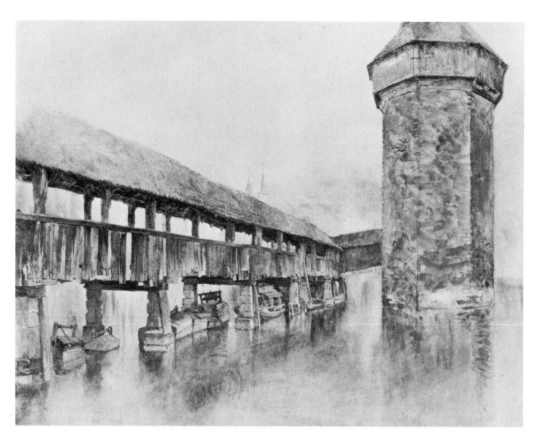

81. *Kapellbrücke, Lucerne. c.* 1866. Water-colour. $7\frac{1}{4}'' \times 11\frac{1}{2}''$. Ashmolean Museum, Oxford.

82. (below) *Market Place, Abbeville.* 1868. Pencil. $14'' \times 20''$. Ashmolean Museum, Oxford.

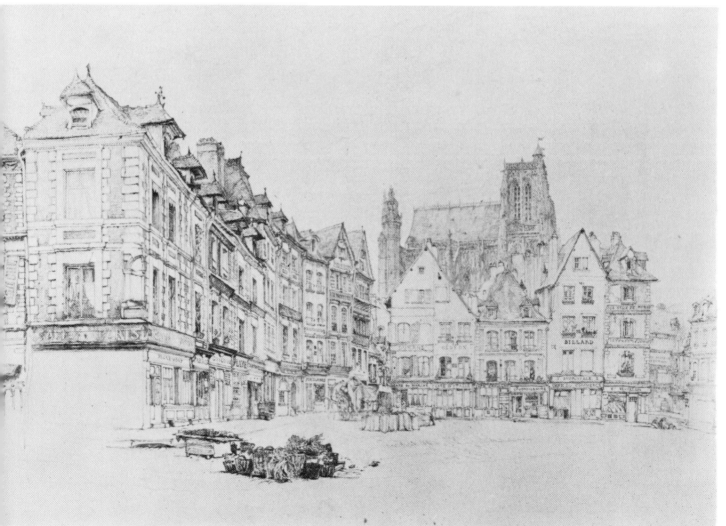

spirit of one of his boyhood heroes, Samuel Prout (Plate 82). The rest of his work there centred on the church of St. Wulfran, and culminated in a highly finished water-colour also recalling Prout in the appetite that it shows for all the picturesque details of the building (Plate 83). This was a subject that carried his memory back to his earliest travels, and to feelings that he later recalled with gladness in the pages of his autobiography.

My most intense happinesses have of course been among the mountains. But for cheerful, unalloyed, unwearying pleasure, the getting in sight of Abbeville on a fine summer afternoon, jumping out in the courtyard of the Hotel de l'Europe, and rushing down the street to see St. Wulfran again before the sun was off the towers, are things to cherish the past for,—to the end.[12]

Ruskin then travelled to Venice and Verona in 1869, to revisit the monuments that he had discussed in *The Stones of Venice*, especially the Castelbarco tomb and the tomb of the Scaligers at Verona. During his stay of over three months he made many sketches, and employed one of his former pupils at the Working Men's College, J. W. Bunney, to make coloured drawings of entire buildings, while he concentrated on details that required, he said, his advanced judgement to be accurately represented. The letters he wrote to his mother show him to have been in a high state of excitement, complaining 'there's just too much everywhere, like having illuminated missals laid open before one in a long row', then exulting that he 'never did so much work in a given time and all of it good', and finally worrying that 'the great difficulty is not to over-excite myself or do too much, all the more difficult because my thoughts of both life and death are not too cheerful.'[13]

A view of the Piazza dei Signori, executed in a sketchy version of the Prout-like linear style that he had used at Abbeville (Plate 84), illustrates the rather gloomy tonality of Ruskin's drawings at this time. Grey shadows, perhaps inspired by photography, and accumulated detail, give the forms a rather dark silhouette on the page,

83. *St. Wulfran, Abbeville.* 1868. Pencil and water-colour. $13\frac{1}{2}'' \times 19\frac{3}{4}''$. Bembridge School, Isle of Wight.

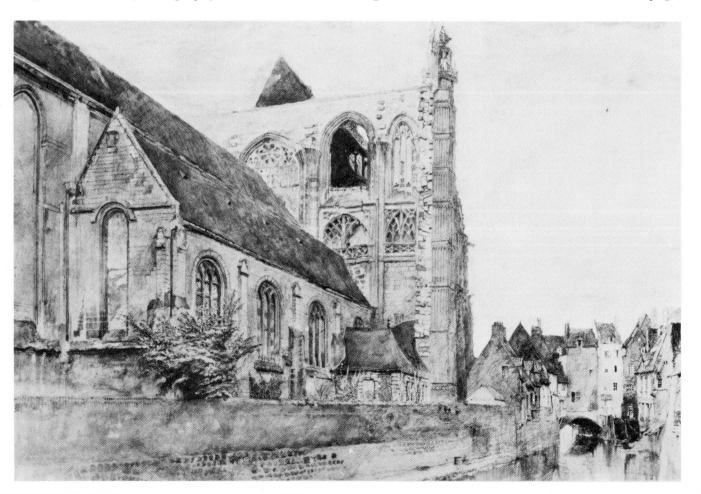

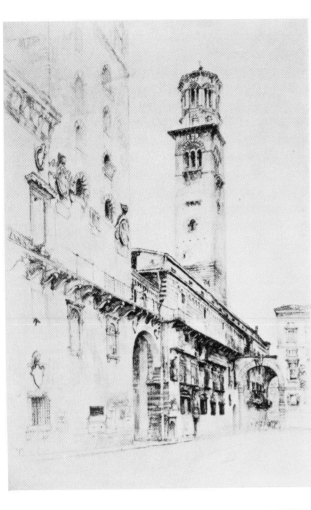

84. *Piazza dei Signori, Verona*. 1869.
Pencil and wash. 13″ × 19″. Ash-
molean Museum, Oxford.

85. (below) *Griffin at Verona*. 1869. Water-colour. $8\frac{1}{4}″ \times 13\frac{3}{4}″$. Ashmolean
Museum, Oxford.

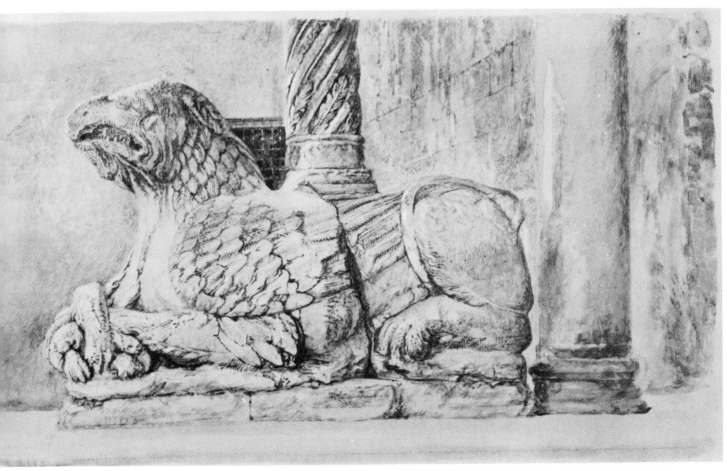

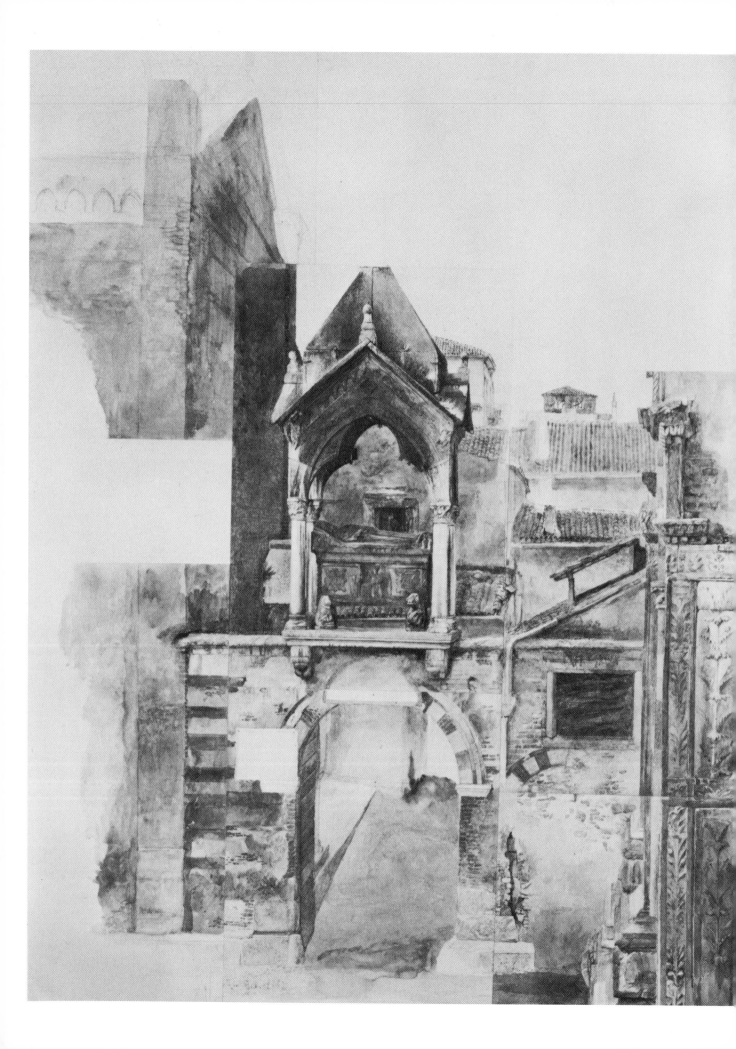

with the effect of a grey sunless day. Also, one notes a certain shakiness in the draughts-manship, as if hand and eye were not co-operating in the usual way as the artist made a specially intense effort to achieve photographic accuracy. A letter mentions the work involved in these Verona drawings. 'I was a quarter of an hour yesterday vainly trying to draw a fold of Can Grande's mantle.'[14]

Similar pains were taken with one of his most impressive works at Verona, a water-colour of a griffin before the door of the cathedral, painted in warm tones of orange, yellow, and grey (Plate 85). The hesitant touches of the brush are charged with feeling, although the expressive effect is achieved in a way entirely different from that used for an earlier example of a carefully finished water-colour, the *Fragment of the Alps* (Plate 60), where linear design dominates and colour tends to follow the flowing contours. Also painted in the manner of the griffin is the most ambitious work of this series, a large view of the Castelbarco Tomb, pieced together from numerous sketch-book pages (Plate 86). The accidental and collage-like pattern, caused by the differing degrees of finish from page to page, makes this drawing, an example of Ruskin's fragmented vision, particularly congenial to modern taste.

3. While he was working at Verona Ruskin received the invitation from Oxford to become its first Slade Professor of Fine Art. He accepted, returned to England in August, and began to prepare his lectures; but his diary recorded many dreams, and his mind was dominated by thoughts of Rose la Touche. Even his inaugural lecture, given in February 1870, had passages that referred indirectly to her, and many of the following lectures were intensely personal in tone, especially in the way he took his audience to be composed of young men such as he had been thirty years before who would both practise and patronize art as he had always done. The collection of visual material that was assembled for the use of his students included over 300 of his own drawings, together with prints and photographs recording all his interests, work, and discoveries. As Joan Evans has noted, 'without him to interpret them they became a succession of samples, some intrinsically beautiful, some merely drab; with him to link them together into a pattern of interpretation they might become the vivid if extremely personal fundamentals of art teaching.'[15] Sir Kenneth Clark has remarked on the incredible lack of coherency in the lectures, their tendency to be like revivalist meetings, and the fact that, while Ruskin did not really want to talk about art at all, he still had something important to say about the educational function of drawing in sharpening powers of observation, and the importance of modern art in the formation of taste.[16] It was impossible for Ruskin to work out systematically his idea of linking the practice of drawing with the development of taste and a knowledge of art; but when his friend Charles Eliot Norton became the first Professor of Fine Arts at Harvard University, he worked with the artist Charles Herbert Moore to develop a coherent programme of university art education based on Ruskin's ideas.[17]

Ruskin made several drawings for his Oxford collection, mainly studies of plants and other small natural forms, but most of the drawings he used were selected from his earlier work. He seemed to lack the energy to do more, and after the outburst of artistic activity in 1868–9 there was a noticeable slackening for the next few years. The tour of 1870 saw him make only a few architectural notes, and one large pencil drawing of the Grand Canal at Venice in the style of the previous year's studies at Verona. He was working strenuously at his Oxford lectures on landscape, and the result was a serious illness in the summer of 1871, with some symptoms of mental breakdown, an unrecognized warning of what was to come. The moods of elation and depression began to alternate with quickening tempo, and there was a marked

86. (left) *The Castelbarco Tomb at Verona*. 1869. Pencil and water-colour. 48″ × 38½″. Education Trust, Brantwood, Coniston.

loosening of his drawing style after this illness. Excited pencil sketches, like one made at Florence in 1872 (Plate 87), became more numerous, and because his Oxford lectures had turned his mind back to his old interest in the Italian primitives, they co-exist with a meticulous copy of a painting by Carpaccio.[18] When his relationship with Rose la Touche reached another crisis in 1872, his lectures began to alarm the Oxford authorities because of their drift toward moral and economic issues. The following year was a time of depression, spent at Brantwood, his new home on Coniston Water, where he drew stones, flowers, feathers, and leaves, and, at the request of his friend C. E. Norton, worked on a series of intense self-portraits that show remarkable contrasts of style (Plates 88, 89). This mood lasted until 1874, becoming so acute that Ruskin consulted a specialist on melancholia, in Paris, at the outset of his tour of that year. Then he gradually 'recovered' and embarked on a new programme of activities in Italy.

Friends had invited him to visit them in Sicily, but it was an unlucky time for him to stray so far from his familiar travel routes. His unstable condition was aggravated by the spectacle of poverty in southern Italy, and his moods oscillated between hatred and exaltation. At one moment he felt Naples to be the most disgusting place in Europe, but later the coast of Sicily seemed unequalled in luxuriance of beauty; he found horror in the rose-coloured morning light on the cone of Mount Etna, but at another time its smoke looked like a vision of the Israelite Pillar of Fire. Two sketches of Etna show how these extremes of feeling were affecting his drawing style. One is serene and jewel-like in its simplicity (Plate 90), but the other shows a black wave of earth and trees rolling with sluggish menace in the foreground, while the volcano is given a strangely twisted cone (Plate 91).

A drawing of a town near Naples, made on the way back to Rome, has the dizzying recession and ragged touch of his most disturbed kind of work (Plate 92), but at Rome he settled down to some quiet copying of Botticelli in the Sistine Chapel. Afterwards he went on to Assisi, Florence, and Lucca, living for a time in the Sacristan's cell at Assisi in a mood of religious excitement, making quick pencil sketches of his cell with exaggerated recessive effects, and carefully copying Cimabue and Giotto. At Florence he copied the frescoes in the Spanish chapel, and at Lucca he made

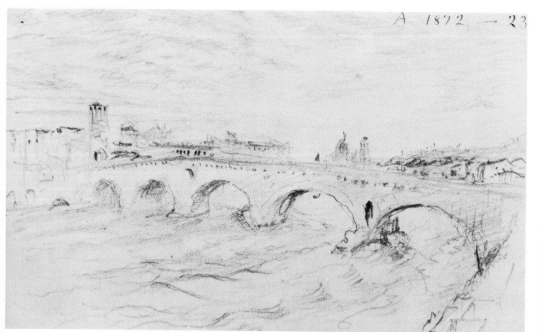

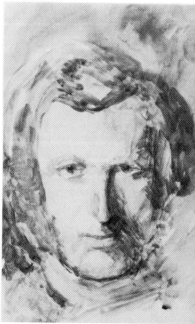

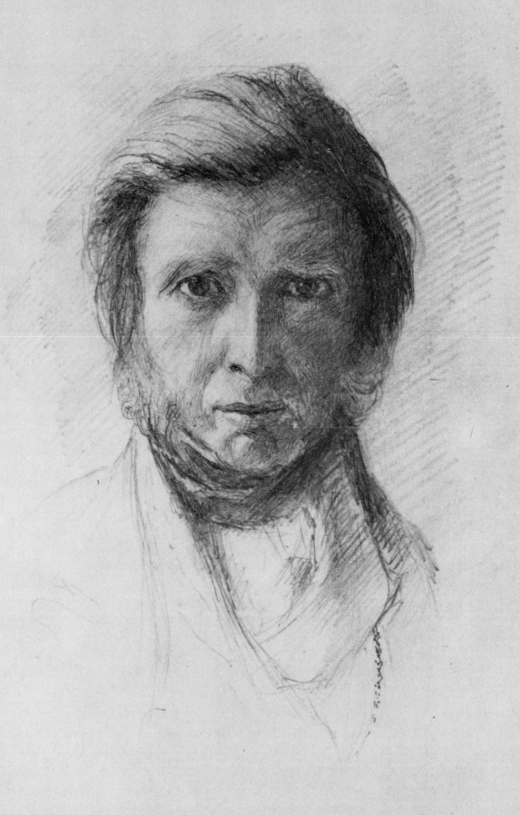

Ruskin (se ipsum)
del.

water-colour sketches of his favourite Renaissance monument, the tomb of Ilaria di Caretto (Plate 93).

Lucca is also the subject of one of his most vivid water-colours, a sketch of old walls and a tower, with hasty splashes of yellow, blue, and grey around the margin of the view, and then, as the eye is drawn into a tunnel-like space, the focus sharpens on a study of vines on a trellis relieved against a sunlit house (Plate 94). The central area is picked out in detail, with small touches of the brush and accents with pen and red ink, as in Turner's late sketches. It should be compared with *The Walls of Lucerne* from about ten years before (Plate 66), where the eye was allowed to wander across the page, following a zig-zag path from one point of focus to another. In the Lucca drawing every effect is intensified, with bold brushwork, dazzling light and colour, and dramatic convergence resulting from a wide angle of vision that gives the eye no opportunity to wander. Exaggerated space composition of this sort, first seen in the Glacier des Bois water-colour of 1844 (Plate 35), returns to become a frequent feature of the later drawings. Ruskin once said that his instinct to draw made him want 'to draw all St. Mark's, and all this Verona stone by stone, to eat it all up into my mind, touch by touch',[19] an appetite that had now become a compulsive hunger, creating the terrific spatial suction of drawings like this water-colour at Lucca.

There followed a year of exhaustion and brooding over the death of Rose la Touche, which had occurred in the spring of 1875, but finally he was well enough, in August of 1878, to travel to Venice with the aim of preparing a new edition of *The Stones of Venice*. There he became desperately busy again copying Carpaccio's *Dream of St. Ursula* and making architectural studies. At one extreme he might spend a day 'softening St. Ursula's cheeks, and altering the curl of her hair over the left temple',[20] or working on an elaborate water-colour study of a portion of St. Mark's (Plate 95). Then he might produce pencil sketches, executed with a hasty calligraphy that transformed familiar scenes into gloomy masses of darkened and broken architecture (Plate 96).

The intensely private character and meaning of many of these drawings can be verified by reference to Ruskin's diaries and other writings. St. Ursula, in his copies of paintings by Carpaccio, became identified in his mind with Rose la Touche, and he began to receive messages from her that he reported to the public in his monthly news-letter to the working men of Great Britain, *Fors Clavigera*. The architectural studies at Venice were described as enormously important historical records, because they preserved subtle effects of colour and decoration which had delighted him years before. These drawings were made in an angry mood, caused by attacks on monuments that had meant so much to him in 'the happy and ardent days' of his youth.[21] All his work at this time was based on the same feeling as that which ran through *Fors Clavigera*, where he wrote as 'a man who has always been the centre of his universe, and now feels himself to be the centre of the universe for other men'.[22]

90. (below) *Etna from Taormina.* 1874. Water-colour. 6¾″ × 9¾″. The British Museum.
91. (below right) *Twilight on Etna.* 1874. Water-colour. 6¾″ × 9¾″. Location unknown.

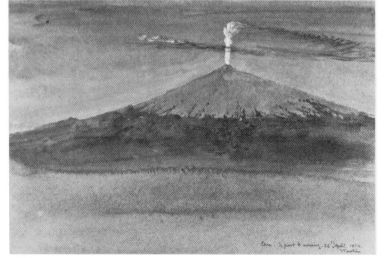

92. *Nocera*. 1874. Pencil, wash and opaque white. $7'' \times 10\frac{1}{8}''$. South London Art Gallery. Reproduced by kind permission of the London Borough of Southwark.

Ruskin was in a precarious state of mind, and the diaries at Venice show him losing control. He saw it himself, noting that his moods of elation and depression were now coming on alternate days, and that he could not focus his attention, or avoid long periods of day-dreaming. The first attack of madness finally came in 1878, and was followed by five more in the ten years before the seizure in 1889 that incapacitated him for the rest of his life.

4. During the period of convalescence after his first attack of mania Ruskin drew feathers and plants, and made a copy of part of his study of St. Mark's from his last visit to Venice, all for Charles Eliot Norton, who was planning an exhibition of his drawings in Boston. By 1880 he was well enough to travel, and a tour in France was undertaken. During the trip he made a dark study of the cathedral of Beauvais, and a more cheerful landscape sketch of Picquigny (Plate 97), which shows some influence

93. *Tomb of Ilaria di Caretto at Lucca.* 1874. Water-colour. $8'' \times 12''$. Ashmolean Museum, Oxford.

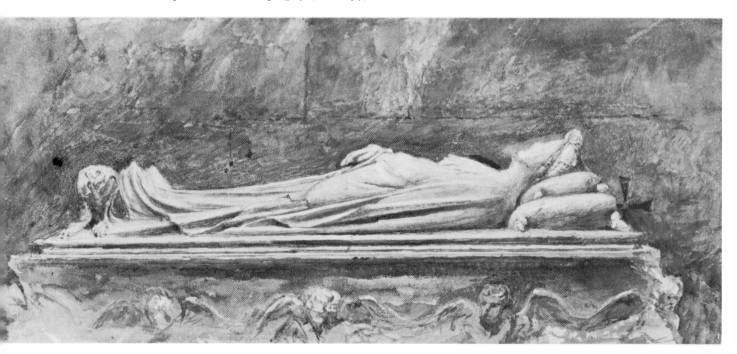

94. *A Vineyard Walk at Lucca.* 1874. Water-colour. 14⅛″ × 19″. Bembridge School, Isle of Wight.

from his travelling companion, Hercules Brabazon, an amateur who had admired Turner's late water-colours, and imitated him in his own distinctive way by using broad washes that give a very abstract impression of his subjects. This influence helps to account for a new breadth of effect and firmness of composition in a few of Ruskin's latest drawings.

There was another attack in 1881, but in the following year Ruskin set out on a tour of Switzerland and Italy, and enjoyed a renewal of energy that enabled him to make a last series of drawings of his favourite sites. Mont Blanc was sketched once more,[23] and at Lucca he drew a splendid view of the façade of San Martino, with a stream of spatial recession rushing out of the square at the left, past the old church leaning heavily against its bell tower (Plate 98). He was also able to make more detailed studies of the façade and porch before going on to Florence, where he undertook a series of drawings of the Ponte Vecchio. These were motivated by an idea comparable with the Swiss-towns project of the fifties. He was planning a history of Christianity which was to give 'a united illustration of the power of the church in the thirteenth century'.[24] Only one volume of this work was written, *The Bible of Amiens* (1880), but nine others were planned, and each was to discuss a major

95. *North-West Porch of St. Mark's at Venice.* 1877. Water-colour. 25″ × 30″. Bembridge School, Isle of Wight.

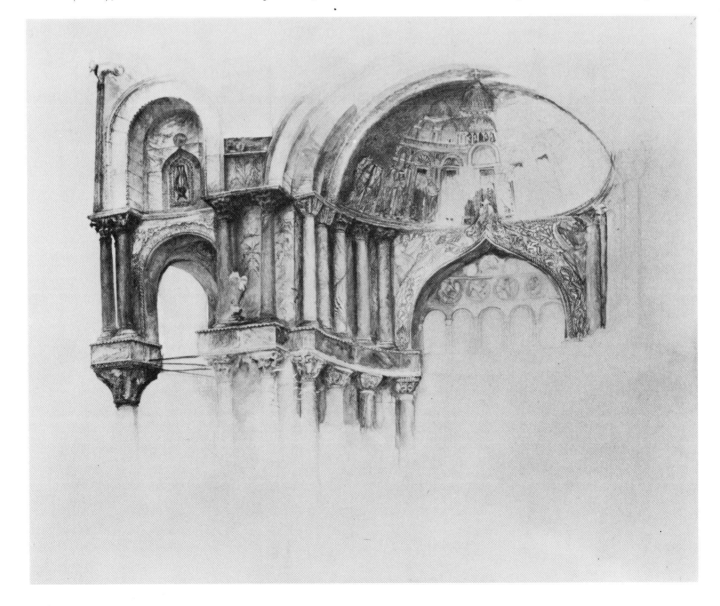

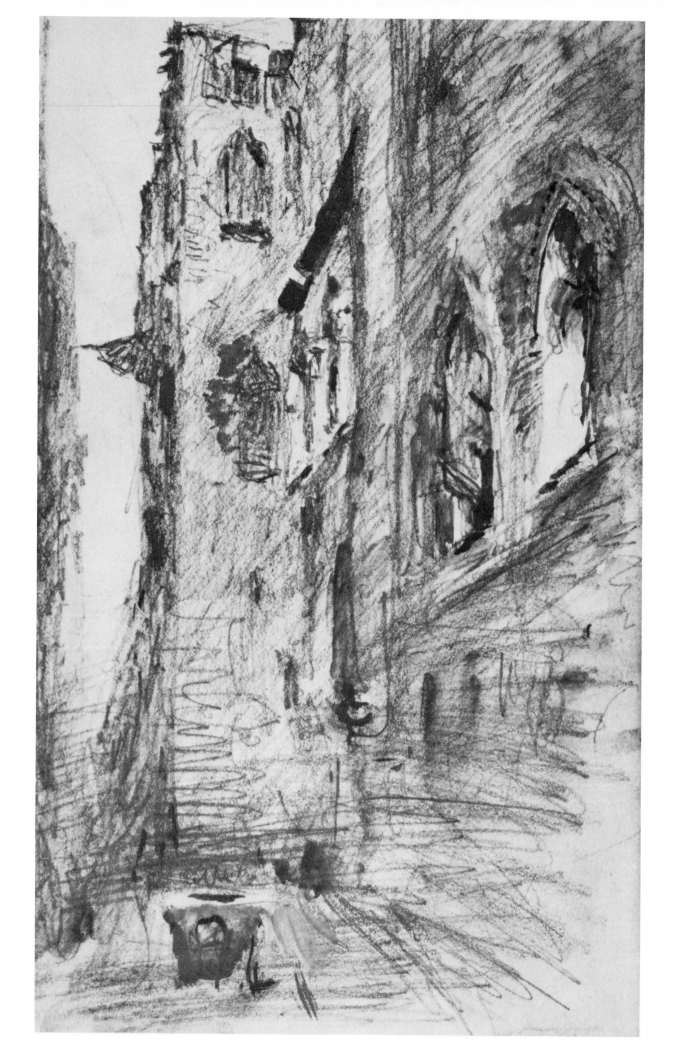

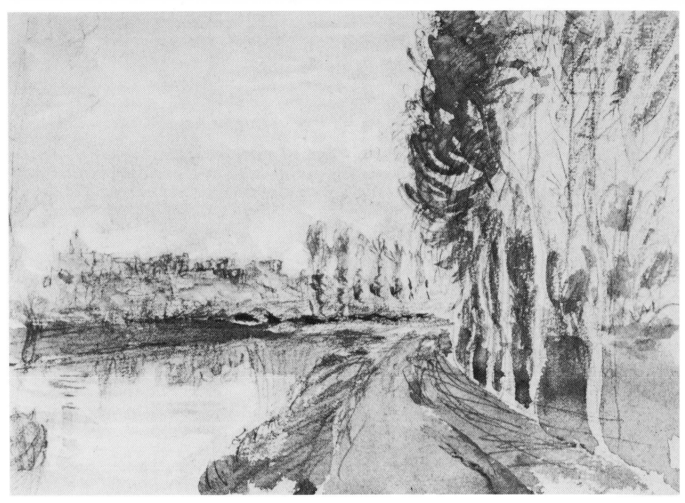

97. *Picquigny*. 1880. Water-colour. $5\frac{7}{8}'' \times 7''$. Bembridge School, Isle of Wight.

96. (left) *Street in Venice*. 1876–7. Pencil and wash. $7\frac{3}{4}'' \times 4\frac{3}{4}''$. South London Art Gallery. Reproduced by kind permission of the London Borough of Southwark.

98. *San Martino, Lucca*. 1882. Pencil and wash. $4\frac{3}{4}'' \times 7\frac{3}{4}''$. Education Trust, Brantwood, Coniston.

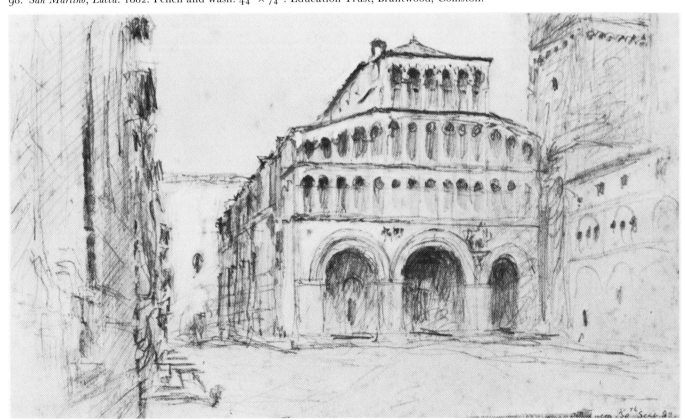

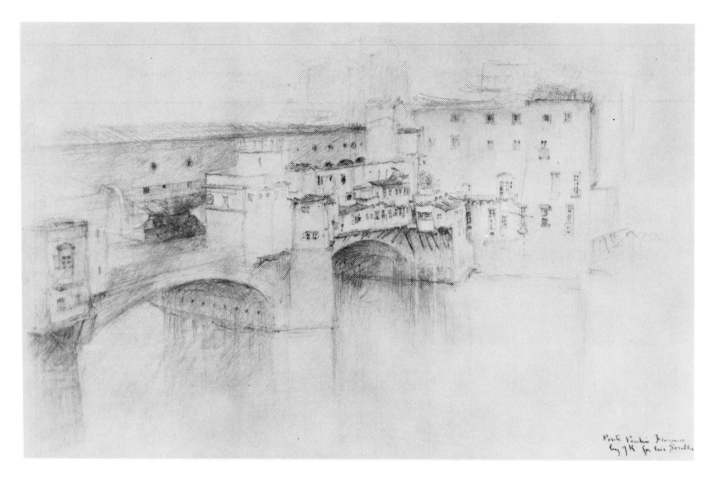

99. *Ponte Vecchio, Florence.*
1882. Pencil. $11\frac{3}{4}'' \times 18\frac{3}{4}''$.
Fogg Art Museum, Harvard
University.

architectural monument as a complete, concentrated, expression of the religion and history of a large geographical area. *Ponte Vecchio* was to be the name of the volume devoted to Florence, so that the drawings of 1882 were once more done from the point of view that saw an architectural monument as endowed with a collective human personality, speaking to the viewer through the visual and emotional impact of its picturesque forms. However, the effect of the Ponte Vecchio drawings contrast sharply with earlier works made with a similar intention. In the 1860 sketch of a bridge at Bremgarten the jaunty rhythm of sharply defined forms gives a strong sense of picturesque individuality to the subject (Plate 67), but at Florence this is replaced by quiet shadows and vaguely-sketched contours surrounding details of windows and roofs that are drawn like private tokens of Ruskin's broken thoughts and feelings (Plate 99). Even more expressive of a tortured sensibility is the remarkable sketch of another Florentine bridge, probably the Ponte di Santa Trinità, where, instead of the voice of history, Ruskin's most desperate moods seem to be given visible form (Plate 100).

The spirit of these last architectural studies had been anticipated by some landscape drawings in 1876. During May of that year Ruskin made a tour of northern England, and sought out the subject of Turner's water-colour, *Junction of the Greta and Tees*, a serene early work which had been in his own collection. Once more, and perhaps for the last time, he made a sketch from a viewpoint taken by Turner, and commented happily in his diary, 'Saw junction, and Greta bed, yesterday; exquisite beyond words. Turner so right! All in lovely light' (Plate 101).[25] But at the same time he made another, more violent, sketch of the river, which illustrates again how the feeling for the harmonious rhythms of nature acquired from his old master could

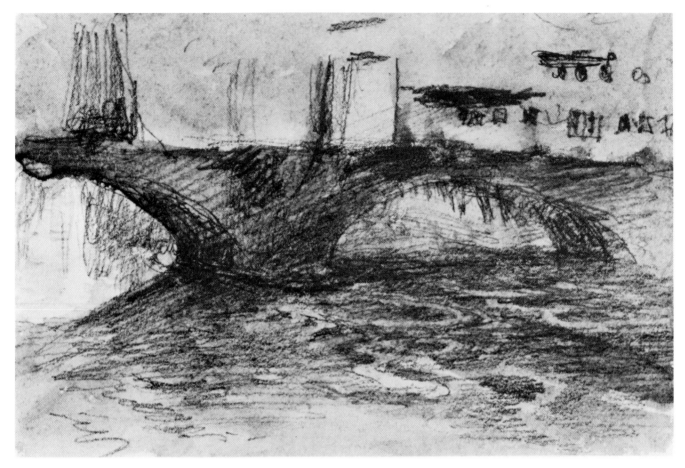

suddenly break down into wild and almost incoherent forms (Plate 102). In mood and style this sketch is comparable with his last Turnerian exercises in a sketch-book dated 1887, containing numerous water-colour studies of clouded skies (Plate 103). They can be associated with the preparation of a new edition of the section on clouds written for *Modern Painters*,[26] and may have been made with recollections of another sketch-book, filled with water-colours of happier summer skies, that Ruskin had found in the Turner bequest many years before.[27]

100. *Ponte di Santa Trinità, Florence.* Probably 1882. Pencil and water-colour. 5″ × 7″. Education Trust, Brantwood, Coniston.

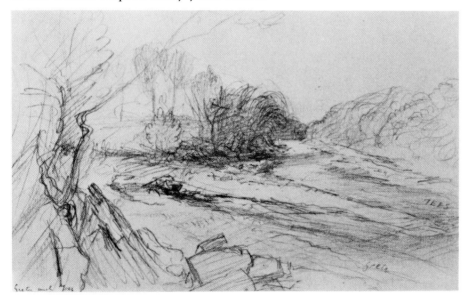

101. *Junction of Greta and Tees.* 1876. Pencil. 5½″ × 8½″. Education Trust, Brantwood, Coniston.

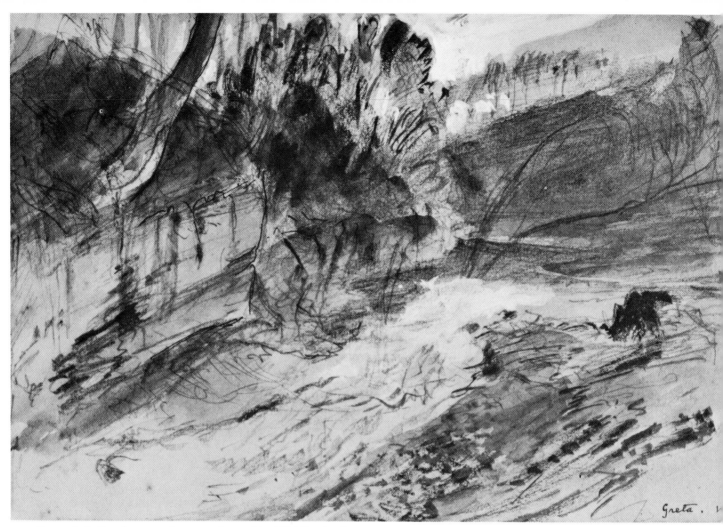

102. *Greta.* 1876. Pencil, pen and water-colour. $5\frac{1}{2}'' \times 8\frac{1}{2}''$. The Art Institute of Chicago, Gift of Mrs. Chauncey McCormick.

103. *Clouds.* 1887. Water-colour. $5\frac{3}{4}'' \times 9''$. Ruskin Museum, Coniston.

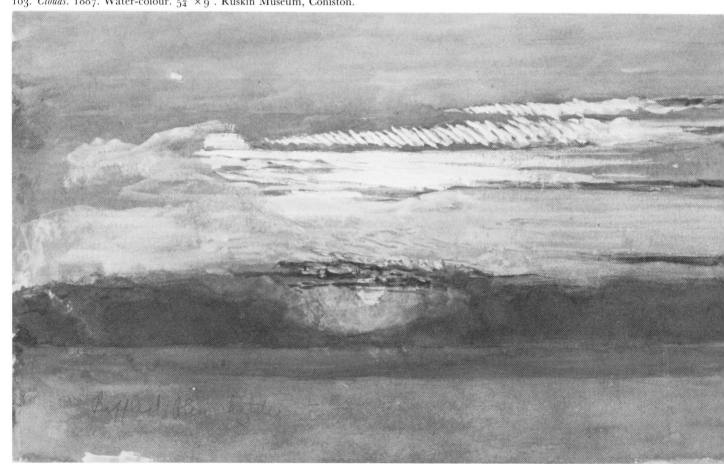

Conclusion

Ruskin's development as an artist shows constant pursuit of difficult goals, a surprising degree of experimental freedom, and progressive refinement of aesthetic quality, factors which give his drawings great interest in the history of English art in the nineteenth century. Yet they have seldom received the attention they deserve, because of their tentative and fragmentary character, the result of Ruskin's conception of himself as an amateur and the self-imposed limitations that this entailed. For many observers this amateurism has placed Ruskin's drawings too far outside the main stream of artistic traditions to merit very serious consideration, and the tendency has often been to regard them merely as intriguing footnotes to a dazzling literary career. Of course, this ignores the seriousness with which Ruskin regarded his drawing as a method of visual research, and accepts uncritically his frequent assertions that he lacked the talent and ambition to pursue art with professional seriousness. In this century, however, we have come to reject Ruskin's conception of the necessary distinction between amateur and professional, and we are eager to recognize the validity of non-professional and non-traditional art wherever it is found. Thus it is possible to recognize in many of Ruskin's drawings qualities that make them comparable with the intense and personal vision of other outsiders, like William Blake and Samuel Palmer.

Nevertheless, it would be wrong to ignore the question of Ruskin's amateurism altogether, simply because it no longer seems very relevant. After all, it is something that he stresses again and again in his writings, and this issue deserves to be regarded as an important key to understanding the meaning he assigned to his own art, and to his critical career as a whole.

Ruskin's most conclusive discussion of the aims and methods of the amateur artist appears in an early chapter in *Modern Painters IV*. Here he is concerned primarily to make a comparison between his own more or less factual drawings of the St. Gothard Pass, and Turner's interpretation of the scene in a water-colour owned by Ruskin. It will be recalled that he used this method to demonstrate the way Turner's imagination could transform his subjects into dream-like combinations of truth and emotion. Such visions are described as 'imaginative topography', and this leads Ruskin to refer to the 'conventional topography' of his old masters, Harding, Fielding, and the rest, who taught those without genius or imagination how to invent a picture by following conventional rules for picturesque effect. He continues by urging amateur artists, denied (like himself) the imagination of a Turner, to accept their lack of genius and renounce the 'conventional topography' of the drawing masters in favour of a new amateur ideal, which he describes as 'historical topography', where 'not a line is to be altered, not a stick nor stone removed. . . .' The picture is to be, as far as possible, the reflection of the place in a mirror, and the artist is to consider himself only as a sensitive and skilful reflector.[1]

By this means the amateur would avoid the distortion of truth resulting from the inferior ideas of beauty held by all 'conventional' artists, from Claude and Salvator

to the modern drawing masters. He would join the company of artists like Fra Angelico, Dürer, and the Pre-Raphaelites, who, Ruskin says, were devoted to making simple records of the truth of nature to the best of their ability and knowledge. His art would then become a form of spiritual discipline, enabling him to achieve direct knowledge of man's relationship with God, through the perception of divine laws guiding the development of natural forms and the course of human history. This would also enable better understanding of the art of masters like Turner and Tintoretto, who are able to utilize the power of the imagination to pass beyond simple imitation of nature to a higher, holy, art glorifying God's work; 'All great art is praise.'[2]

Ruskin recognized that his ideal of photographic faithfulness to visual impressions in amateur practice was not really attainable. The 'historical topographer' must employ some short cuts and conventions, selecting what seem to him the leading lines among the thousands that are visible, and, since it is 'the instinctive affection of each painter which guides him in the omissions he is to make, or signs he is to use', the disposition of lines and accents in his work will *express* these affections. This is 'the only inspiration he is capable of, but it is a kind of inspiration still', not Turnerian imagination to be sure, but possessing definite aesthetic value.[3] Furthermore, he notes that the rapid sketch, with its unconscious exaggerations, will have not only a special personal accent, but a kind of truth that the photograph misses. To illustrate this he compares one of his own drawings of the walls and towers at Fribourg with a photograph of the same subject, and points out that, in his rendering, the walls curve more than they do in the photograph. Yet this conveys a 'truer idea', for 'the notablest thing in the town of Fribourg is that all its walls have got flexible spines, and creep up and down the precipices more in the manner of cats than walls.'[4] He goes on to emphasize that this kind of truth can be achieved only by exaggerations made in a quite unpremeditated way, if the work is to avoid the taint of feeble and self-conscious imagination.[5]

This was Ruskin's mature conception of the proper aims and methods of amateur art, based on his own training and experience as an amateur artist seeking a meaningful relationship with nature and the great masters. It lies behind his instruction-book for amateurs, *The Elements of Drawing*, and his own practice in later years. What he finally wanted, and perhaps achieved, was a style expressing a spirit in sympathy with nature through the self-forgetful analysis of visual impressions—a style deliberately renouncing the highest artistic aspirations of past and present. It is this renunciation that gives so much of Ruskin's work and theory a modern aspect. The theme of 'the innocence of the eye' understandably caught the attention of the Neo-Impressionists in France, while the aestheticism of his theories of abstract linear design underlines his importance as an anticipator of other Post-Impressionist trends, like Symbolism and Art Nouveau. His emphasis on unconscious self-expression points along one of the paths of Post-Romantic art toward Expressionism, where the Romantic intimacy between man and nature is meant to be achieved in a direct and personal way, without dramatic conventions borrowed from the past. Finally, the unbridgeable gulf that he places between the amateur artist and the inspired creator of beauty foreshadows a modern sense of alienation between the artist and the middle classes, although Ruskin hoped that this would establish a new and more healthy relationship between the artist and his public, based on reverence for creative power. By placing Turner's kind of imaginative creation beyond the reach of his own art and the art of other amateurs, he intended to restore mystery and wonder to the artistic process as it would be understood by the artists and art patrons of the future.

However, what has happened in this century is that Ruskin's sense of the heroic grandeur of masters like Turner and Tintoretto, so superior to the ordinary talents of

artists like himself, has been converted into a feeling of alienation from all the great traditions of the past. The modern artist lives in an age where the scientific questions that challenged Ruskin's faith have been carried so much farther that it is no longer possible for him to understand an art based on certainty of a higher spiritual power that gives unity to life. The great imaginative efforts of the past, which resulted in what Ruskin regarded as works of praise for this power, are seen by many as a kind of heroic and beautiful self-deception. The result is that all the leading talents of the present and the recent past have deliberately abandoned the paths of traditional imaginative creation in favour of an individual search for truth of form, and spontaneous personal expression, so that we are now accustomed to art that, by the standards of the past, seems fragmented and incomplete. Consequently, it is possible to recognize Ruskin's movement in this direction in his own art, and the related emphasis in his criticism on the extreme difficulty of achieving complete imaginative comprehension of reality, as important symptoms of a development in the history of Western culture which has set the stage for many of the attitudes and activities of artists in our own day.

Notes

Introduction

1. Robert L. Herbert, Introduction, pp. vii–viii, in *The Art Criticism of John Ruskin*, New York, 1964.
2. Baldesare Castiglione, *The Book of the Courtier*, trans. and ed. Leonard P. Opdycke, New York, 1902, pp. 65–6.
3. *Arnold's Library of the Fine Arts*, I, London, 1832, pp. 118–19.
4. *Somerset House Gazette*, London, 1823, p. 162.
5. Ibid., p. 162.

Chapter 1

1. Edward T. Cook and Alexander Wedderburn (eds.), *The Complete Works of John Ruskin*, London, 1903–12 (hereafter cited as *Works*), I, p. xxxii, note.
2. *Works*, XXXV, p. 75.
3. *Works*, I, p. xxxii, note.
4. *Works*, XXXV, p. 185.
5. *Works*, XXXV, p. 177.
6. *Works*, I, p. xxxii, note.
7. R. S. Lambert (ed.), *Grand Tour*, London, 1935, p. 154.
8. *Works*, XXXV, p. 79.
9. Ruskin Gallery, Bembridge School, Isle of Wight.
10. *Works*, II, Plate 14.
11. *Works*, II, p. 382.
12. *Works*, XXXV, p. 214.
13. *Works*, XIV, pp. 389–90.
14. Joseph Farington, Diary, 1793–1821, British Museum Typescript, entry for 1 June 1808, p. 4077.
15. Ibid., entry for 21 June 1811, p. 5843.
16. *The Review of Publications of Art*, I, London, 1808, p. 173.
17. William M. Craig, *A Course of Lectures on Drawing, Painting, and Engraving, Considered as Branches of Elegant Education*, London, 1821, p. 88.
18. Ibid., p. 183.
19. Farington Diaries, op. cit., entry for 27 Feb. 1806, pp. 3166–7.
20. William Marshal Craig, *An Essay on the Study of Nature in Drawing*, London, 1793, p. 21.
21. W. H. Pyne, 'The Rise and Progress of Water-Colour Painting in England', *Somerset House Gazette*, London, 1823, p. 145.
22. John T. Smith, *Remarks on Rural Scenery*, London, 1797, p. 6.
23. Ibid., p. 7.
24. W. M. Thackeray, *Sketches after the English Landscape Painters*, London, n. d., notes for Plates IV and VIII.

25. *Somerset House Gazette*, II, London, 1824, p. 83.
26. John Varley, *A Treatise on the Principles of Landscape for Students and Amateurs in that Art*, London, 1816–17, Introduction, p. 1.
27. David Cox, *A Treatise on Landscape Painting and Effect in Water-Colours*, London, 1813.
28. *Arnold's Magazine of the Fine Arts*, IV, 1834, p. 151.

Chapter 2

1. *Ackermann's Repository*, Series II, Vol. III, London, 1817, p. 352.
2. J. L. Roget, *A History of the 'Old Water-Colour' Society*, London, 1891.
 Richard and Samuel Redgrave, *A Century of British Painters*, London, 1947, pp. 445–7.
3. *Works*, XXXV, pp. 215–16.
4. *Works*, XIV, p. 396.
5. *Works*, III, p. 196.
6. *The Magazine of the Fine Arts*, London, 1821, p. 119.
7. T. H. Fielding, *On the Theory of Painting*, London, 1836, p. 20.
8. *Works*, I, pp. 189–205.
9. Jeremiah Joyce, *Scientific Dialogues*, London, 1833.
 Robert Jameson, *Manual of Minerology*, Edinburgh, 1821.
10. H.-B. de Saussure, *Voyages dans les Alps*, Neuchatel, 1779–96.
11. *Works*, I, p. xxxvii.
12. J. C. Loudon, *An Encyclopaedia of Cottage, Farm, and Villa Architecture*, London, 1836.
13. Henry Russell Hitchcock, *Architecture, Nineteenth and Twentieth Centuries*, London, 1958, p. 436, note 12.
14. William Gilpin, *Observations on the River Wye . . .*, London, 1789, pp. 43–50.
15. *Ackermann's Repository*, IV, London, 1810, p. 428.
16. *Works*, XXXV, p. 624.
17. *Works*, I, pp. 1–188.
18. Ibid., p. 47.
19. Ibid., p. 50.
20. Ibid., p. 46, note 2.
21. Ibid., p. 112.
22. Ibid., p. 173.
23. *Works*, I, pp. 215–34, pp. 235–45.
24. *Works*, III, p. 636.
25. A contemporary critic quoted in A. J. Finberg, *The Life of J. M. W. Turner, R.A.*, Oxford, 1939, p. 79.

26. John Eagles, *The Sketcher*, London, 1856, p. 6.

27. Ibid., p. 72.

28. Quoted from a characterization of Eagles's aims and methods in the Introduction to *The Sketcher*, ibid., pp. vii–viii.

29. *Works*, III, p. 639.

30. *Works*, XXXV, p. 305.

31. *Works*, I, 421–2.

32. Ibid., pp. 424–5.

33. *Works*, XXXV, p. 262.

34. Joan Evans and John Howard Whitehouse (eds.), *The Diaries of John Ruskin*, Oxford, 1956–9 (hereafter cited as *Diaries*), I, Plate 3, and *Works*, I, Plate 14.

35. *Diaries*, I, p. 147.

36. Ibid., pp. 120, 190.

37. The street scene at Genoa is in the collection of Bembridge School, Isle of Wight. The sketch in the Cathedral is in the collection of the Education Trust at Brantwood, Coniston.

38. *Diaries*, I, p. 100.

39. Ibid., p. 109.

40. *Works*, IV, Plate 4.

41. Ibid., p. 111.

42. *Works*, XXXV, Plate 12.

43. *Works*, XXXV, p. 276.

44. *Works*, I, Plate 15.

45. *Diaries*, I, p. 118.

46. *Works*, XXXVI, Plate 3.

47. *Diaries*, I, p. 160.

48. *Works*, XXXV, p. 419.

49. *Diaries*, I, p. 171.

50. Ibid., p. 126.

51. Ibid., p. 183.

52. *Works*, IV, Plate 2, and *Works*, XIX, Plate 20.

53. *Works*, XXXV, p. 296.

54. Ibid., p. 285.

55. *Diaries*, I, p. 103.

Chapter 3

1. For the place of this work in the Cunliffe Collection see James S. Dearden, 'The Cunliffe Collection of Ruskin Drawings', *The Connoisseur*, Vol. 171, no. 690 (1969), pp. 237–40.

2. *Works*, XXXV, pp. 301–2.

3. *Works*, I, p. 425.

4. *The Repository of Arts, Literature, Fashions, Manufactures, etc.*, Series II, Vol. VIII, 1819, p. 297, and Vol. XI, 1821, p. 371.

5. Quoted in Finberg, *Life of J. M. W. Turner*, op. cit., p. 273.

6. J. D. Harding, *Elementary Art; or, the Use of the Lead Pencil*, London, 1834, p. 25.

7. J. D. Harding, *The Principles and Practice of Art*, London, 1845, p. 77.

8. Ibid., p. 66.

9. J. D. Harding, *Elementary Art*, op. cit., pp. 13–14.

10. *Works*, VI, Plate 28.

11. *Diaries*, I, p. 223, entries for 1 June and 7 June.

12. *Works*, XXXV, pp. 314–15.

13. Ibid., p. 310.

14. *Works*, II, p. 382.

15. *Works*, II, Frontispiece.

16. *Works*, XXXVIII, 'Catalogue of Drawings', No. 421.

17. *Works*, XXXV, Plate 17.

18. Now in the Boston Museum of Fine Arts.

19. *Works*, III, p. 529, note.

20. Ibid., pp. 529–30.

21. *Works*, III, p. 624.

22. *Works*, III, Plate 4.

23. *The Poems of Samuel Rogers*, London, 1834, p. 192.

24. *Works*, II, p. xli.

25. *Diaries*, I, p. 164.

26. F. T. Kugler, *A Handbook of the History of Painting*, ed. C. L. Eastlake, London, 1842.

G. F. Waagen, *Work of Art and Artists in England*, London, 1838.

27. *Works*, III, pp. 200–1, note.

28. *Works*, VI, Plates 20 and 21.

29. *Works*, VI, pp. 38–41.

30. *Diaries*, I, Plate 21.

31. *Works*, XXXV, p. 419.

32. *Works*, VIII, p. xxiii.

33. *Works*, VIII, pp. 90–8.

34. *Works*, III, p. 210, note. For Ruskin's interest in photography see Aaron Scharf, *Art and Photography*, London, 1968, pp. 69–74.

35. *Works*, IX, p. 431.

36. *Works*, VIII, p. xxxii.

37. *Works*, XXXV, p. 624.

38. Cf. John de Rosenberg, *The Darkening Glass*, New York, 1961, p. 69.

39. *Works*, XVIII, p. 443.

Chapter 4

1. *Works*, XXVI, p. 373.

2. *Works*, XXXV, p. 452.

3. *Diaries*, II, p. 381.

4. *Works*, XXXVI, p. 101.

5. *Works*, XXI, Plate 29.

6. *Diaries*, II, p. 404.

7. *Works*, VI p. 179.

8. William Buckland, *Geology and Minerology Considered with Reference to Natural Theology*, London, 1836.

9. *Works*, VI, p. 176.

10. Ibid., p. 214.

11. Ibid., pp. 232–3.

12. Ibid., p. 238.

13. For the linear tradition in English art see Nikolaus Pevsner, *The Englishness of English Art*, New York, 1956, Chapter V.

14. *Works*, VI, p. 239 and note.

15. *Works*, II, p. 624.

16. *Works*, XII, pp. 158, 320, 324.

17. *Works*, VI, p. 368.

18. Ibid., pp. 176–7.

19. *Works*, III, p. 427.

20. *Works*, VI, p. 414.

21. *Works*, XXXVI, p. 115.

22. *Works*, VI, p. 385.

23. *Works*, VII, p. xxxii.

24. *Works*, VI, p. 170.

25. *Works*, XIII, p. 236.

26. Ibid., p. li.

27. Kenneth Clark, Introduction, Exhibition

Catalogue, *Drawings by John Ruskin*, Arts Council, 1960, p. 7.
 28. *Works*, VII, Plate 76.
 29. *Works*, XV, pp. 78–9.
 30. *Works*, VIII, p. 234.
 31. *Diaries*, II, p. 493.
 32. *Works*, XV, p. 18.
 33. Ibid., p. 133.
 34. Ibid., p. 103.
 35. Ibid., p. 104.
 36. Ibid., p. 49.
 37. Ibid., p. 27.
 38. Ibid., pp. 144–5.
 39. Ibid., p. 161.
 40. Ibid., p. 154.

Chapter 5
 1. *Works*, XV, p. 51.
 2. R. H. Wilenski, *John Ruskin, an Introduction to Further Study of his Work*, London, 1933.
 3. *Works*, XXXIV, pp. 7ff.
 4. *Diaries*, III, pp. 720, 883, 886.
 5. John D. Rosenberg, *The Darkening Glass*, New York, 1961, p. 212.
 6. *Diaries*, II, p. 566.
 7. Ibid., p. 559.
 8. *Works*, XXXVI, Plate 19.
 9. *Letters of Charles Eliot Norton*, Boston, 1913, II, p. 46.
 10. *Letters of Charles Eliot Norton*, op. cit., I, p. 430.
 11. *Letters of Charles Eliot Norton*, op. cit., II, p. 16.
 12. *Works*, XXXV, p. 157.
 13. *Works*, XIX, pp. lii–liii.
 14. Ibid., p. li.
 15. Joan Evans, *John Ruskin*, London, 1954, p. 319.
 16. Sir Kenneth Clark, *Ruskin at Oxford*, Oxford, 1947.
 17. F. J. Mather, *Charles Herbert Moore . . .* , Princeton, N.J., 1957.
 18. *Works*, XII, Plate 6.
 19. E. T. Cook, *The Life of John Ruskin*, London, 1911, I, p. 263.
 20. *Diaries*, III, p. 936.
 21. *Works*, XXIV, pp. 405–9.
 22. Joan Evans, *John Ruskin*, op. cit., p. 325.
 23. *Works*, XXXV, Plate 34.
 24. *Works*, XXXIII, p. lviii.
 25. *Diaries*, III, p. 898.
 26. See Ruskin's Preface for *Coeli Enarrant*, in *Works*, VI, pp. 486–7.
 27. A page from Turner's 'Skies' sketchbook of *c.* 1818 is reproduced in Martin Butlin, *Turner Water-Colours*, London, 1962, Plate 7.

Conclusion
 1. *Works*, VI, p. 31.
 2. *Works*, XV, p. 351.
 3. *Works*, VI, p. 45.
 4. Ibid., p. 46.
 5. Ibid., p. 47.

Select Bibliography

ABRAMS, M. H., *The Mirror and the Lamp*, London, 1960.

ALISON, A., *Essays on the Nature and Principles of Taste*, Edinburgh, 1855.

ANONYMOUS, 'Observations on the Rise and Progress of Painting in Water-colours', *Ackermann's Repository*, VIII (1812), pp. 257–326; IX (1813), pp. 23–221.

ANONYMOUS, 'Thoughts on Landscape Painting', *Library of the Fine Arts*, III (1832), pp. 16–28.

BALLANTINE, J., *Life of David Roberts*, Edinburgh, 1866.

BARBIER, Carl Paul, *William Gilpin*, Oxford, 1963.

BATE, W. J., *From Classic to Romantic*, New York, 1961.

BELL, C. F., 'Fresh Light on Some Water-Colour Painters of the Old British School', *Walpole Society*, V (1915–17), pp. 49–83.

BINYON, Laurence, *English Water-Colours*, London, 1933.

——, *Landscape in English Art and Poetry*, London, 1931.

BOASE, T. S. R., *English Art, 1800–1870*, Oxford, 1959.

BORENIUS, Tancred, 'The Rediscovery of the Primitives', *Quarterly Review*, 239 (1923), pp. 258–70.

BRAGMAN, Louis J., 'The Case of John Ruskin: A Study in Cyclothymia', *The American Journal of Psychiatry*, XCI (Mar. 1935), pp. 1137–59.

BUCKLAND, William, *Geology and Minerology Considered with Natural Theology*, London, 1836.

BURD, Van AKEN, 'Ruskin's Quest for a Theory of Imagination', *Modern Language Quarterly*, XVII (Mar. 1956), pp. 60–72.

BURKE, Edmund, *A Philosophical Enquiry into the Origin of our Ideas of the Sublime and the Beautiful*, ed. J. T. Boulton, London, 1958.

BURY, Adrian, 'W. H. Pyne', *The Old Water-Colour Society Club Annual*, XXVIII (1950), pp. 1–9.

BUTLIN, Martin, *Turner Watercolours*, London, 1962.

CATALOGUE, Bembridge School, Isle of Wight, *The Ruskin Gallery, being part of the collection made by John Howard Whitehouse, Esq. and consisting mainly of drawings by John Ruskin*, n.d.

——, Brantwood, Coniston, *Catalogue of the Pictures by John Ruskin and other Artists at Brantwood, Coniston*, J. S. Dearden, Isle of Wight, 1960.

——, Coniston Institute, *Ruskin Museum Catalogue*, 5th edn., Coniston, 1919.

EXHIBITION CATALOGUE, Arts Council, Aldeburgh, London, and Colchester, *Drawings by John Ruskin*, 1960.

——, Arts Council, London, *Ruskin and his Circle*, 1964.

——, *Notes on Drawings by Mr. Ruskin placed on Exhibition by Professor Norton in Boston*, Cambridge, 1879.

——, Fogg Art Museum, *Paintings and Drawings of the Pre-Raphaelites and their Circle*, Harvard, 1946.

——, Fogg Art Museum, *Ruskin, In memory of Charles Eliot Norton*, Harvard, Cambridge, Mass., 1909–10.

——, Leicester City Museum and Art Gallery, *Sir George Beaumont*, 1938.

——, London County Council, The Iveagh Bequest, Kenwood, *William Gilpin and the Picturesque*, 1959.

——, Manchester, City Art Gallery, *Ruskin*, 1904.

——, Philadelphia Museum of Art, *Romantic Art in Britain: Paintings and Drawings, 1760–1860*, 1968.

CLARE, Charles, *Landscape Painting*, New York, 1950.

CLARK, Kenneth, *Ruskin at Oxford: an Inaugural Lecture Delivered before the University of Oxford, 14 November 1946*, Oxford, 1947.

COLLINGWOOD, W. G., *The Art Teaching of John Ruskin*, London, 1891.

——, *The Life and Work of John Ruskin*, 2 vols., London, 1893.

COOK, E. T., *The Life of John Ruskin*, 2 vols., London, 1911.

CRAIG, William M., *A Course of Lectures on Drawing, Painting, and Engraving Considered as Branches of Elegant Education*, London, 1821.

——, *An Essay on the Study of Nature in Drawing*, London, 1793.

CUNDALL, H. M., *A History of British Water-Colour Painting*, London, 1908.

DEARDEN, James S., 'The Cunliffe Collection of Ruskin Drawings', *The Connoisseur*, Vol. 171, no. 690 (1969), pp. 237–40.

EAGLES, John, *The Sketcher*, London, 1856.

EDWARDS, Edward, . . . *Perspective on the Principles of Dr. Brook Taylor*, London, 1806.

EDWARDS, Ralph, 'Queen Charlotte's Painter in Water-Colours', *The Collector* (Dec. 1930), pp. 198–201.

EVANS, Joan, *John Ruskin*, London, 1954.

FARINGTON, Joseph, *Diary*, 1793–1821, British Museum Typescript.

FIELDING, T. H., *On Painting in Oil and Water Colours*, London, 1839.

——, *On the Theory of Painting*, London, 1836.

——, *Synopsis of Practical Perspective* . . . , London, 1824.

FINBERG, A. J., *Complete Inventory of the Drawings of the Turner Bequest, arranged chronologically*, 2 vols., London, 1909.

——, *History of Turner's 'Liber Studiorum'*, London, 1924.

——, *The Life of J. M. W. Turner, R.A.*, Oxford, 1961.

——, *Turner's Sketches and Drawings*, New York, 1916.

GILPIN, William, *An Essay upon Prints*, London, 1768.

——, *Observations on the River Wye . . . Relative Chiefly to Picturesque Beauty made in . . . 1770*, London, 1789.

——, *Three Essays: on Picturesque Beauty; on Picturesque Travel; and on Sketching Landscape: . . . to these are now added Two Essays, giving an account of the principles and mode in which the author executed his own drawings*, 3rd edn., London, 1808.

GIRTIN, Thomas and LOSHAK, David, *The Art of Thomas Girtin*, London, 1954.

GOETZ, Sister Mary Dorothea, *A Study of Ruskin's Concept of the Imagination*, The Catholic University of America, Washington, D.C., 1947.

GOMBRICH, E. H., *Art and Illusion*, London, 1960.

HARDIE, Martin, *Water-colour Painting in Britain*, 3 vols., London, 1966–8.

HARDING, J. D., *Elementary Art: On the Use of the Lead Pencil*, London, 1834.

——, *The Park and the Forest*, London, 1842.

——, *The Principles and Practice of Art*, London, 1845.

HARRISON, F., *John Ruskin*, London, 1920.

HERRMANN, Luke, *Ruskin and Turner*, London, 1968.

HIND, C. L., *Hercules Brabazon Brabazon*, London, 1912.

HIPPLE, Walter J., *The Beautiful, the Sublime and the Picturesque*, Carbondale, Ill., 1957.

HUSSEY, Christopher, *The Picturesque*, London, 1927.

KAINES-SMITH, S. C., 'T. H. Fielding', *The Old Water-Colour Society Club Annual*, III (1926), pp. 8–16.

KNIGHT, Richard Payne, *An Analytical Inquiry into the Principles of Taste*, London, 1805.

LADD, Henry, *The Victorian Morality of Art: An Analysis of Ruskin's Esthetic*, New York, 1932.

LAMBERT, R. S. (ed.), *Grand Tour*, New York, 1937.

LAUDER, Thomas Dick (ed.), *Sir Uvedale Price on the Picturesque* . . . , Edinburgh, 1842.

LEMAITRE, Henri, *Le Paysage anglais à l'aquarelle, 1760–1851*, Paris, 1955.

LEON, Derrick, *Ruskin: the Great Victorian*, London, 1949.

LOWENFELD, Viktor, *Creative and Mental Growth*, New York, 1957.

LYELL, Charles, *Principles of Geology*, London, 1849.

McKENZIE, Gordon, *Critical Responsiveness: A study of the Psychological Current in Later Eighteenth-Century Criticism*, University of California Press, Berkeley, 1949.

MALTON, Thomas, *A Complete Treatise on Perspective*, London, 1775.

MATHER, F. J., *Charles Herbert Moore . . .*, Princeton, N.J., 1957.

MILLAIS, J. G., *The Life and Letters of Sir John Everett Millais*, London, 1890.

MONK, Samuel H., *The Sublime: A Study of Critical Theories in the XVIIIth Century*, New York, 1935.

NICHOLSON, Francis, *The Practice of Drawing and Painting Landscape from Nature in Water-Colours*, London, 1820.

OPPE, A. P., 'Art in Early Victorian England', *Early Victorian England, 1830–1865*, ed. G. M. Young, London, 1934, Vol. II, pp. 101–76.

PYNE, W. H., *Rudiments of Landscape Drawing*, London, 1812.

——, 'The Rise and Progress of Water-Colour Painting in England', *Somerset House Gazette*, I (1824), pp. 65–7, 81–5, 97–9, 113–14, 129–32, 145–6, 161, 163, 177–9, 193–4.

[PYNE, W. H.?], 'Hints to Amateurs in the Study of Landscape', *Library of the Fine Arts* (Nov. 1831), pp. 277–83; (Dec. 1832), pp. 357–65.

——, 'Historical Sketch of Painting in Water-Colours', *Library of the Fine Arts* (June 1831), pp. 403–5.

——, 'On the Study of Landscape from Nature, by one of the Founders of the Society of Painters in Water-Colours', *Library of the Fine Arts* (Nov. 1832), pp. 116–28; (Jan. 1833), pp. 310–15.

QUENNELL, Peter, *John Ruskin: the Portrait of a Prophet*, New York, 1949.

RAWLINSON, W. G., *The Engraved Work of J. M. W. Turner, R.A.*, 2 vols., London, 1908, 1913.

REAU, Louis, *Histoire de l'expansion de l'art français*, Paris, 1931.

RIO, Alexis F., *De la Poésie chrétiènne (de l'Art chrétien)*, Paris, 1836–55.

ROBERTS, David, *The Holy Land . . .*, London, 1842–9.

ROGERS, Samuel, *Italy, a Poem*, London, 1830.

ROGET, J. L., *A History of the 'Old Water-Colour' Society*, London, 1891.

ROSENBERG, John D., *The Darkening Glass*, New York, 1961.

RUSKIN, John, *Letters of John Ruskin to Charles Eliot Norton*, ed. Charles Eliot Norton, 2 vols., Boston and New York, 1905.

——, *Praeterita*, ed. Sir Kenneth Clark, London, 1949.

——, *The Diaries of John Ruskin*, selected and ed. Joan Evans and John H. Whitehouse, 3 vols., Oxford, 1956–9.

——, *The Puppet Show, or Amusing Characters for Children, with Coloured Plates*, c. 1829, Holograph Collection of Dr. Helen Gill Viljoen, Flushing, New York.

——, *The Works of John Ruskin*, ed. E. T. Cook and A. Wedderburn, 39 vols., London, 1903–12.

——, *Turner and Ruskin*, ed. Frederick Wedmore, London, 1900.

RUSKIN, John James, *The Account Books of John James Ruskin*, MS. 28 in the collection of the Education Trust, Bembridge School, Isle of Wight.

SCHARF, Aaron, *Art and Photography*, London, 1968.

SCHMID, F., *The Practice of Painting*, London, 1948.

SMITH, John Thomas, *Remarks on Rural Scenery*, London, 1797.

STEEGMAN, John, 'Lord Lindsay's *History of Christian Art*', *Journal of the Warburg and Courtauld Institutes*, X (1947), pp. 123–31.

STEVENS, M., 'A Study of English Manuals of Drawing', unpublished Master's dissertation, Leeds University, 1959.

TAYLOR, Brook, *New Principles of Linear Perspective*, London, 1715.

TEMPLEMAN, William D., *The Life and Work of William Gilpin*, Urbana, Ill., 1939.

THACKERAY, W. M., *Sketches after the English Landscape Painters*, London, 1850.

——, *The Landscape Painters of England*, London, 1850.

VARLEY, John, *A Practical Treatise on Perspective*, London, 1820.

——, *A Treatise on the Principles of Landscape for Students and Amateurs in that Art*, London, 1816–17.

VILJOEN, Helen Gill, *Ruskin's Scottish Heritage: a Prelude*, Urbana, Ill., 1956.

WHITEHOUSE, J. Howard, *Ruskin and Brantwood*, Cambridge, 1937.

——, *Ruskin the Painter and his Works at Bembridge*, Oxford, 1938.

WILENSKI, R. H., *John Ruskin: an Introduction to Further Study of his Life and Work*, London, 1933.

WILLIAMS, Iola, *Early English Water-Colours*, London, 1952.

WILLIS, R., *Remarks on the Architecture of the Middle Ages*, Cambridge, 1835.

Index